The Color Design Source Book

USING FABRICS, PAINTS, & ACCESSORIES FOR SUCCESSFUL DECORATING

Designer Catherine Randy
Senior editor Sophie Bevan
Location research manager Kate Brunt
Location research assistant Sarah Hepworth
Production Patricia Harrington
Art director Gabriella Le Grazie
Publishing director Alison Starling

Additional styling Marlena Burgess, Emily Jewsbury

First published in the United States in 2001 by Ryland Peters & Small, Inc. 519 Broadway 5th Floor New York NY 10012 www.rylandpeters.com

10987654321

Text © Caroline Clifton-Mogg 2001 Design and photographs © Ryland Peters & Small 2001

The author's moral rights have been asserted. All rights reserved. No part of this publication may be reproduced, stored in a retrieval system, or transmitted in any form or by any means, electronic, mechanical, photocopying, or otherwise, without the prior permission of the publisher.

Library of Congress Cataloging-in-Publication Data

Clifton-Mogg, Caroline.

The color design sourcebook : using fabrics, paints & accessories for successful decorating / Caroline Clifton-Mogg; photography by Alan Williams.

p. cm.
Includes index.
ISBN 1-84172-225-1
1. Color in interior decoration. I. Title.

NK2115.5.C6 C55 2001 747'.94--dc21

2001031878

Printed and bound in China

JACKET PICTURE CREDITS

FRONT: Juan Corbella's apartment in London designed by HM2, Richard Webb with Andrew Hanson/photographer Christopher Drake.

SPINE: Richard Oyarzarbal's apartment in London designed by Urban Research Laboratory

BACK (clockwise from top left):
New York apartment designed by Bruce Bierman, Lindsay Taylor's

apartment in Glasgow, Katie
Bassford King's house in London
designed by Touch Interior Design,
Donata Sartorio's apartment in
Milan, private apartment in London
designed by Hugh Broughton
Architects, Jennifer & Geoffrey
Symonds' apartment in New York
designed by Jennifer Post Design.
Photography by Alan Williams.

Contents

6	INTRUDUCTION
10	COLOR INSPIRATIONS
12	Understanding color
16	Color through history
22	COLORS EXPLORED
26	Whites, grays, and blacks
40	Creams and browns
52	Reds, pinks, and purples
74	Blues: azure to aqua
88	Greens: emerald to lime
102	Yellows, oranges, and gold
102	renows, oranges, and gore
120	COLORS IN COMBINATION
124	A lesson in tone
128	Gaelic blend
130	Nearly neutrals
134	Harmonious hues
136	Complementary clash
140	Twentieth-century tone
144	Autumn light
148	Soft simplicity
150	Ice-cream cool
154	Sharp contrast
156	COLORS TO TRANSFORM
160	Color zoning
168	Making shapes
172	Creating atmosphere

176 178 180 182	COLOR TECHNIQUES Unusual finishes Washes and glazes Decorative paintwork
186	SUPPLIERS
188	CREDITS
189	PICTURE CREDITS
190	INDEX
192	ACKNOWLEDGMENTS

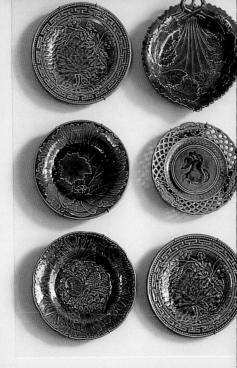

Introduction

COLOR IS NOT A LUXURY. IT IS AN ESSENTIAL. IT IS SO MUCH PART OF US AND SO MUCH PART OF OUR LIVES THAT IT IS EASY TO GET OUT OF THE HABIT OF REALLY THINKING ABOUT IT IN A CONCENTRATED MANNER—ABOUT THE EXTRAORDINARY VARIETY OF SHADES AND TONES THAT ARE AVAILABLE, AND WHAT THEY MEAN TO US.

Color is both the easiest and the hardest element in interior decoration. We accept it totally; we would be lost without it; we expect to use it in our homes, and we expect to use it to best effect. And color bestows life to everything around it—reason enough to use it and to use it boldly. But too often we take color for granted, without thinking about how to employ it, or which colors would be right for us to live and work with. Like any other discipline, the use of color benefits from consideration. Which colors do you empathize with? Which colors do you recall with pleasure or nostalgia—would they work again now? What colors do you wear—your choice of clothes color, even if you are a dyed-in-the-wool black-only addict, can say a lot about the range of color—or no color you would be happiest living with.

A good way to start the process of choice is to put together a scrapbook of both single colors and color combinations that you are drawn to—a fragment of material, plain or patterned, old or new; clippings from magazines showing rooms that use color in an interesting way; postcards of paintings or illustrations.

That is the first part of choosing the right scheme: to identify the colors you would be happiest living with. The second part is the practical element: to find out how your choice of color will look in situ. Try out samples where they will be applied—on the kitchen wall next to the stove, between the bathtub and the sink, in the darkest part of the hall. It is vital that a color is looked at over as long a period, as large an area, and in as many different lights, as possible. It is old advice, but none the less true for that.

BELOW LEFT Some colors work better with wood than others. A rich brown-red terracotta brings out the color and grain of the oak door and paneling, as well as of the floor and the furniture, in a way that others colors would not. There is a harmony here between color and texture.

BELOW Also effective against the dark wooden door and stairs beyond is a kitchen painted in paler colors of the same spectrum: cream cabinets below the wooden counter are highlighted with upper cabinets in both stone and mushroom. Other doors are brushed aluminum and opaque glass.

OPPOSITE A room of natural neutrals has stone-painted walls hung with muted pastels and watercolors. The wooden eaves are painted white, and the carpet is mushroom wool. This quiet haven is enlivened by a chair covered in what at first appears to be striped material, but which is, of course, a selection of traditional linen dishtowels in assorted checks and stripes, some that have even been monogrammed.

ABOVE A muted palette can contain colors other than neutrals, so long as they are of the same tonal values. Here, soft blues, pale lilacs, browns, and creams are harmonious together.

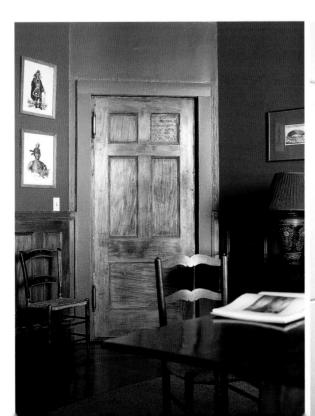

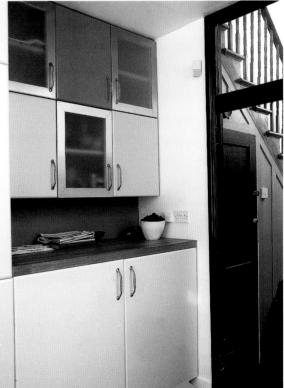

The way in which colors relate to each other has long been refined and consigned to charts of mathematical correctness. Although it is doubtful that you would wish to choose colors from a chart, color relationships are interesting in themselves.

OPPOSITE Looking at complementary colors gives food for thought, and that is why a knowledge of the color wheel is useful. By studying an illustration of one, your own ideas can be crystallized into schemes-you gain insight into which families of color will work together and bring out the best in each other. Throughout the centuries, variations on the color wheel have been designed to help artists in their work. This illustration is a painting. Color Spheres by Philipp Otto Runge, dating from the late eighteenth century. It shows a series of globes for copper, aquatint, and watercolors. From the top left, clockwise, he calls them, "View of the white pole." "View of the black pole," "A cross-section through both poles," and "A crosssection through the equator."

As I say elsewhere, colors are affected not only by the light outside, but also by the immediate external surroundings; buildings, trees, and grass all alter to a certain degree how the colors inside is perceived.

The earliest facts we are taught about color—probably at school—are of the importance of primary colors (red, yellow, and blue) and how different combinations of two primaries can be mixed to make three secondary colors (purple, orange, and green); also that two secondary colors can be mixed to make some of those subtle tertiary colors. Tertiaries can, in fact, be almost indefinite in number, as they can be made from compounds of primaries, secondaries, and other tertiaries, in different degrees and combinations. Tertiaries are probably the easiest colors to live with, being subtle combinations that incorporate the strengths of their more strident cousins.

The basic color wheel is often shown as a brightly colored segmented circle, and many of us glance at it once, see nothing that particularly appeals, and move on. But the lessons of the color wheel are very useful when it comes to choosing colors for decorating, particularly when thinking about which colors will work well together. Consider, for example, complementary colors: colors, of equal intensity, that lie opposite each other on the wheel. Among the primaries, for example, the opposite to blue on the wheel is orange; the opposite to red is green; and the opposite to yellow is purple. A primary's opposite is the color that does not have that particular primary in its composition. Decoratively speaking, it is not, of course, necessary to use fire-engine red and emerald green (unless you want to); you could equally use a

pinkish red and a dark ivy-leaf green. Equally, secondary complementaries are more subtle versions of the primary hues; turquoise, for example, is complementary to tangerine.

Applied to interior decoration, a complementary color is one that, when used in small doses, draws attention to and grounds the central color; when mixing colors, a dash of the complementary color will tone down the stronger color. Within secondary and tertiary colors, the range of combinations and schemes is infinite, and looking at the different areas of color—seeing the ones that blend and the ones that contrast—will always light the imagination.

Strictly speaking, white added to an existing color makes what is called a tint; black added to the same color makes what is known as a shade and, when both black and white are added, the finished result is called a tone. In reality, these three terms are often misused, and the assumption should not be made that a color so named will necessarily have been mixed in the way described. Too much white or too much black added to a color tends to make it misty or murky, with considerable loss of definition.

Tone of color is also important. Colors that share the same intensity have the same tonal value and tend to work well together. This is a safe guide, but one that must be used with discretion, for tonal harmony is upset by texture—the same color will look different in paint or linen, for example.

So read your color chart, spin your color wheel and study the results, while remembering that in the end it is what you like and feel attracted to that will be most successful.

Farbenkugel. Ansicht des schwarzen Poles. Ansicht des weissen Poles . Durchschnitt Durchschnitt durch die beyden Pole. durch den Acquator. Gr

FAR LEFT Inspiration for colors and color schemes can come from many sources, such as the delicacy of flowers and fruits cut and brought inside, combined with colored glass and gold details. LEFT Clever combinations and use of color can often be found in decorative details. Here, in a corner of a room, a heavily gilded frame against a wall washed in rich yellow is accented by a deep-red pillow, decorated with a golden spray. RIGHT Inspiration can also come from what has gone before. This wonderful combination of deep green-blue combined with amassed gold leaf is reminiscent

of medieval religious paintings.

Color inspirations

A washed-out world of no color, like an endless low-clouded, gray dawn, is a prospect so depressing and alien that it is difficult to comprehend. We need color around us, in the natural world and in our homes, on our walls and floors, in our textiles and art.

Yet, despite this need to surround ourselves with color, finding the right colors for interior decoration can be a daunting prospect, and inspiration can seem far away. But it is not that distant. Color, in all its forms, is interwoven firmly into our lives—throughout history, eyewitness accounts of events, places, or people nearly always make some reference to the colors of the scene

described—color of costume, of decoration, and the surrounding landscape. And when color pigments were difficult to come by, men used what they could find in an inventive and creative way, often turning to nature's combinations as a starting point. As new colors were developed, they were incorporated into daily life—some more readily than others, depending on their scarcity and value. So, when you are searching for ideas, study carefully that which has gone before as well as that which is around you now: decoration, costume, art, nature—inspiration is not as elusive as you might think.

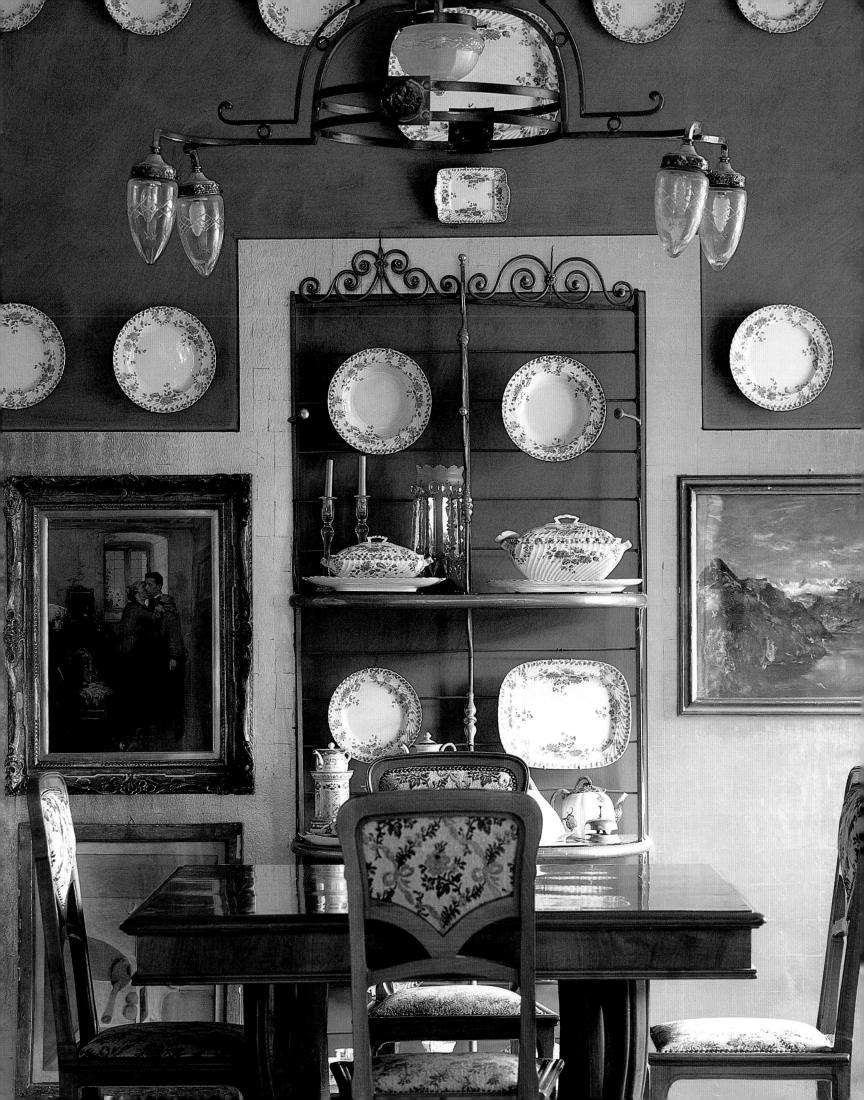

Understanding color

ACCUSTOMED, AS WE ARE TODAY, TO HAVING LITERALLY HUNDREDS OF PAINT COLORS AVAILABLE AT THE TOUCH OF THE BUTTON ON AN AUTOMATIC MIXING MACHINE, AS WELL AS THE CHOICE OF THOUSANDS OF TEXTILES, PRINTED AND WOVEN IN BRIGHT DESIGNS, IT IS INSTRUCTIVE TO THINK OF THE LENGTHS—THE SHEER INVENTIVENESS AND RESOURCEFULNESS—TO WHICH PEOPLE HAVE GONE IN ORDER TO BRING COLOR INTO THEIR LIVES.

All paint colors and dyes as we know them today are derived from mixing pigments with a binding medium, which allows them to be transferred onto a surface. Until the middle of the nineteenth century, when rapid chemical advances were made and pigments began to be produced synthetically, colors were naturally obtained from the minerals and earth, vegetables and plants that were available. Early mediums included egg for the making of tempera, and later oil.

There are about eight earth pigments, including sienna, ocher, and umber, and these could be mixed with minerals like iron oxide and copper-based pigments to give a range of colors that suited every need. Roots like indigo were used, too. Rare, precious—and correspondingly expensive—colors were also made: rich ultramarine blue from crushed, ground lapis lazuli, and the brightest green from malachite treated the same way. The tones and hues of colors differed, of course, from region to region, which is why today we associate certain colors—particularly those made from earth and clay—with certain areas

Yarn, too, was rarely left in its natural, undyed state. From flowers and fruit to roots and bark— and even shellfish—dyes were squeezed from the natural world to bring color to the neutral tones of wool, linen, and cotton. In fact, textiles, rather than flat planes of color seen on walls, are often the starting point for color inspirations. Historically, fashion has inspired choices of decorative colors, and it still does. To go to a museum of costume or an archive exhibition can be positively regenerating—

the color of embroidered threads on a eighteenth-century brocade vest, the woven designs on a nineteenth-century "kirking" shawl. Modern fashion can be equally thought-provoking—both street and couture fashion are constantly looking for new ways to use color, many of which can be translated into decorative terms. This is also true of accessories: many couture houses, for example, once designed silk headscarves (an essential for the elegant woman). Painted designs were hand-screened onto silk squares, and the thought and subtlety of color that went into these period pieces are textbook examples of the use of color in our time.

BELOW The artists of the Impressionist movement used color to convey the spirit of the immediacy of the natural world. The landscape in Pierre Auguste Renoir's Chemin montant dans les hautes herbes (c. 1876) is painted in greens, yellows, blacks, and whites—with dashes of red, the complementary color to green, introduced at strategic points.

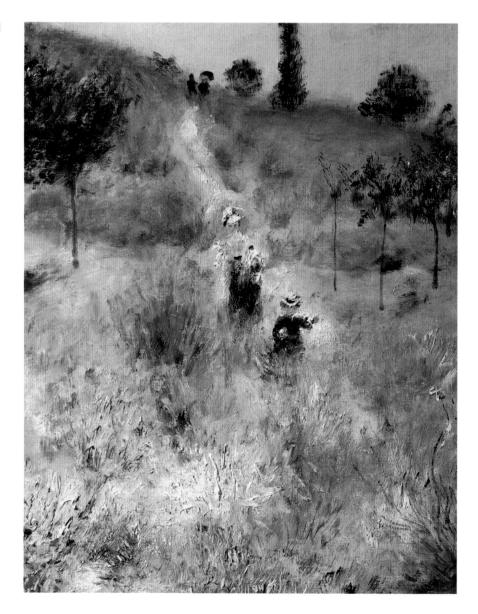

Paintings are another fertile source of color inspiration. This applies not only to the colors that artists have used harmoniously, but also in the way in which groups, such as the Impressionists and the Post-Impressionists, used paint in a very precise manner, putting small dashes of colors separately, but next to each other, so that in close-up a dense mosaic of identifiable color can be seen, while at a distance something completely different appears.

Familiarity breeds, if not contempt, then at least laziness. We often accept what we see around us without analyzing why we are pleased by one thing and dismayed by another. All artists—lesser and greater—look, and really try to see what it is they are looking at. And, to find inspiration from a painting, look at it again, and again, to see not only how the colors work together but also why they work.

Whether you find your inspiration in a museum or an art gallery, from the pages of a magazine, or walking down the street, the interesting thing is that each and every source, indeed all applied color, is

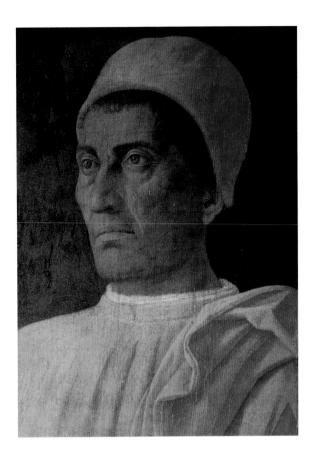

LEFT In the Renaissance painter, Andrea Mantegna's (1431-1506) magnificent portrait of Cardinal Carlo de Medici, the eye is drawn to the richness of color in the robes, emphasized by the thin circle of gold at the neck. **BELOW** The Card Players by Paul Cézanne (1839-1906) is a wonderfully rich, dark study. Browns, greens, oranges, yellows, and reds all work together with touches of black, white, andsurprisingly—pink.

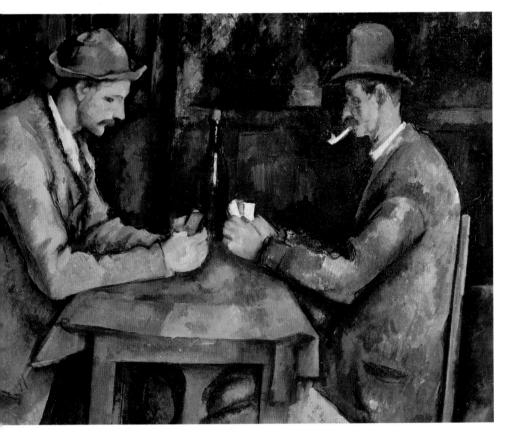

based on what we see around us in the natural world. When we are inspired by the tones in a painting, we can remember that the artist arrived at that particular effect through his wish to recreate the shades and tones of the world around him. These are the subtleties and nuances that every artist, from the first cave painter onward, has struggled to interpret and develop. From Piero della Francesca, Fra Angelico, and Giotto to Titian, Gainsborough, and Reynolds, Renoir and Cézanne to Van Gogh and Matisse—all of them spent their working lives analyzing and refining the best way to use their brush strokes and the color they had—or could make—to show the tones and colors of nature at their truest.

It would be hard to find a better set of instructors, so we, too, perhaps should take the color combinations of nature as our first point of inspirational departure. The most important thing is to look—really look at the natural colors around us. Everything—a leaf, a flower, a stone—is affected by the color of the day, the strength of the sunlight at the moment we are

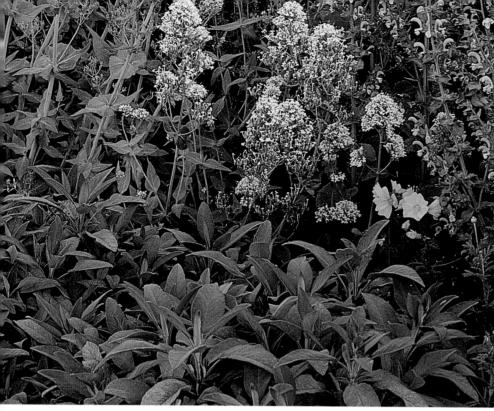

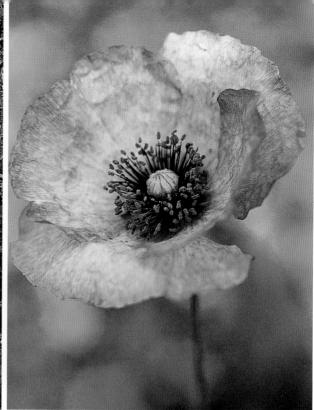

THIS PAGE A bed of herbs in greens from mauve to gray to white; tree bark in every gold-toned variation; startling narcissus flowers against blue-green leaves; and the fragile beauty of a poppy, its center of delicately striped red and yellow, encircled in green, and surrounded by soft white petals tipped with smoke gray—nature never stops teaching us about color.

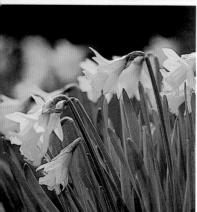

looking at it. Light affects everything: The sky itself is a perfect example: look at the sky on a sunlit day to see how many changes in tone there are, from the deepness of the bowl over our heads down to the muted tones of the horizon, and the way that a passing cloud will change and intensify those colors.

As far as color combinations go, whether subtle or striking, nature, even in miniature, never gets it wrong: recollect the face of a viola with its intense shades of pure purple, mauve, yellow, and white; an olive or willow leaf—cool, gray-silver on one side, a harmonizing gray-green on the other; old-fashioned pinks with a clear pink petal that contrasts with a dark blood-red center, framed by a gray-blue leaf; a white hydrangea as it slowly ages into watered lime green, touched with dashes of mauve-pink and claret. And, on a more awesome scale, the color of a New England autumn—a travel cliché perhaps, but only because the flamboyantly bright reds, russets, ochers. oranges, and toffee browns still make the eve stop with surprise and delight. Or, on a quieter level, there is a traditional English rural, wooded landscape, where nothing but green is seen, but with so many subtle variations on a theme that it seems as if an entire paintbox has been employed. The variety of color, of contrast, and of tone to be found in nature can never fail to astonish and delight.

In the same way that light changes everything, we see both outside and inside, so lands of light inspire us with the color that we experience there. In many parts of the world, decorative colors are natural pigments used in their full intensity, rather than the diluted colors so often seen in northern Europe and North America. In India, for example—where the trees, shrubs, and flowers are vivid and striking, and the palaces of Rajasthan have vibrant interiors with walls studded with bright jewels set against marble—dyes and paints bring color to everyday surfaces. These invigorating, exciting pigments have a sharpness and a brightness that more than hold their own under the harsh sunlight, although they might be difficult to live with in more shadowed climes.

In the Caribbean, the fierceness of the light highlights paintwork that was originally painted in cheerful bright pinks, mauves, and blues, but which speedily fades to softer shades that harmonize with a natural background of blue water, yellow-green palms, and impossibly pale gold sand. Caribbean inspiration could also be found in the show-off sunsets of orange, fire red, shell pink, cream, pale yellow, and a touch of old silver, all set against a blackening sea.

The colors of southern France, in the hills of Provence and by the Mediterranean, are another color inspiration. The sun shines brightly here, but the light

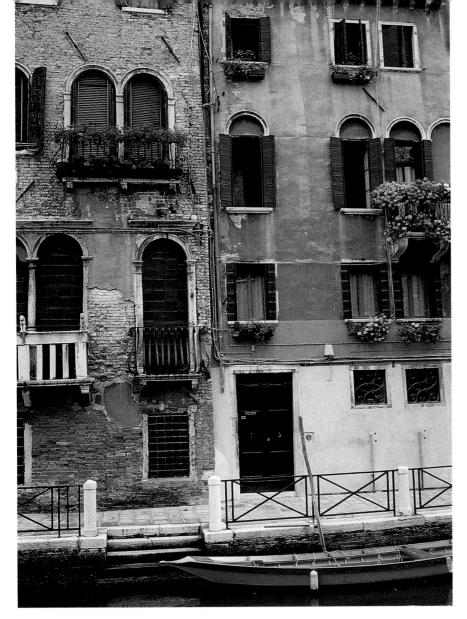

is diffused and softer than that of the Caribbean. This softness is reflected in the tones of the indigenous trees and plants. There is a subtlety in the colors of the olive trees, the fields of lavender, and the shutters of faded blue, mauve, or green against an ocher or sienna background. These colors translate with comparative ease to more temperate atmospheres.

Lavender fields, in fact, are good examples of the effect natural light has on our surroundings. Compare the lavender fields of Provence, France, and those of New England. Both grow the same crop, but the first impression of the color of the fields is very different. In the softer, diffused light of New England, the lavender looks equally soft, equally diffused; under the clear bright light of southern France, the same lavender reaches intensely toward you, emphasizing its brightness and clarity and sheer shock value.

Not only do these international examples provide inspiration for color combinations, but they also highlight the need to consider the natural light in a space before selecting colors. All the colors in your scheme will be affected by what one might call external influences: what is outside the window, whether it is the strength of the sunlight, the color of the sky, the surrounding buildings, or nature, green and in the raw.

ABOVE Certain colors and tones are indelibly associated with places and countries. The faded earth red of this house on a Venetian canal sums up much of Italy; indeed, its commercial counterpart is sometimes known as Tuscan red. It is the naturalness of this color that attracts, the way it seems to be part of the very fabric of the house. brighter, newer patches next to older, faded pink areas. The traditional dark green used for the shutters enhances the color. RIGHT Very much a color of the sands and the desert, the warm ocher of this Moroccan mausoleum again seems to exude from the walls, rather than being imposed onto them. The colors of the two different tile designs blend and tone with the wall color in perfect harmony.

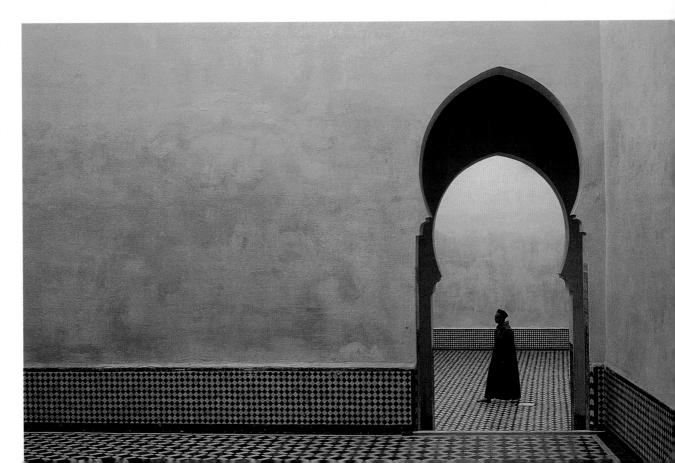

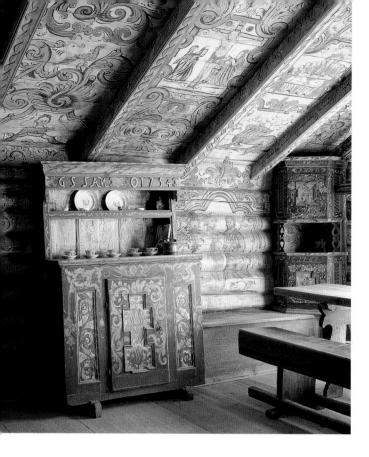

LEFT The embellishment of one's surroundings is one of man's most primitive inclinations. To this end. color has always excited, and artists and craftsmen have used it in profusion. Men, beasts, and religious subjects cover every surface of this Norwegian room, decorated in the eighteenth century in a style known as "rosemaling." BELOW The ancient Romans used profuse and strong color inside their houses. This room in the Villa of Mysteries in Pompeii shows the women's rite of the sacred agape boldly painted, employing deep red and black extensively, the wall divided into broad panels.

No sooner had early man come in from the cold than he began to draw markings on his cave walls, pounding and mashing the earth and vegetable matter to produce the colors he desired. Even the earliest cave paintings—like those executed at Lascaux in France—show traces of color within them.

The ancient Egyptians were possibly the first to appreciate the power of color fully, and, from the ornate sarcophagi to the richly frescoed interiors, color was an integral part of Egyptian art. They used mainly primary colors: red was made from hematite, an iron ore; yellow, from the mineral orpiment; and blue was made either from the mineral cobalt or from copper. Green was also used, made from the semiprecious mineral malachite; and white was used to vary the tones of these colors. The Egyptians also often outlined their fresco paintings in a vegetable or bone black.

It is hard to know exactly how extensively the Greeks used color in decoration, since very few domestic buildings survive and there are no known pictorial records. We do, however, know that Greek houses were relatively simple inside—much of daily life was pursued in the open—and that they used the paint they had boldly in one or more colors, most often red, which may be combined with white, yellow, and black.

The Romans loved color and used it with confidence in their homes. Rooms were painted by applying single colors to different areas. The walls of a receiving room might be divided into three sections-dado, middle, and entablature. Dados were usually dark, even black, with simple geometric designs; the central section was often painted purple, green, blue, or yellow and might have descriptive scenes or landscapes on it, surrounded with panels filled with decorative motifs; and above might be a painted frieze of some description, often on a white background. The murals were bright and literally shone, a finish perhaps achieved by polishing the painted surface. And, in Pompeii, where the interiors were even more sophisticated, color was used lavishly. often mixed to produce softer tones that worked together in a harmonious way.

Color through history

COLOR HAS BEEN A KEY ELEMENT IN INTERIOR DESIGN EVER SINCE MAN FIRST DISCOVERED HOW TO USE PIGMENTS DERIVED FROM THE EARTH AND VEGETABLE MATTER. THE WAYS MAN HAS SINCE USED THIS TECHNOLOGY TO ADORN HIS SURROUNDINGS IS A LESSON TO US ALL IN THE POWER AND IMPORTANCE OF COLOR IN OUR HOMES.

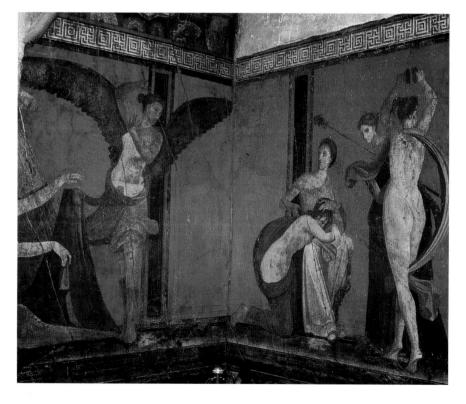

16 color inspirations

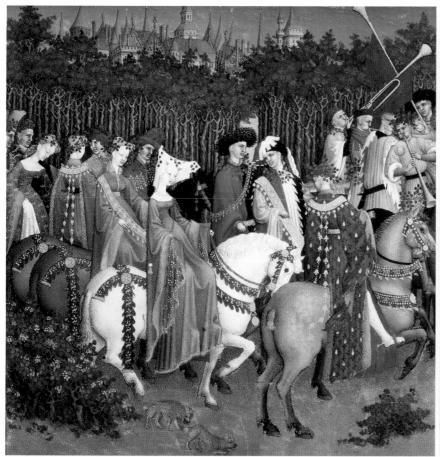

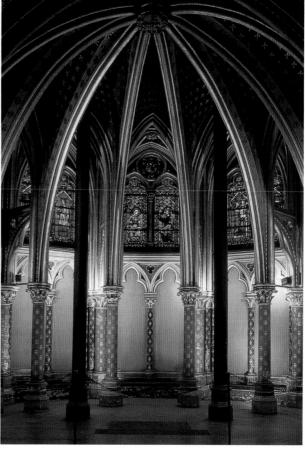

ABOVE The color that was alive in daily life in medieval Europe was faithfully recorded and echoed in paintings and in the decoration of buildings. This page from the fifteenth-century book, Les Riches Heures by Pol de Limbourg, depicts "The palace and town of Riom with courtiers in procession on May Day," and illustrates the passion of the time for color and decoration. ABOVE RIGHT The lower chapel of the medieval Sainte Chapelle in Paris, recently restored, is breathtaking. Every surface is ornamented with fleurs-de-lys, stars, and wide and narrow bands of bright color.

Color was everywhere in medieval Europe: Romanesque and Gothic interiors throbbed with color, profuse and brilliant. It is almost a cliché to say that the gray interiors we see today were once of bursting brightness: color was applied to stone and wood as well as walls and ceilings; when the stone was decorated, the attendant bosses, pendants, and carvings were also painted. Even the undersides of arches and beams were painted and gilded, as were the spaces between. At first, color-often white or blue—was applied en masse, then picked out with bright tints and enriched with gold flowers, stars, and other motifs. Over time, the schemes became more sophisticated and clever. Curious—and surprisingly daring—color combinations began to appear. They used black, white, and red; red, bright blue, and gold. Narrow bands of color wound around struts like early barber-shop poles, and stars were painted in gold onto heavenly blue ceilings. They used counter-changes:

one panel might be painted white with black decoration; another, black with white designs. And artists employed trompe l'oeil, as curled scrolls with writing were seemingly attached to beams and rafters. Exuberant and free-flowing as it all looked, there were distinct and clever rules that were employed to provide harmony. The rich colors used, which included red, blue, green, and purple, were invariably separated from each other with thin lines of gold, yellow, black, or white. Very bright colors were often painted on backgrounds of yellow or gold, white or silver or black, which not only gave them prominence, but also contained them, not allowing the feast of pattern and color to confuse the eye.

To see one of these interiors restored—Sainte Chapelle in Paris, for example—is breathtaking. The richness, the imagination, the ideas, are startling. Not only are the best of these medieval interiors historically fascinating, they are also fuel for your own decorative

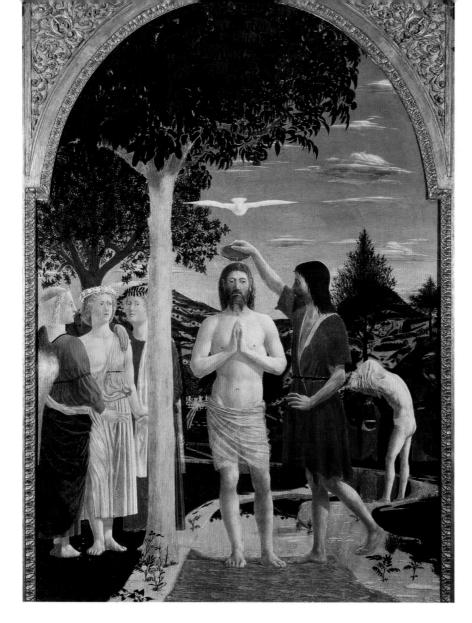

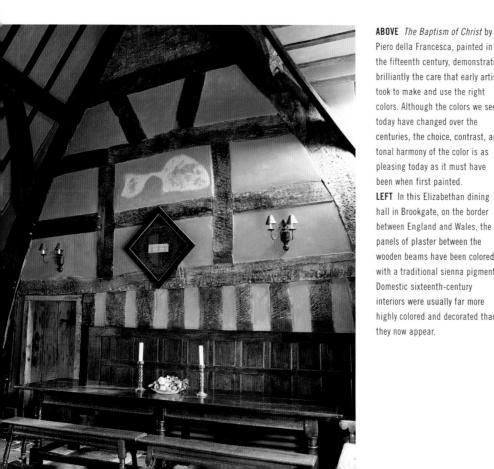

Piero della Francesca, painted in the fifteenth century, demonstrates brilliantly the care that early artists took to make and use the right colors. Although the colors we see today have changed over the centuries, the choice, contrast, and tonal harmony of the color is as pleasing today as it must have been when first painted. **LEFT** In this Elizabethan dining hall in Brookgate, on the border between England and Wales, the panels of plaster between the wooden beams have been colored with a traditional sienna pigment. Domestic sixteenth-century interiors were usually far more highly colored and decorated than they now appear.

inspiration, for, although such design may seem far removed from decorative schemes of today, inspiration lies in the combination of color, the use of pattern, and the discipline behind the free-flowing designs.

Religious symbolism played its part, too, in the chosen colors of early, and indeed later, artists. White stands for light and purity; blue represents contemplative faith, the heavens, and is of course the color of the Virgin Mary; red stands for militant faith, genius, fire, and charity; green is for hope and rebirth; and black is for mourning.

From medieval times on, chemists and artists were mixing pigments together, as well as experimenting with different minerals and chemicals to try to increase the range of color available. And, by the fifteenth century, there were many more colors in pigment form than ever before. Most widely used still were the earth colors: raw and burnt sienna, raw and burnt umber, and the ochers. These were cheap and easily obtainable from the earth, but now they were mixed with other compounds to produce a far greater variety of shades and hues.

Even then, fashion affected the popularity of various colors. In England, for example, the livery colors of the Tudors were green, white, and red; and these shades became extremely fashionable throughout the reigns of the Tudor kings and queens. At that time, color was used both inside and out: Tudor gardens had brightly painted wooden fence rails and tall wooden posts topped with painted and carved heraldic figures. With painted and gilded wood and plaster inside, as well as walls of embroidered and woven hangings, how cheerful and colorful life must have looked.

The Renaissance, particularly as it developed in Italy, influenced many areas of artistic life, including the use and choice of color throughout Europe. Artists like Raphael (1483–1520) and his contemporaries rediscovered in the ruins of ancient Rome vestiges of classical decoration—the grotesques (so called because these designs were originally discovered in grottoes of excavated villas), the murals, the wonderful decorative flights of fancy. Inspired by what they saw, they painted similar decoration in new buildings, such

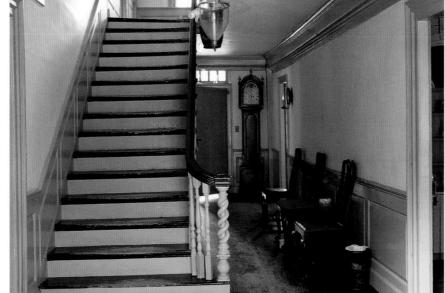

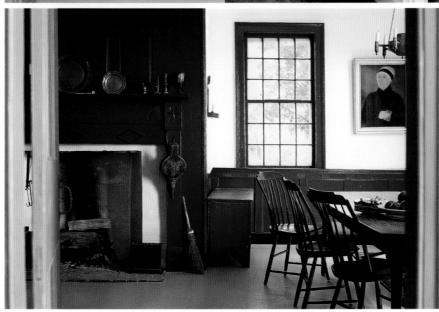

LEFT The decoration of Ham House, outside London, home of the Duke and Duchess of Lauderdale at the end of the seventeenth century, was known even in its own time as being the last word in taste and fine decorative techniques

TOP The hall of the Joseph Webb house in Wethersfield, Connecticut, built in the late eighteenth century, is painted with oil paints in the original colors of Georgian green and pale lilac. Green, made from an expensive pigment, was particularly popular among the wealthy.

ABOVE Although certain pigments were expensive, others were cheaper and widely used, particularly in less important, secondary rooms. In this colonial house in New York state. the woodwork has been painted in inexpensive Spanish brown.

as the Villa Madama and the Loggie of the Vatican. In fact. Renaissance artists covered most interiors with bright decoration: walls and richly carved, embellished wooden ceilings, color and gilding were everywhere. Many more pigments were used during the Renaissance, and black and white were added to other colors in measured quantities to increase the range of tones. Such color and designs continued to influence the decorative arts for hundreds of years.

In northern Europe, where the light was not so strong and the temperament quieter, less vivid colors were preferred. In England, Renaissance influence permeated slowly through domestic decoration, and surfaces became increasingly ornamented with frescoed and painted walls and ceilings, highlighted by judicious gilding. The seventeenth century was a time of monumental interior architecture, with pilasters and coffering, and wall paintings executed on canvas.

The new settlers in America, however, had not the same luxury of choice where color was concerned. There, pigments and dyes for paints and textiles were prized from the land, and boiled and beaten into submission for use at home. For the early settlers, nothing was to be wasted, and cloth brought from Europe was recycled into useful household goods, while linen and wool and cotton were woven and dyed, using all parts of the plant from the root to the leaf, the nuts, and the bark.

By the eighteenth century, there were two standards of color. For most people, cheap pigments and mediums were used; houses were whitewashed outside, and coated with distemper inside. Distemper was ground chalk mixed with glue size and tinted with a pigment. Usually the pigment was an earth color, but sometimes something a little more exotic was used—ox blood, for example, gave a fetching rusty pink. It was a different story for the wealthy. Throughout the eighteenth century, the range of colors available became increasingly sophisticated. In the early 1700s, many interiors had painted wood paneling; any visible plaster was painted with oilbased paint in neutrals, like white or stone, with the paneling in wood tones, like buff, walnut brown, and

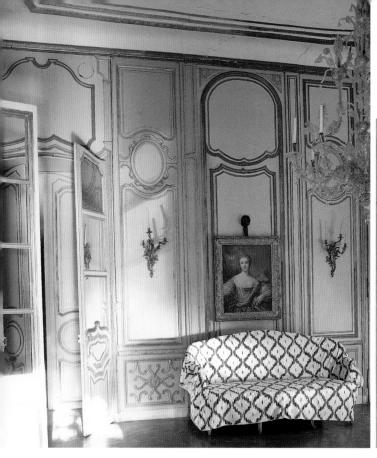

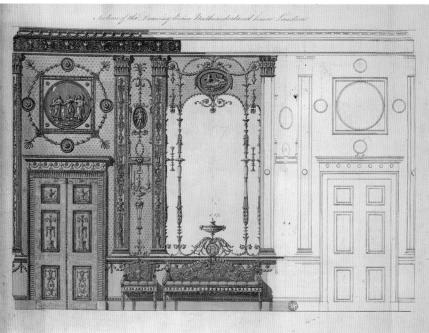

chocolate. However, as the century progressed and plaster replaced paneling, paint was increasingly popular—for the rich. Those wonderful colors appeared that we now associate with the eighteenth century in general, and with the designs of Robert Adam in particular—colors like pea green, sky blue, light pink, and lemon, all achieved by mixing different pigments and experimenting with proportions. Deeper tones of green and blue were still the most expensive, and therefore the most desired.

During the seventeenth (and certainly by the eighteenth) century, supremacy in the decorative arts had shifted from Italy to France, and the French remained at the forefront of interior decoration and style until the late 1800s. Over the period marked by the reigns of the four Louis, there were various popular color schemes: Louis XIII (1601–43) introduced paintings as decoration, with both floral designs and figurative pictures; while under Louis XIV (1638–1715), color became lighter and brighter, and houses decorated during the reign of Louis XV (1710–74) often combined gold and pale colors in sinuous rococo designs. The truncated reign of Louis XVI (1754–93) saw the first steps toward a new classical simplicity. Many of the colors used

during the period—white, pale pink, blue, slate gray and soft browns, often with touches of gold—are still thought of today as quintessentially French.

By the end of the eighteenth (and the beginning of the nineteenth) century, the decorative style in England, France, and Italy had come to embrace the lure of the antique, and both Regency and Empire interiors were often decorated with strong colors, like black and terracotta red—many of them imitating the deep pigments that had been used by the ancient Greeks and Romans. The classical references were also repeated in the way the walls were colored, with the baseboards, dado wall, and ceiling moldings all decorated to recall the form of the classical column. Many of these colors were bright, but they were still relatively soft, coming as they did from natural pigments.

All that was to change: the advances of the Industrial Revolution were about to play their part in the history of color. Paint technology was advancing, synthetic pigments were under experimentation and, in the mid-1800s, new colors exploded into the world, some shown for the first time in their startling glory at the Great Exhibition of 1851 in London. Now there were purples, lilacs, salmon pinks, oranges, acid

ABOVE LEFT The delicacy of decoration in eighteenth-century France was appreciated throughout Europe. Here, a salon in a small eighteenth-century chateau is decorated entirely with carved and gilded paneling on a soft gray background.

ABOVE During the mid-eighteenth century, Robert Adam, after spending much time in Italy, introduced into England delicate, colorful interior schemes such as this one for Northumberland House in London. His schemes often included designs for furniture and carpets as well.

RIGHT In the late nineteenth century. William Morris formed his own design and manufacturing company and introduced to the Victorians the idea of using natural dyes and pigments in textiles and wallpapers that were designed as representations of natural life. The design shown here, "Wandle," is a printed textile, manufactured by Morris & Co. and Aymer Vallance. Many of Morris's designs are still made today.

vellows, and many greens, both bright and dark. They were used with abandon on walls and ceilings, and the surrounding woodwork, too, was often painted in a dark, heavy color. This was the period when, for the first time ever, mass production meant that many of the elements of a decorated interior, which had previously been available only to the wealthy, could now be bought by all. Not only the new paints, but also textiles, floor coverings, and wallpaper most of them brightly patterned—could be bought at reasonable prices. Unfortunately, the replacement of the craftsman by the machine meant that the quality was often suspect, and the new schemes loud and garish.

The nineteenth century was not entirely a place of the bright, brash, and bold. With other likeminded souls, the architect and ornamental designer, Owen Jones (1809-74), sought to redefine the principles of design, pattern, and color. In 1856, his influential book Grammar of Ornament was first published, which presented thousands of ornamental motifs drawn from the ancient world through to the Renaissance. A few years later, the British artist and craftsman, William Morris (1834-96), developed these ideas, forming his own, now famous, movement and manufacturing company, introducing (or rather re-introducing) the idea of simplicity in design and the use of natural dyes and pigments.

BELOW In general, as the twentieth century progressed, the use of color in design became simpler than it had been in preceding centuries. Artists like David Hockney, whose Beverley Hills Housewife (painted in 1966) is seen here, used flat planes of color in a way that influenced other artists and designers of the time.

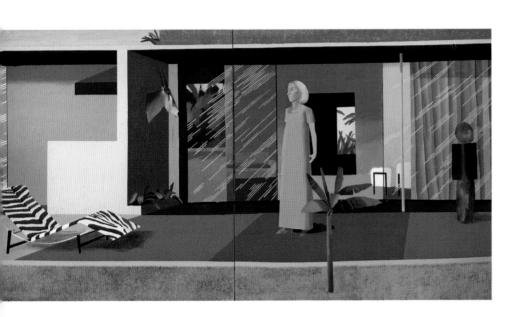

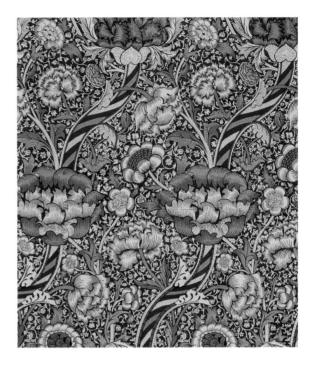

These softer, clearer colors survived the transition from the nineteenth to the twentieth century, and were echoed by some modern designers. As the century advanced, the new profession of "interior designers" espoused simplified design and decorative schemes, and new attitudes to color, which ranged from the studies in neutrals promoted by fashionable decorators of the 1920s and 1930s to the bright, almost naïve color preferred by the Omega movement and used with abandon on every flat surface.

The twentieth century became a time for everything to be tried-from the 1960s, where fashion, decoration, textiles (even upholstery and accessories) were suffused with bright, bold, often harsh color, to periods where the virtues of natural color and textures were much vaunted. Which brings us to our own, young century: today we seem to have a new attitude toward color-an attitude of no attitude. We seem easy with it, and its availability has meant that we swing effortlessly through color phases and fashions—sometimes bright and strong, sometimes pale and reflective. The big difference seems to be not so much in the colors used, but in the quality and texture of those colors. And there is more to come

Colors explored

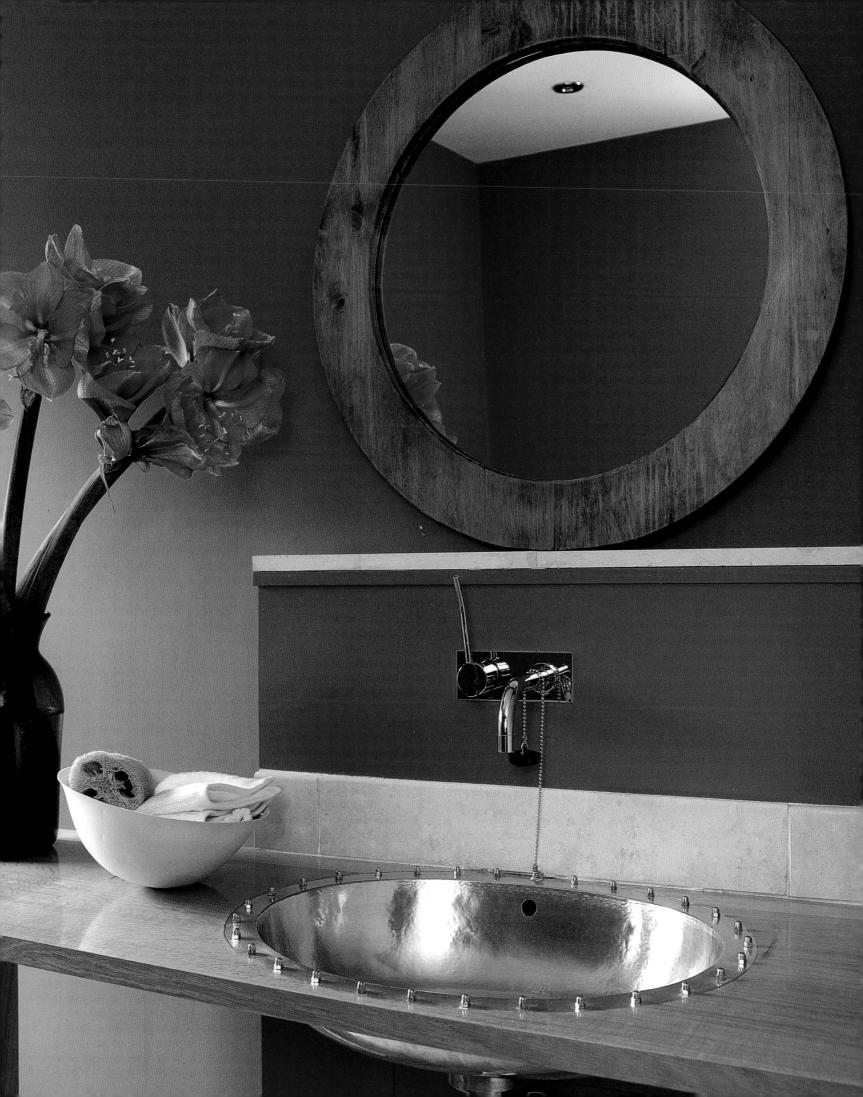

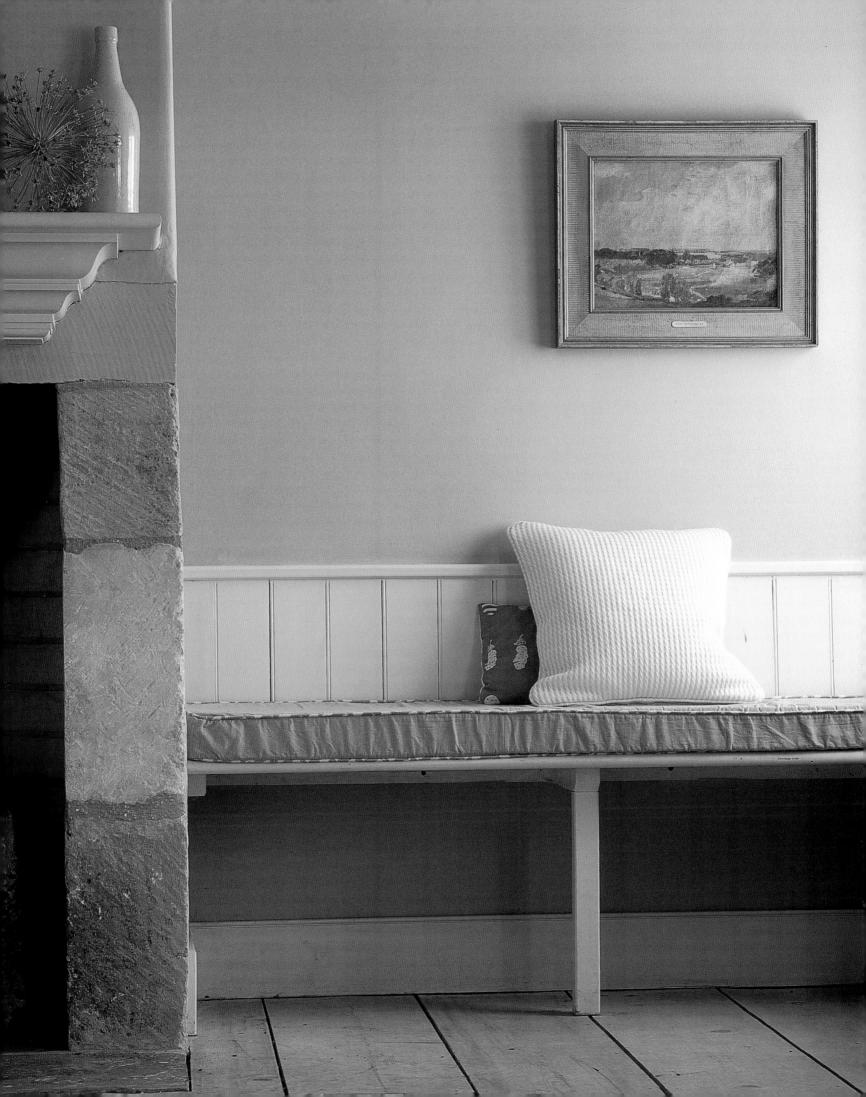

An infinite variety of tones and shades can be created from combining primary colors and from adding white and black, which of course makes choosing the color you like not quite as simple as it first sounds.

When deciding what color to use in the home, first think about what colors—or tones of color—instinctively appeal to you when you see them by chance. The sort of colors that you like to wear can be helpful here, although that is not to say that if you are wedded to black then your home should be nothing but an underworld symphony.

Prismatic colors are violet, indigo, blue, green, yellow, orange, and red—the seven colors seen from the decomposition of a ray of light when passed through the prism. The colors of the spectrum have varying tones because our eyes are more sensitive to some colors than to others. Yellow is always light in tone because our eyes are most sensitive to it, while pure red and pure blue appear the darkest. In dim light, our eyes are most sensitive to green and blue, and any red becomes very dark.

Nuances of color—all the subtle hues and tones we see around us—are made by adding basic yellows, reds, blues, and blacks, either to each other or to white; and, depending on the balance of pigments combined, either cold or warm tones of color are created.

Originally, artists used basic earth and metal pigments and experimented mixing different pigments together, as well as mixing them with white, to arrive at the color they wanted. Today, the large paint companies do the same thing commercially, and on a huge scale, using modern synthetic pigments; but I think it helps to remember that every color is simply a combination of other colors and that, depending on the strength and color values of the originals, different new colors can be created in profusion.

OPPOSITE Natural tones are as beautiful as bright colors. Soft and welcoming, they work particularly well when they take their cue from the color of natural materials, such as the golden stone of this country fireplace.

PREVIOUS PAGE The tones used in this bathroom are carefully chosen to work together. The walls are deep red, but with a brown-terracotta tinge, which is complemented perfectly by the natural wood of the wash basin surround and wooden frame of the mirror. The beaten metal basin adds a sharp tone of contrast.

Whites, grays, and blacks

Whites, grays, blacks—this is where the story of neutrals begins. The colors we broadly think of as neutrals—all those soft subtle shades without which decorating the home would be impossible are colors that are usually made by adding white to basic pigments. These neutral shades should not be dismissed out of hand. Neither dull nor boring, they are in fact the most sophisticated colors around. Many of us start our lives in color using shades that get quickly to the point—the sort of colors that need no introduction. But, as we learn more about color, we begin to appreciate the subtlety of so-called neutrals—their air of quiet calm and confidence. They are not primaries, nor secondaries, nor even complementary—they are nuances of color

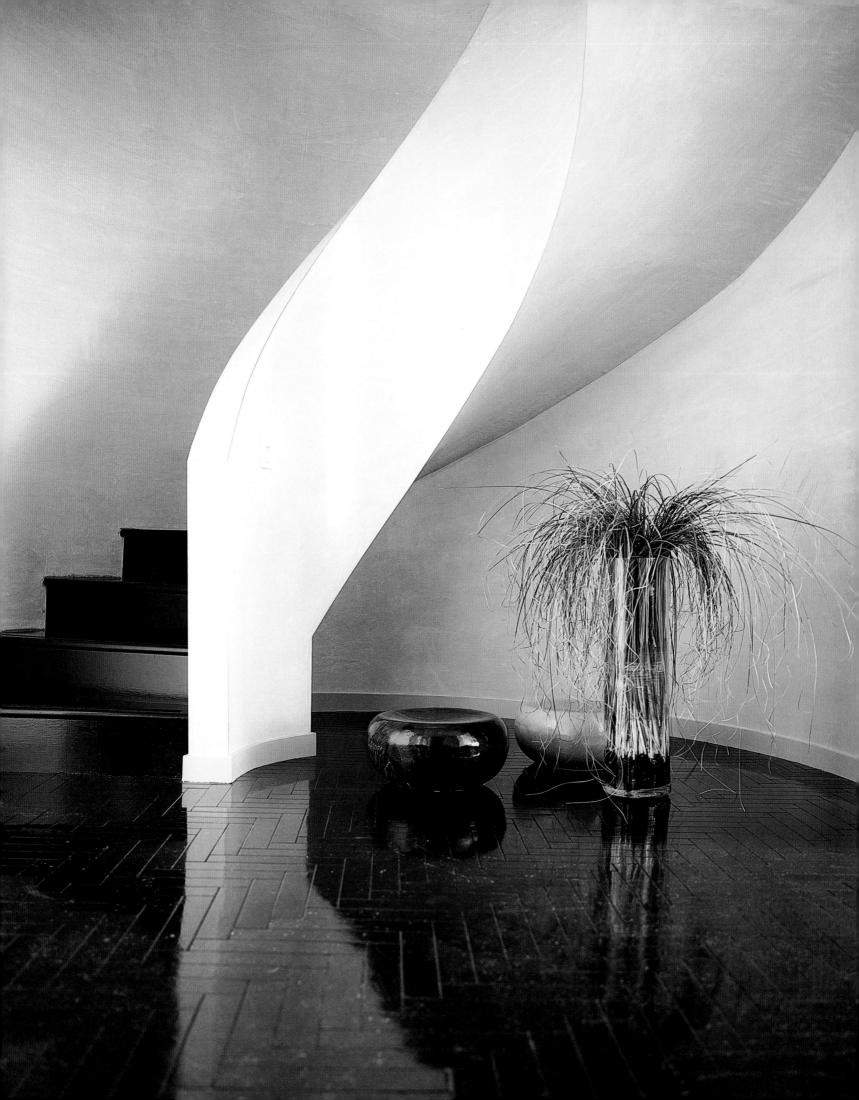

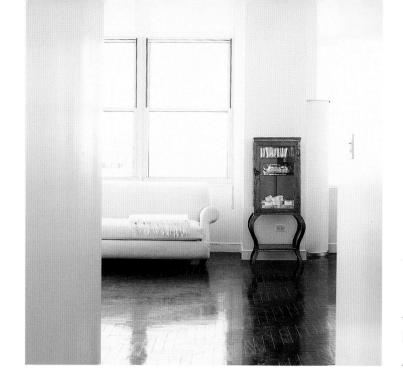

Pure whites and off-whites

YOU MIGHT THINK THAT WHITE IS WHITE IS WHITE, BUT THERE IS MUCH MORE TO THE STORY. IT SEEMS SO EASY TO SAY WHAT WHITE IS, BUT ACTUALLY IT'S EASIER TO SAY WHAT IT ISN'T. IT ISN'T A FLAT SHEET OF NOTHING; IT IS A COLOR THAT PRODUCES EMOTIONS AND FEELINGS, AND WARM WHITES ARE VERY DIFFERENT FROM COOL WHITES.

ABOVE As glossy as a dark, frozen pond, the highly varnished almostblack wood of the floor is in striking and telling contrast to the ice-white sheen of the walls and woodwork. A white-covered day-bed sits beneath the window, and grounding the design is a small cabinet that brings curves into an otherwise linear scheme.

Pure white on its own, unrelieved and bouncing back off the walls around you, only ever works in countries where strong sunlight and, even more important, deep shadows are apparent every day. Likewise, snowy marble is only acceptable to our eyes when it has become a little spoiled by time. It is important to recognize that pure white is *not* brilliant white; nothing except a box of optically bleached detergent and

LEFT If you are using a color entirely on its own—particularly such a stark, uncompromising color as white—it is important to emphasize the purity of that color by introducing something strong in contrast. Here, the fact that these chairs are not only white, but white leather to boot, demands a striking addition, which is supplied by the plentiful use of traditional brass upholstery studs that closely follow the lines of the chair.

builders' all-purpose paint are brilliant white, and this artificial shade has no place in interior decoration.

Most artists and decorators will always use more than one shade of white. The late interior designer John Fowler, for example, sometimes employed ten shades of white—pure white, broken whites, off-whites—that he might put together in one room—and that would be only for the paintwork. Fowler used these tones of pure white and off-white on the wood-work, using the baseboard, dado rail, and paneled doors as his canvases. There he highlighted, shaded, and added depth and variation in almost imperceptible fashion to create a subtle and interesting end result.

If you want to use and combine off-whites in the same manner, vary the finish as well as the tone—paint some surfaces in a matt finish, some in a soft sheen, with perhaps one that shines reflectively. Experiment with balancing the tones and emphasizing one feature while minimizing another. Bear in mind, too, that whites, like most other colors, take on a hint of other colors they are paired with, depending on how they are used, what surface they cover, and what the prevailing natural or artificial light is.

WARM WHITES

Warm whites smack of luxury—ivory, buttermilk, pale cream—and I would like to have them all around me constantly; all, that is, except magnolia, for which (along with brilliant white) I have a complete loathing,

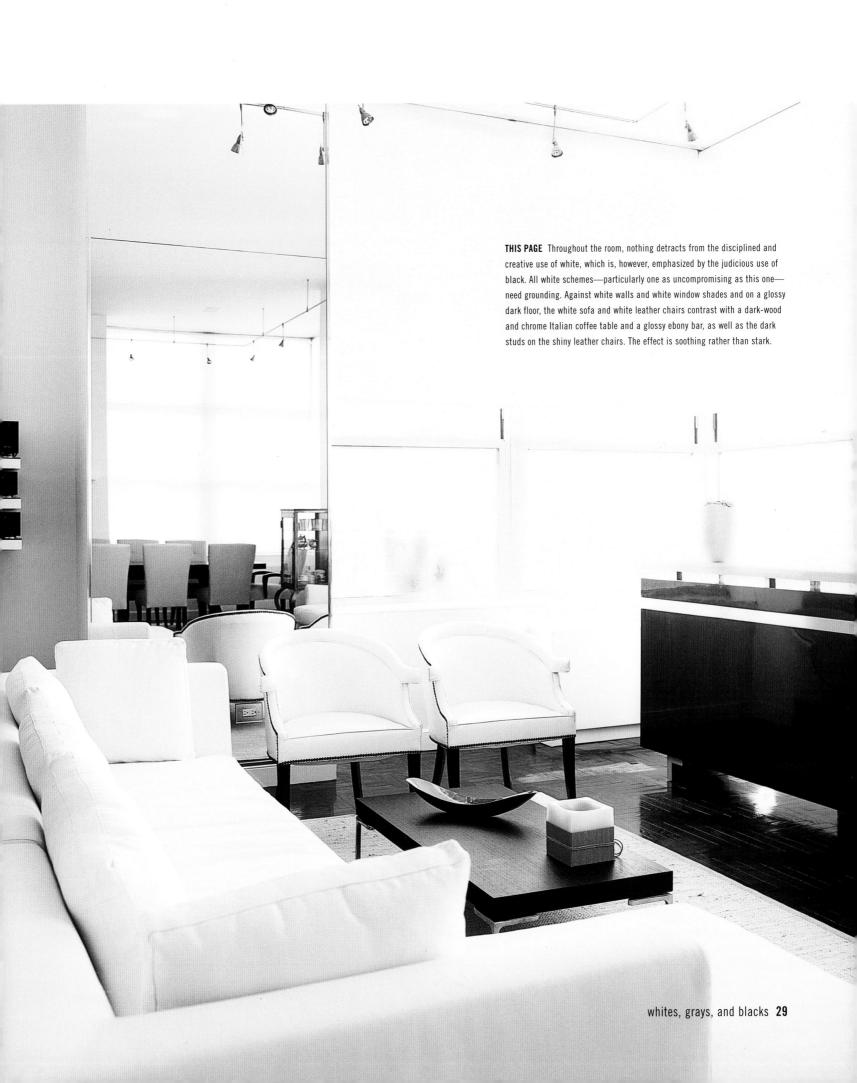

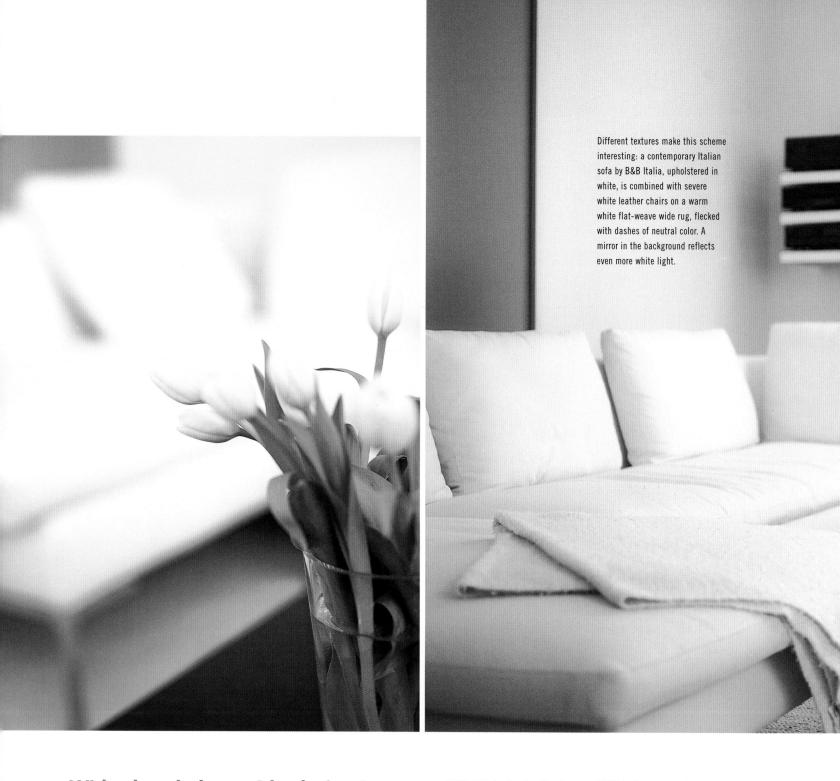

White is pristine; white is fresh—there is no cleaner, fresher color. But, if nothing but white is to be used, keep it soft and add some tones that reflect a little warmth.

ABOVE LEFT As almost nothing in interior decoration looks worse than grubby white upholstery, a pure-white decorative scheme is not for everyone; indeed, it is only for the very neat few. However, in this light, bright Manhattan apartment, a successful exercise in using white has been conducted, which cannot fail to appeal.

RIGHT In the same way that white flowers of different shades and tones will all work together in a garden devoted to them alone, so do different whites work successfully in all-white interiors. The varying tones to be found in white flowers—yellow, green, blue, pink, gray—add a subtle note to manmade schemes.

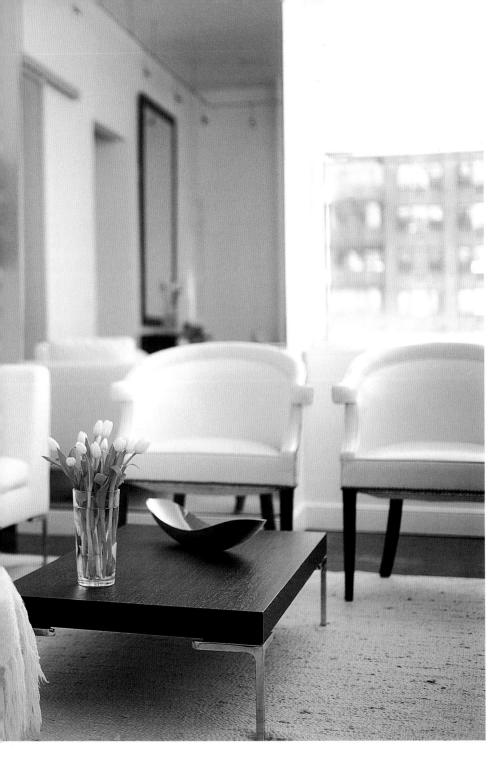

probably because they are both associated with that most depressing of phrases: "a builder's finish."

Warm whites are soft and calming. These are the whites that are mixed with a touch of raw sienna or with raw umber; yellow ocher mixed with white adds warm tones to make pale creams and vellums—these, in their deeper and still-warmer shades appear again in the chapter on creams and browns (see pages 40–51). The decorator's term is "broken white," and, if you are using ready-mixed paint, then those who know, swear by a white that has just a touch of yellow added to it to give the perfect warm hue.

White will always work in a scheme with one other color—any other color. Soft whites, particularly when two or three are gathered together, make other colors sing. The white will reflect tones of the second color within itself, so choose your white with this in mind. If the other shade is orange-red, for example, a warm white with a dash of yellow will work, rather than a gray-toned white. Needless to say, warm whites work better than cool tones in a cold climate or in rooms that don't get a great deal of sunlight.

COOL WHITES

If warm whites are soft, then cool whites are sophisticated—sometimes very sophisticated. Cool whites are not pure, nor are they brilliant whites; they are off-whites produced by combining pure white pigment with a dash of one of the blacks or blues or perhaps a touch of cold yellow. These combinations

THIS PAGE When built-in kitchens were first designed, the newest and best were nearly always allwhite, presumably to strengthen the contrast between the inefficient past and the streamlined future. Today, they can still shock with their single-minded modernity. This white example—in the same apartment as the living room of the previous pages—is pristine and glossy. Shiny white walls compete with reflective surfaces on the chairs and table as well as the kitchen cabinets. The only contrast comes in the tile floor.

produce subtle tones that range from pearl to putty to parchment.

Using a palette of cool whites together means mixing them in all elements of the room, because, as decorator Syrie Maugham demonstrated in the 1930s, a white-neutral palette only really works in a room where, not only is there a strong contrast of shade and light, but also where each different texture is strongly emphasized. As she advocated, so designers follow today the idea of rough with smooth, leather with velvet, stone with lacquer. It must be said that mixing cool whites together in a room is probably not the easiest of schemes for decorative beginners. Because of their pale subtlety, their almost evanescent qualities, they do need to be handled with confidence.

Cool whites include that particular soft white touched with green, which looks so right in houses of a certain age (namely dating from the eighteenth and

nineteenth centuries); and the gray-white that is indelibly associated with sophisticated French interiors of the eighteenth and nineteenth centuries. These cool whites are so subtle that, on entering a room, it is not always instantly possible to name and describe the color around you—which is what makes them so useful. Think of the color of a pearl or a piece of almost-white jade or alabaster. Gray-white, cool blue-white (not to be confused with the unmentionable brilliant white), and real snow-white are also tones that we often associate with Scandinavian decoration.

Most color schemes, and that includes those which are predominantly white, are improved with a dash of a contrasting shade. But contrast, in this instance, does not have to be translated as strong or bright. A flash of red or green will highlight white, but so too will softer shades—rose pink or watered turquoise blue.

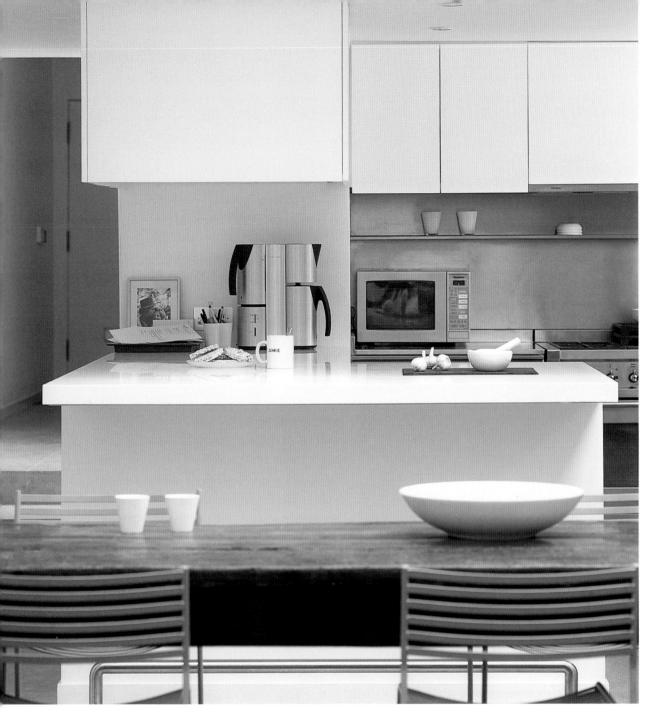

THIS PAGE In this all-white kitchen, although there is no apparent contrast of strong color, there is instead a contrast of tone and texture. Like frosted ice in a cave of snow, the appliances—the stove, the microwave, and so onare all stainless steel with a brushed finish, as is the deep wall behind the equipment. The units themselves are white, as are the walls. The counter is dense white Corian and in front of the units is a long dining table made of polished dark wood, which is surrounded with gray-painted chairs. The effect is far from frosty.

Grays and blacks

AT MANY PERIODS THROUGH DECORATIVE HISTORY, GRAY AND BLACK HAVE BEEN TREATED WITH CAUTION. BLACK, IN PARTICULAR, HAS MORE OFTEN BEEN UTILIZED AS AN ACCENT OR AS A DEVICE TO EMPHASIZE THE VALUE AND STRENGTH OF OTHER COLORS OR ARCHITECTURAL FEATURES, THAN AS A COLOR IN ITS OWN RIGHT.

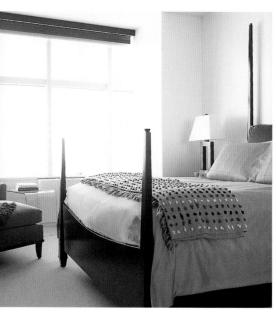

In fashion terms, all colors have their moment, and now is the moment for gray, in every shade from off-white to nearly black. Gray is often thought of as boring or even bland. For many years it languished, written off as a dark and dismal "bachelor's color." It is true that, in cooler climes, it can be a difficult color to decorate with, although the French have always appreciated the beauty and practical applications of gray, which they tint with pinks and blues, making it a warm and accommodating shade that both flatters and complements other colors.

WARM GRAYS

Warm grays can make an immensely flattering background for furniture and textiles; think of them used in a bedroom, mixed with deep pinks or spiky yellows. And one of the most flattering of color combinations, both in fashion and in decoration, is warm pale gray with warm but pale shell pink.

Perhaps to some, grays are a little Edwardian, but they are none the worse for that—Edwardian elegance is much admired, and gray can be part of some of the most sophisticated decorative fancies. Think of grisaille work—paneling and trophies, painted as

THIS PAGE This bedroom is an object lesson in how to use grays and blacks together to achieve a welcoming, warm, and interesting room. As a background, the walls are painted warm white, and the half-tester bed is black, with gray bed-linen which, in this setting, is warmer than traditional white. Bedside furniture and lamps are dark-toned, and all the accessories are in tones of black and gray, from the wool damask throw to the pillows in smoky fur and black leather. Once again, the combination and contrast of texture is of the essence in achieving an easy balance between style and comfort.

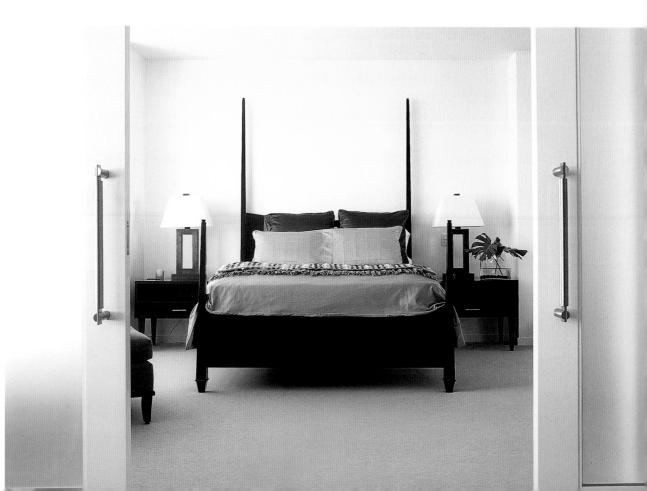

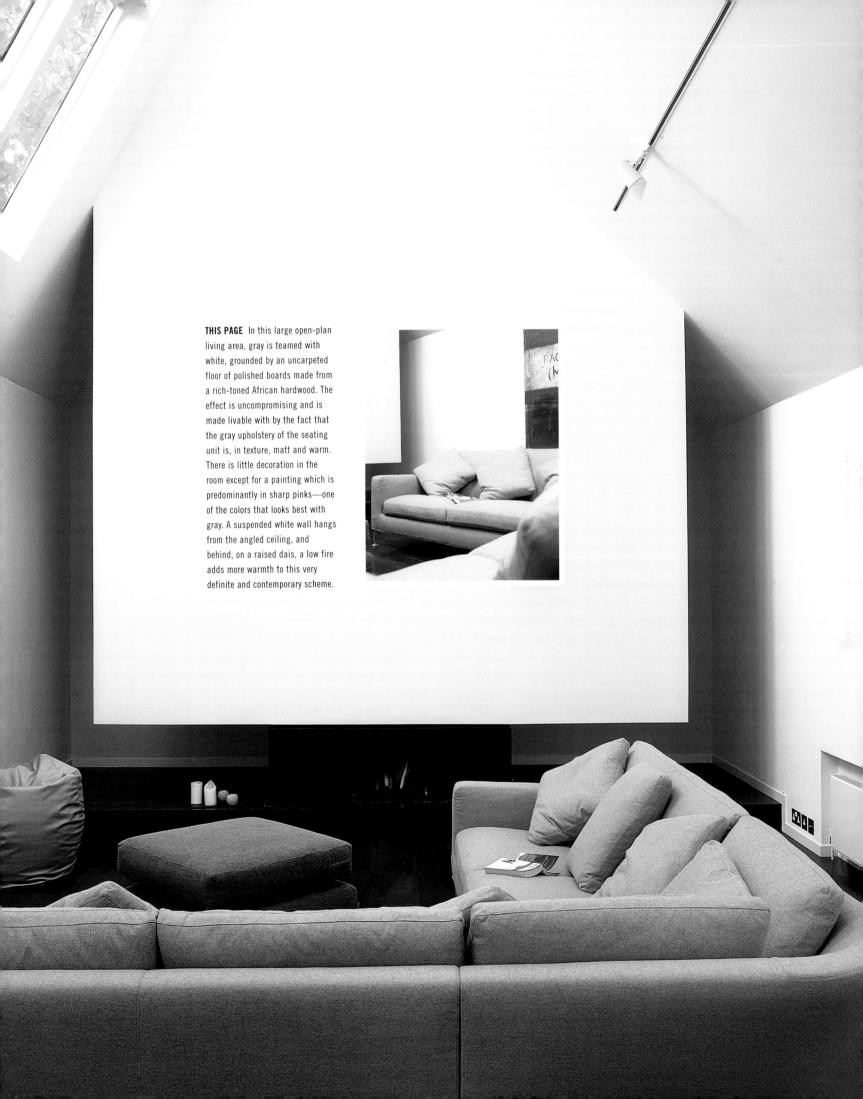

RIGHT AND BELOW RIGHT Dove gray is one of the most attractive of grays. Soft and accommodating, never strident, it is a perfect background color for displaying objects or pictures. On this rustic internal veranda in an apartment in Milan, it is the ideal foil for a display of cheerfully patterned porcelain plates.

OPPOSITE In this Paris living room, the walls are painted the lightest of grays as a background color. They have then been inset with hand-painted panels of stylized birds and branches, which are edged with gold. Everything has been chosen to coordinate with gentle charm. On the mantelpiece is a pair of soft gray-white bisque porcelain figures, and against the panels is an antique chair covered in gray-and-white ticking. Flat gray woodwork—softer than the same shade would be in a gloss finishand old parquet flooring complete the picture. Note the fillet of gold edging the opening of the fireplace and echoing the gold molding around the panels.

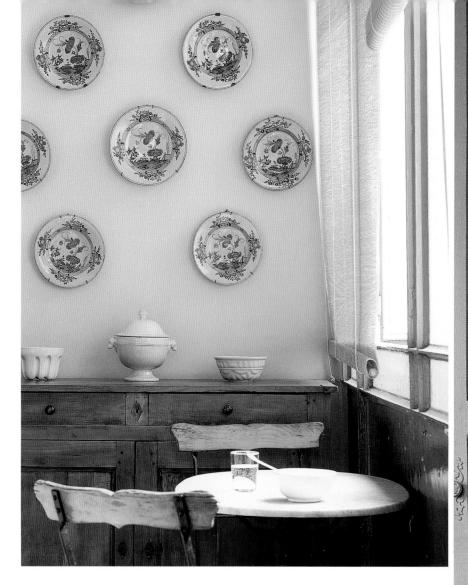

trompe l'oeil ovals directly onto plaster and wood, and executed entirely in grays. Think of fawn and taupe, or noted interior designer Nancy Lancaster's "elephant's breath" (well, one knows what she meant). Like all neutrals, they are subtle to a fault; think of wood smoke—almost colorless and nearly here, nearly there.

COOL GRAYS

An absolute and obvious rule of using color is that any cool color should be used with caution in cold rooms and under cold lights, and that rule particularly applies to grays. The closer a cool gray is to black, the more light it absorbs and the more it demands from its surroundings; conversely, the more white it contains, the more accessible—but colder—it appears.

It is strange that many of us have a problem using gray in interiors when we are so wedded to it in our clothes; there is barely a wardrobe around that does not contain some item of clothing in the ever-useful,

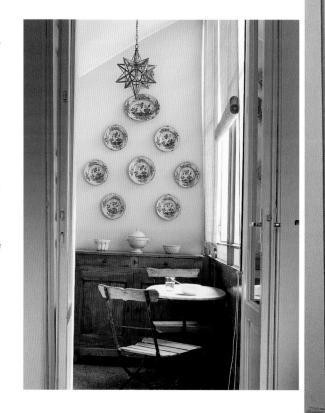

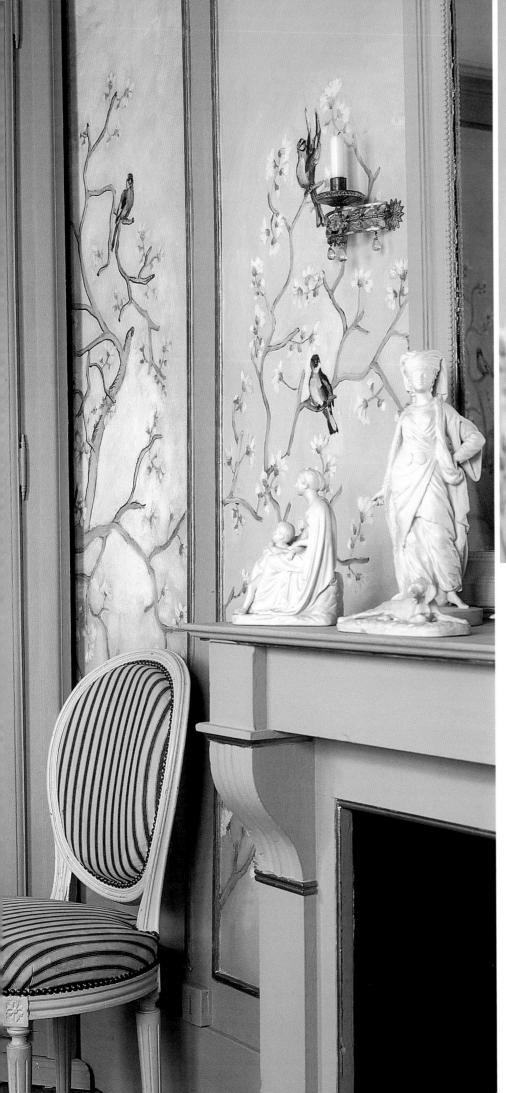

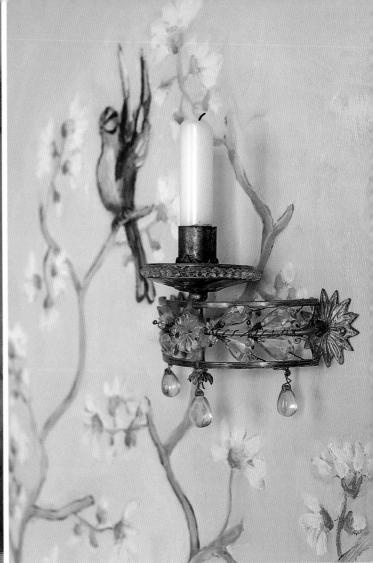

Gold, used judiciously and with a light hand, is a wonderful foil for cool gray.

perennially flattering gray. Thinking in fashion and textile terms is one way to visualize the range of gray: flannel, angora, satin. The natural world gives us more: ash, pebbles, graphite, wet stones, mother-of-pearl, inside an oyster shell, slate, silver, and pewter.

Painted cool gray-and-white stripes in a hall or stairway will never date and will age gracefully. Cool grays all look wonderful with slashes of bright strong color—bright yellow in particular, but equally jade green, vermilion red, or gold. And remember that, in the garden, cool gray plants are valued for their ability to make any flowers of a blue-pink nature look their best. Once again, nature leads the way.

BELOW It takes a brave decorator to use unadulterated black like this, but its effectiveness is beyond question. With the exception of the stripped and varnished wooden boards, all black rules. To use black in these quantities successfully, it is important to contrast finishes and tones. Nothing here is actually the same color. The rough black of the fireplace is different from the polished black of the chair. The dark blue-gray of the walls differs from that of the early twentieth-century

heavy beaten-metal screen. The different materials present in the room, and the subsequent startling difference in textures, are vital to the room's success.

RIGHT In this bedroom, blacks and grays tell a far more muted story.

Against a pale-gray wall is a headboard of a soft brown-gray textile, and on white bed-linen are chunky gray knitted pillows. The corresponding furniture is dark wood—very simple, very masculine, but not at all strident.

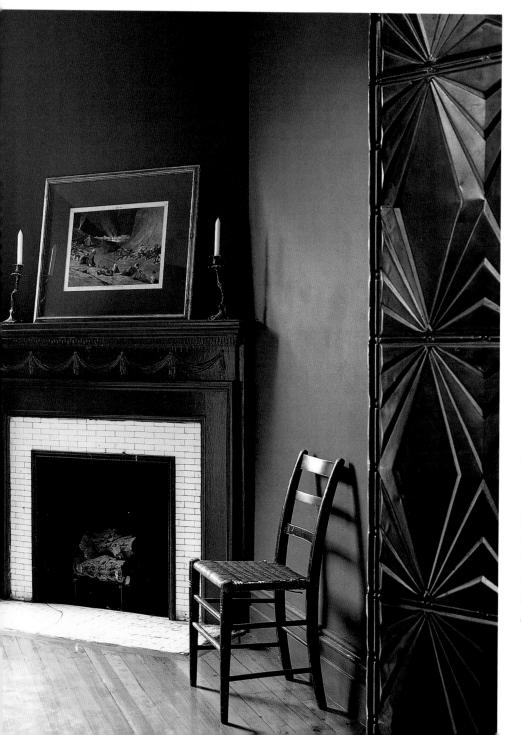

BLACKS

In the decoration of the Middle Ages, black was much used in the form of judiciously placed fine lines, accentuating the richness of a neighboring color. Again, in the early nineteenth century, it was paired with yellow, buff, or cream to emphasize and strengthen those colors. Black is, in fact, the squeeze of lemon that brings out the flavor of colors it is paired with.

In some periods, however—notably the Palladian decorative schemes of the early eighteenth century—black was used with more confidence. And in the twentieth century—in what is for me one of the most striking descriptions ever of a fictional room—Dorothy Sayers described the study of her dashing detective, Lord Peter Wimsey, as being decorated in Chinese yellow and glossy black—a dashing combination and one that must have been seen in the rooms of Lord Peter's Regency ancestors.

Black is, of course, associated with night and the dark, as well as with the bachelor apartments of would-be Lotharios, which makes it a difficult color for many people to use. But do not dismiss it; black has many depths. Originally, black pigments were derived from different sources; there was lampblack, bone black (a brown-black), and vine black (a blue-black), and today you can approximate these different tones with paints or tinted glazes, depending on the look you want. Each of these shades can be used to throw other colors and finishes into relief—think of glossy black and rich chestnut, chalky black, and warm white, or even the Wimsey way—with bright, reflective yellow.

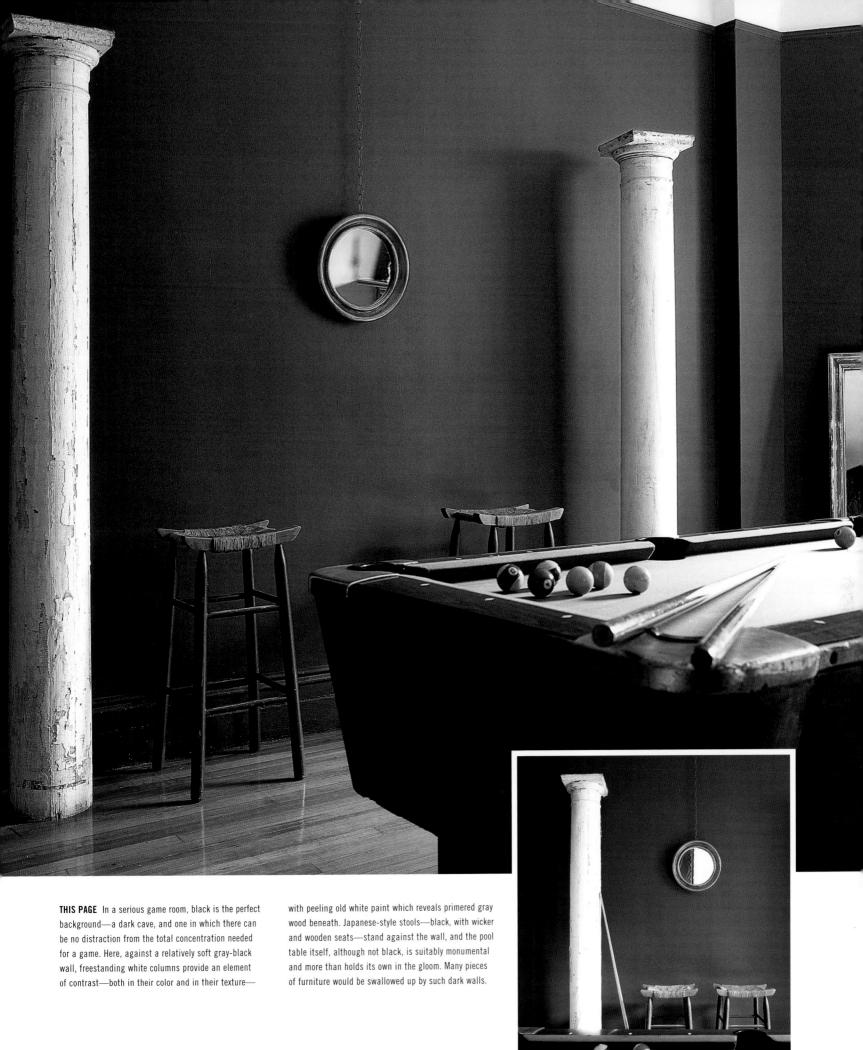

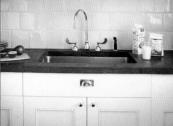

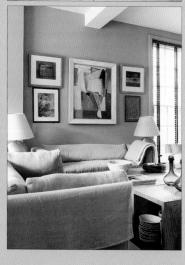

Creams and browns

The neutral range continues into the warmer spectrum with creams and browns. Browns—earth tones—are literally the most natural of all colors. for it was in the earth that the search for color was first undertaken. Words like "sienna," "ocher," "umber"—these are evocative names. And, from dark chocolate brown to yellowy cream, these are colors to which we respond naturally and warmly. Once again, you make a great mistake if you dismiss these tones as dull or bland. As we have seen, wellchosen neutrals can look more expensive than any other group of colors—think 1950s Hollywood star with skin of porcelain and hair of platinum, dressed in sheer nylons, pale cashmere, and buttery camel. Neutrals are words like "putty," "parchment," "palomino," "ivory." They even sound expensive.

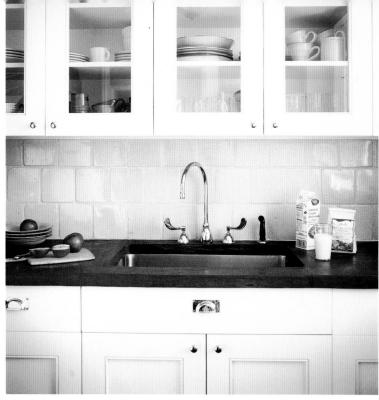

Creams

THE VERY WORD 'CREAM' CONJURES UP, FOR GOURMANDS AT ANY RATE, AN IMMEDIATE AND PLEASURABLE ASSOCIATION. RICHER OR PALER, CREAMS ARE FOREVER USEFUL IN THE HOME AND CAN BE USED WHEREVER A TOUCH OF WARMTH IS REQUIRED.

The earth tones of sienna, ocher, and umber are just as important today in decorative terms as they were when the artists of antiquity first ground them into powder and mixed them with mediums to use as paint. When these earth pigments are heated, they, not surprisingly, become burned—giving us yet more evocative names and an almost infinite variety of rich tones that can add warmth, depth, or even a cool cast when they are mixed with other colors. It is, indeed, through the judicious use of these earthy pigments that we can achieve all those tones of cream that the lover of neutrals is so keen to employ.

An entire room painted in a single shade of cream would look boring rather than subtle. Indeed, one of the problems that many people find with using cream today in decoration is that it carries

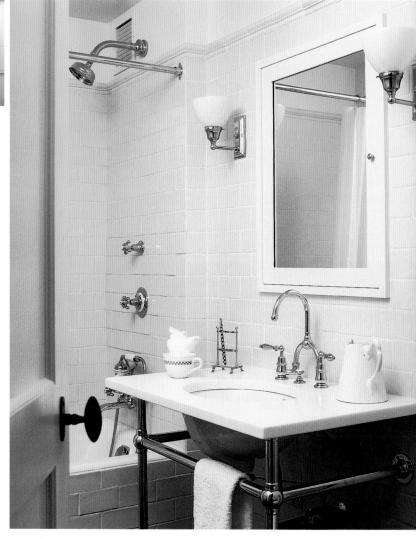

TOP LEFT Cream-painted kitchens are, for many people, reminiscent of the 1930s, the days before built-in kitchens were as ubiquitous—and, in some cases, forbidding—as they are today. In this kitchen, the cream tiles and units make for a comfortable, even cozy, look with intimations of home-cooking and comfort food. Cleverly, all the china has been chosen to work with the palette, rather than to contrast.

ABOVE AND TOP RIGHT In a small bathroom in the same apartment as the kitchen, a creamy shade of tile—the color of warm milk and honey—has been contrasted with white for an up-to-the-minute effect. Remarkably easy to achieve, and as stylish as the proverbial paint, it is an easy way to treat a bathroom with all-white period fixtures that will neither date nor pall.

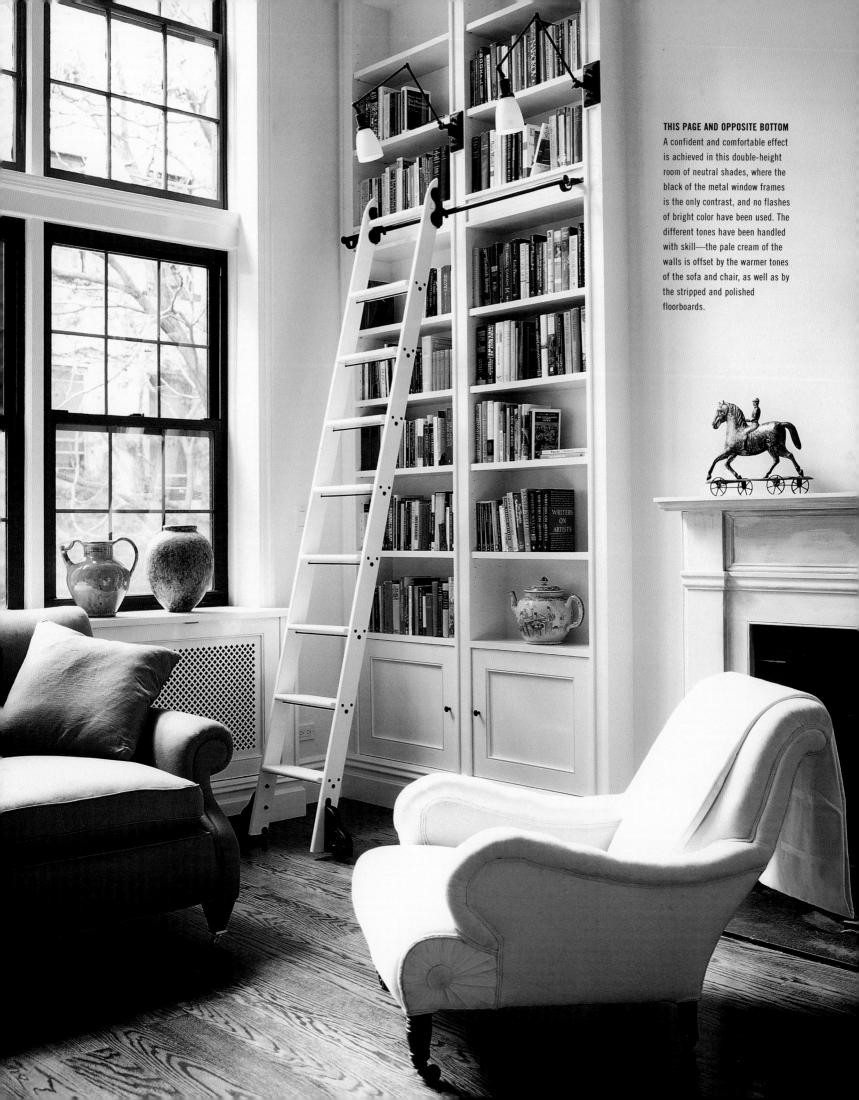

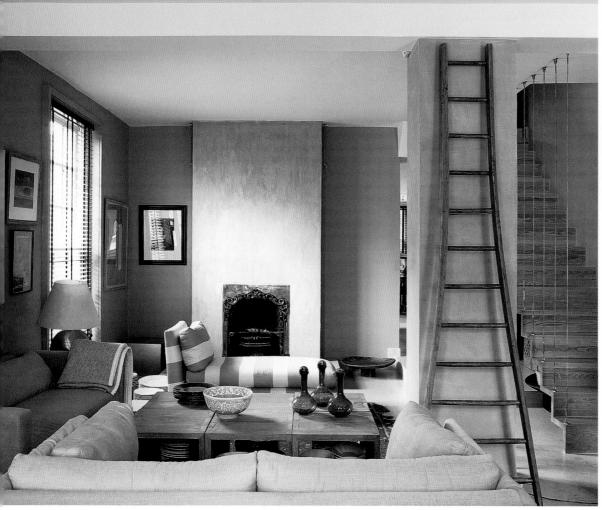

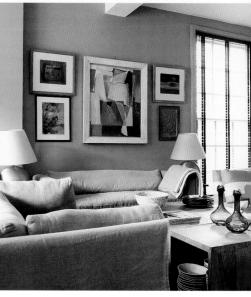

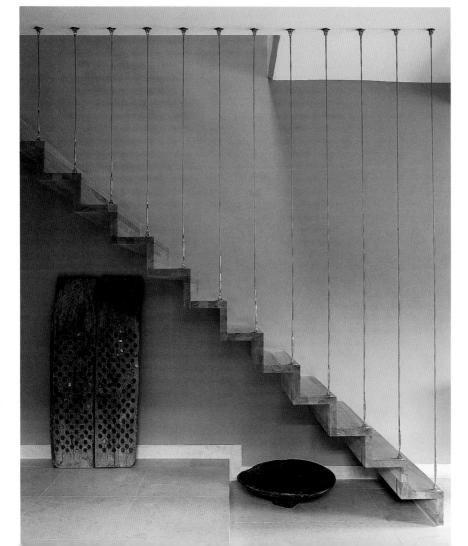

with it an in-built prejudice. For so long during the twentieth century, creams seemed to be thought of as a fail-safe solution, used in situations where the dull was to be preferred. Cream used to carry the stigma of "good taste," to be used anywhere and everywhere on the grounds that it could never be criticized. There was never any idea of using more than one cream; indeed, one wonders if painters knew there was more than one cream.

It is the case, however, that neutrals in general (and creams in particular) always look better when mixed together. Tonal contrast—perhaps on the woodwork or floor and in the textiles—will help to pull the room together and give the scheme depth.

THIS PAGE In this open living space, neutral shades have been used in both deep and pale versions to create warm contrasts. The fireplace wall is thrown into relief by being colored a pale, rough oatmeal, while the remainder of the wall is a deeper, but coordinated, burlap shade. Throughout the room

there is this contrast of neutral tone: a freestanding structural pillar is matched to the fireplace; the floor is pale-cream marble; while the open staircase has simple polished wooden treads that add yet another dimension to the neutral palette.

If, on the other hand, you do not want to employ a full palette of creams in the room you are decorating, it is important to include a note of perceptible contrast. In fact, many decorators feel that any color on its own—particularly one as subtle as cream—is meaningless unless it is combined with at least one other color. It is, after all, the interdependence of colors and their relationships when presented together that produce successful and harmonic schemes that are pleasing to the eye. Think of a flash of burnt orange, a stripe of leaf green, a slash of fire-engine red; it is combinations like these that add excitement, and they are very easy to achieve within a cream color scheme. With this in mind, cream—in all its many manifestations—should actually be thought of as the most useful color in the entire decorating palette. It complements and contrasts with so many other favored colors, and by slightly adjusting the degree of warmth, it can be used to accentuate, diminish, enhance, or dilute.

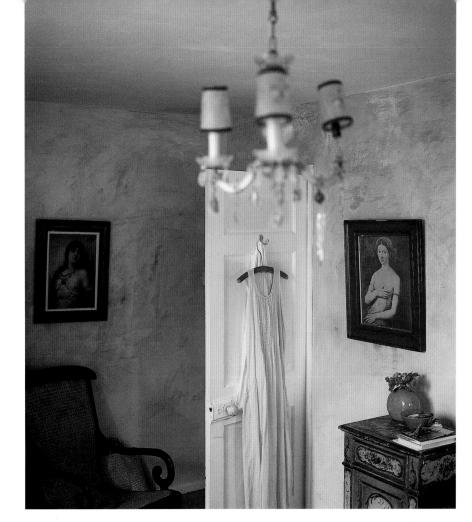

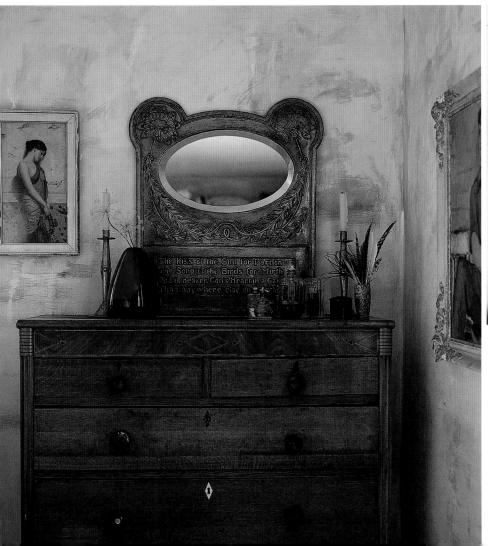

THIS PAGE In a bedroom, the tone is of warm flesh pink-beige tinted with white. Flat, almost chalky in appearance, it makes a perfect background color for antique furnishings, as well as being an

eminently suitable color for a room associated with rest and relaxation. On the chest of drawers, a collection of feathers draws attention to the brown undertones of the wall behind.

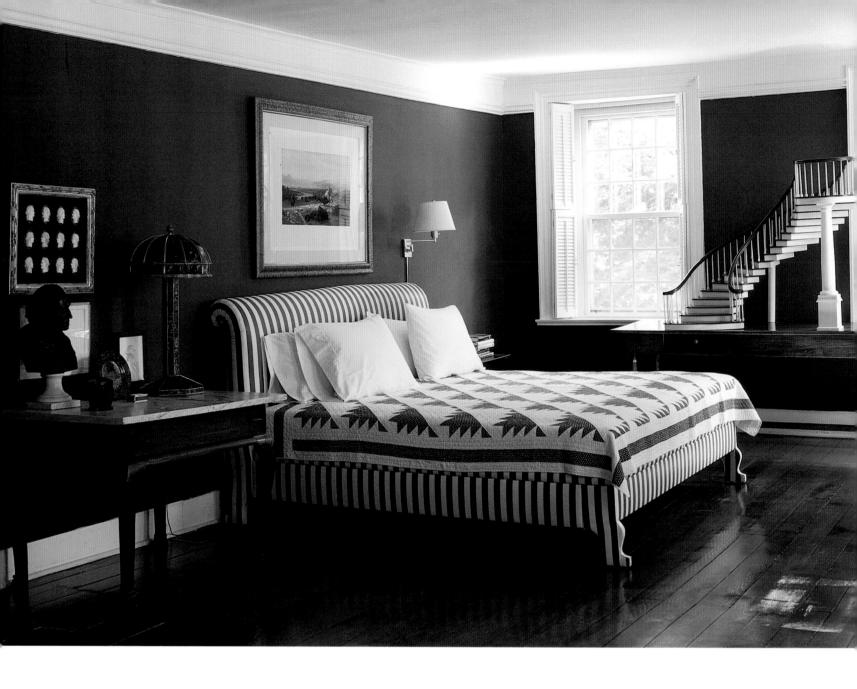

THIS PAGE Deep chocolate-brown paint, with a glowing silk finishlike the best sort of chocolate bar—is used throughout this room with a most dramatic effect. The curved-back bed has been upholstered in wide-brown-striped cotton and then dressed with an antique patchwork quilt, unusually made from scraps of brown material. Even the wooden floor has been stained, polished, and left in its pristine state. With so much strong color, the window frames have sensibly been painted white, and white shutters have been hung instead of curtains. It is difficult to overemphasize how important the touches of white are in this setting.

Browns

SO WIDE IS THE RANGE OF BROWNS, SO SOFT AND WARM, SHARP AND COOL, THAT THEY DEMAND TO BE LOOKED AT WITH A WIDER EYE. NOT ONLY DO THEY WORK WELL WITH MANY OTHER COLORS, BUT ALSO IN COMBINATION WITH EACH OTHER, PARTICULARLY WHEN TONES SPANNING THE ENTIRE RANGE ARE CHOSEN.

As a popular decorating color, brown has been somewhat out of favor in recent years. It was much loved in the nineteenth and early twentieth centuries when, in its darkest form, it was widely used on all woodwork and floors, often in a high-gloss finish. Later, in the 1960s, it enjoyed an enthusiastic revival; it sometimes felt as though no room was complete without a single chocolate-brown wall, which often seemed to be complemented by a second wall colored in a brilliant flame orange.

However, shiny dark brown (much like cold, pale green) was also for a long time associated with cheerless institutions, such as schools, hospitals, and government buildings.

WARM BROWNS

We warm to browns, and we particularly warm to warm browns. They make up a wonderful color group, linked to the natural world, which is probably why we feel such an affinity with them. Think of nuts—pale filberts and polished pecans; of hide—tanned leather and butter-soft suede; of wood—polished maple and pine; of warm spices like cinnamon and nutmeg; and of beans like coffee and cocoa—chocoholics need look no further.

To get the best from warm browns, visualize the fall in its beauty. Perhaps more than at any other time of year, it is in fall that we remark on the color of the surrounding landscape, and of deciduous trees in particular. We notice how, as the leaves change and the sun gets lower on the horizon, there is a harmony of tone that crosses the spectrum, ranging from bright yelloworange browns, to warm, deep red-browns. And, as the leaves start to fall,

THIS PAGE A decorative scheme that demonstrates again the advisability of leavening all-brown color schemes with a dash of sharp contrast. In this contemporary, rather masculine dining room, red is the accent color, on show here in the red leather dining chairs. The brightness of the shade brings into focus the walls, which are the color of ripe tobacco leaves, as well as the wooden dining table and the polished parquet floor. A rug of abstract design reemphasizes the color scheme.

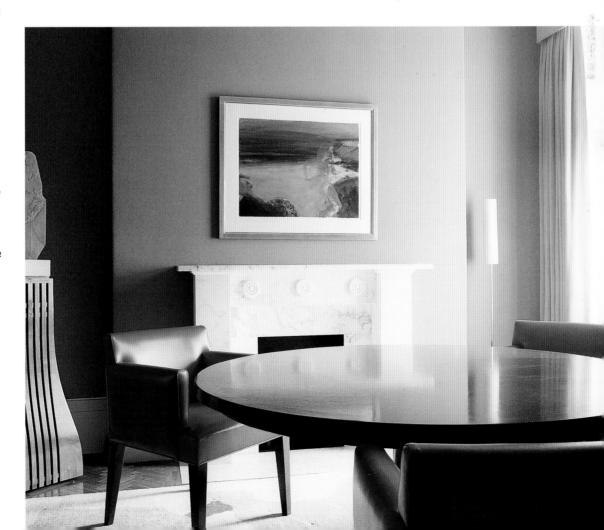

BELOW Tones of brown, particularly warm browns, are very effective in a bathroom, always making it look warm and comfortable. The secret with these softer, paler shades—

unlike their darker, deeper cousins—is not to stray too far from the milky taupe palette. The whole room is pulled together here by the deeper-toned baseboard.

their tints become paler and softer, with a pink tone, not the more strident red.

Warm browns work well together and have always been used to harmonize with other colors. Brown terracotta—not orange and not red—is a fine color, and like all the red-browns can be very successfully paired with black. A warm reddish brown was particularly popular during the American Colonial period and blended well with wooden floors and polished furniture. These browns are welcoming and can be used to effect in halls and other spaces that need to have an instant effect. Think of tan-tanned leather rather than skin—which is an accommodating shade, neither masculine nor feminine, and which can be used effectively in rooms with neutral functions, such as halls, studies, and bathrooms, as well as an accent in rooms decorated in warm whites. Warm browns are also good for rooms with a cool light, adding comfort and an air of relaxation.

COOL BROWNS

Cool browns are tinged with green, green-yellow, or a touch of black. Like warm browns, they are also very much colors of nature—not so much autumnal nature, more nature's background—of tree bark and

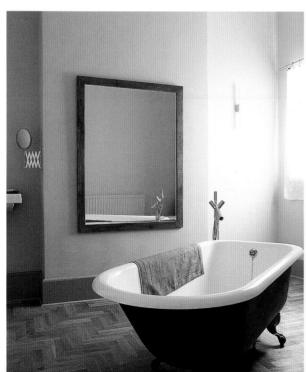

The decorative touches in this taupe-toned bathroom come from the functional and the essential. The interest is in the wood-framed mirror, the chrome fixtures, the wall-hung towel rod, the towels themselves and even the strip light, hung vertically instead of in conventional fashion. No other details are required.

LEFT AND BELOW Small rooms often look more effective decorated in a way that emphasizes their cozy qualities. Textile-hung walls always make for instant cocoons, and in this small half-bath, textured silk—of a surprisingly wide stripe—has been used in nutty tones like hazel and pecan. The second surprise is that the silk has been hung horizontally rather than vertically, which would have been the more obvious choice. In contrast, the floor is cool-veined cream marble, and the basin is glass; they are balanced by the warmth of the silk.

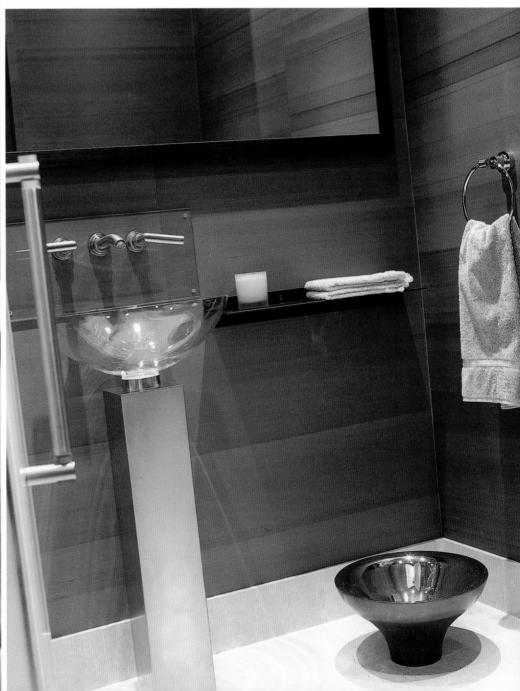

of dying leaves. Cool browns are camouflage colors, the colors of animal fur and pelts—think donkeys and dormice. They are the color of garden earth, and often have an element of black in them.

This natural aspect of cool browns reminds one of basic military camouflage colors—often a mixture of cool green, black, and cool brown—

which are used together because they tend to merge gently into a natural background. Cool browns and cool greens have the power of making objects recede and become subordinate, as well as darkening a room and therefore making it seem smaller. So, when you use these tones, remember that unless you use them with color or objects that lift them, your

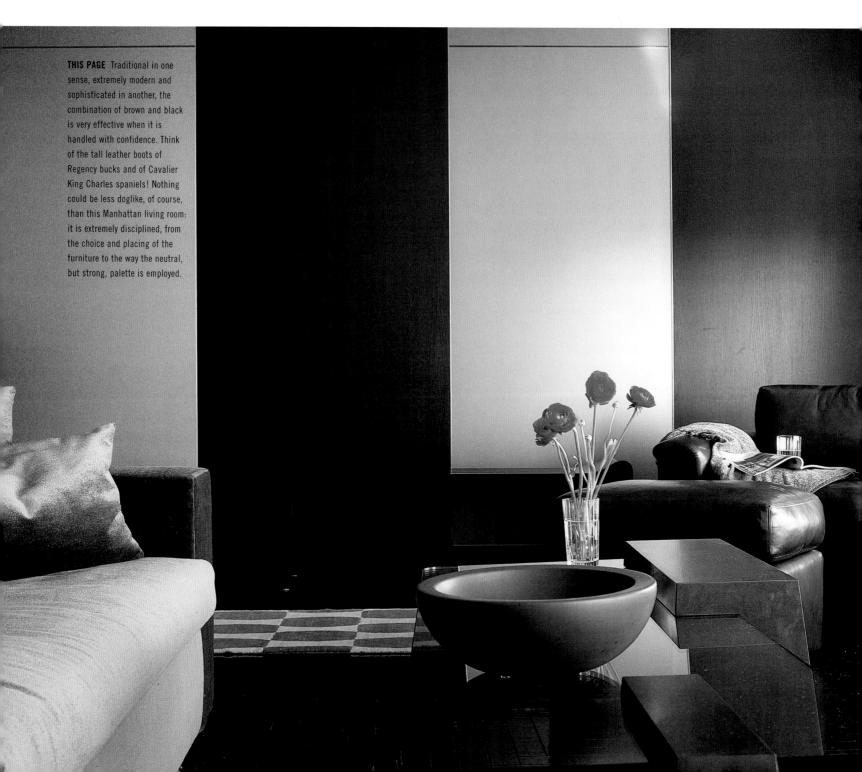

scheme, too, will become a background, and perhaps even fade away. Some cool browns are very close to cool greens in tonality, and it is difficult to quantify the color all the time. A bit more green and it becomes green, a bit more brown and it becomes brown. So many interesting colors come somewhere into this range, such as a color that is presently popular in some

hand-mixed paint brands; a sort of brown-green putty color, that sometimes looks as though it has been mixed with a bit of sand or green mud. Cool brown colors, ranging from the pale to the deep, were much used in the beginning of the eighteenth century when they were given names like "stone" and "wainscot," describing the surfaces they were imitating.

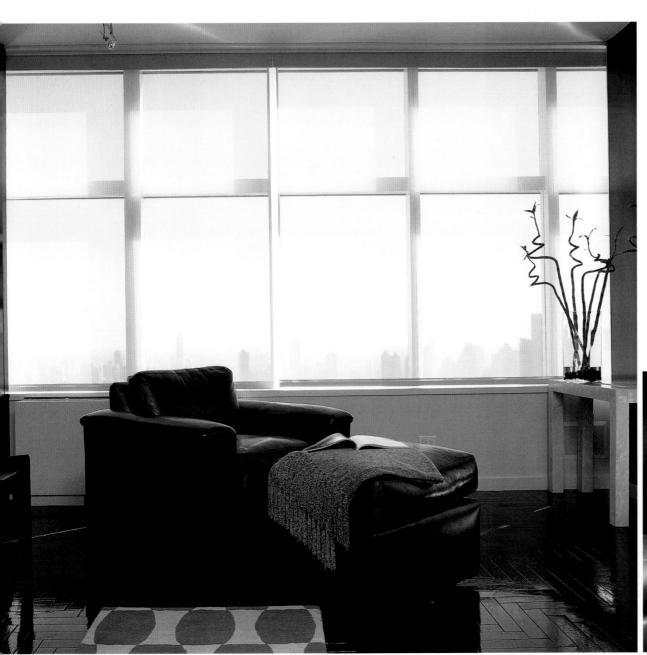

ABOVE AND BELOW Throughout this room, the sternest discipline is employed to achieve the final effect. The furniture is carefully chosen: a deep-brown leather chair with matching ottoman, and a long cream-and-brown upholstered sofa by Cappellini. The floor is old parquet, rejuvenated in glossy black lacquer. The walls are severe panels: black alternating with pale taupe, and each edged—a telling detail-in chrome. The tables, too, alternate in tone-one creamveined marble, the other in shiny glass. Light relief comes from a cappuccino-and-cream rug. LEFT As in so many contemporary city interiors, the windows are left uncurtained and, here, in their square symmetry, echo the internal design of the room.

Reds, pinks, and purples

In their brightest and clearest forms, red, pink, and purple are colors to treat with respect, for they demand attention. All shades of red are stimulating and appear in many guises, often edging toward the purple or the pink. Consider some of the natural variations—flowers like hibiscus, camellia, or indeed the depth of a red rose. Then think of crimson, claret, coral, carmine, and magenta all assertive and strong. All pinks, of course, are based on red, the dominant primary color, which has been diluted with white and perhaps a little blue or yellow. Purple, in its strongest form, is a straight combination of red with blue, another primary; and, depending on the strengths and proportions of the two primaries, the resultant purple will be warmer or cooler in tone.

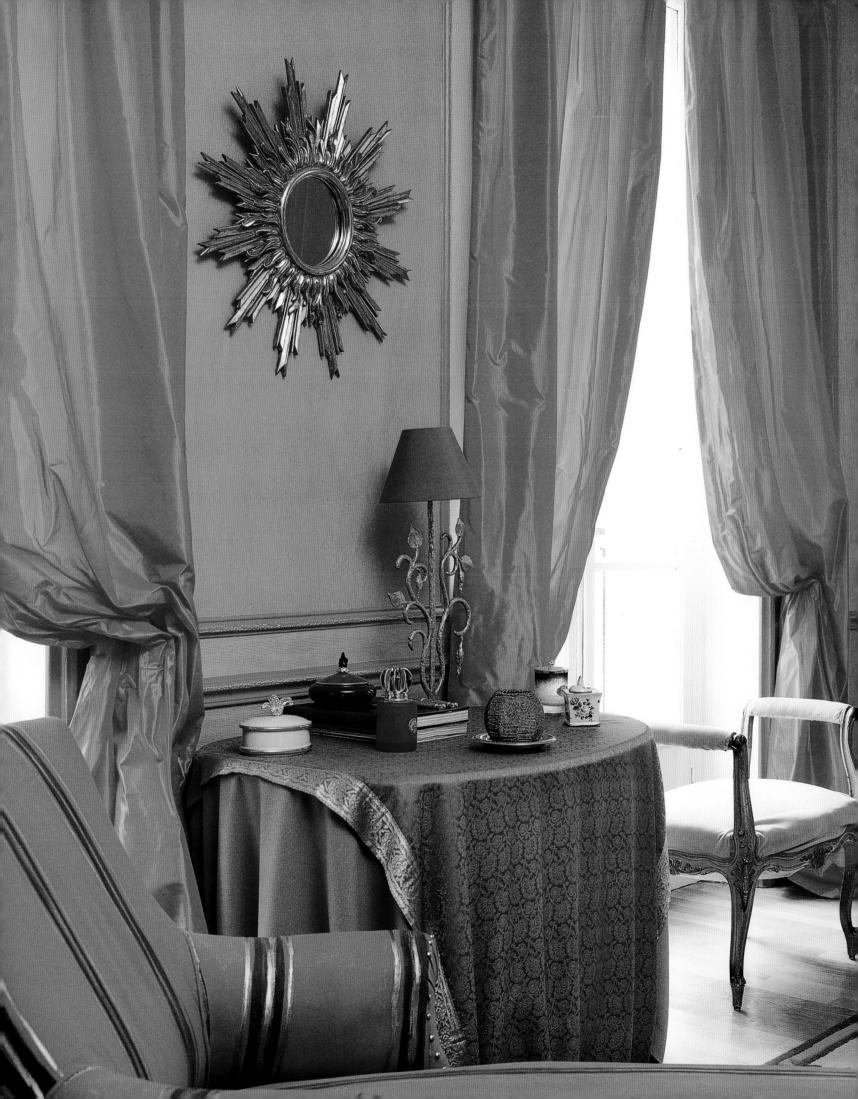

Reds

A RED ROSE IS THE TRADITIONAL SYMBOL OF TRUE LOVE, YET "TO SEE RED" IS TO LOSE CONTROL. IT IS EVIDENT THAT RED, IN ALL ITS MANIFESTATIONS, IS A VERY POWERFUL COLOR THAT EVOKES STRONG FEELINGS.

Every culture incorporates red in some guise into its design and decoration. It is a positive color, a color of life. But that same red has also, even if subconsciously, more violent associations, such as those connected with blood, wounds, and therefore battle, with passion and anger. Red is the color of revolution, and it can, indeed (if used in undiluted form) cause revolution in a room.

Red ocher, an earth pigment, was one of the first sources of red. Another was cinnabar, a naturally occurring, rare, and therefore expensive vermilion. In China, vermilion was the Imperial red, and so popular was this strong, assertive pigment that, by the thirteenth century, it had been produced by chemical means and was thereafter used widely.

As a pure primary color, red becomes varied when it is mixed with other tones in smaller or larger degrees. As a color in decorating, red has weight. It asks to be noticed, and noticed it is. If you do not want to use it as the dominant color, just a touch of red will complete many other color schemes—it has

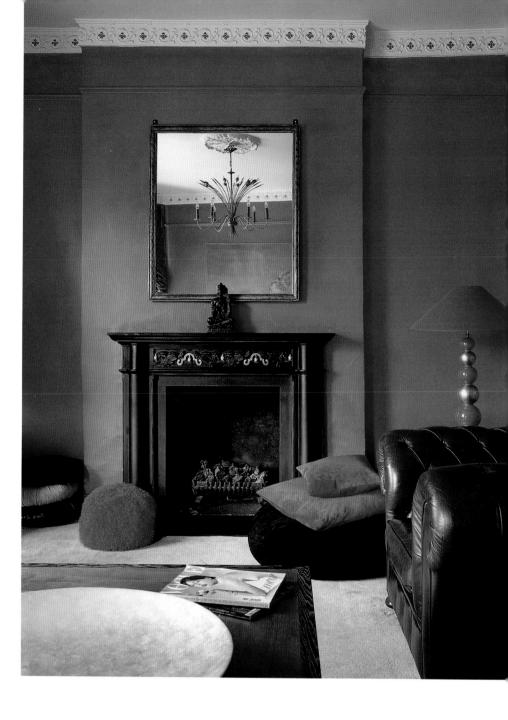

THIS PAGE Warm, strong, and immensely livable, the walls in the living room of designer Pascale Bredillet-Boateng are as much of a red statement as you could find, and all the better for that. The walls have been painted in a flat red pigment and then glazed over in dark red, so that a flat effect is avoided. The purple leather chair and the brighter red suede pillows lift the room without jarring contrast. The curtains are also based on red, but lightened with a soft glint of gold that is echoed in the pillows on the sofa.

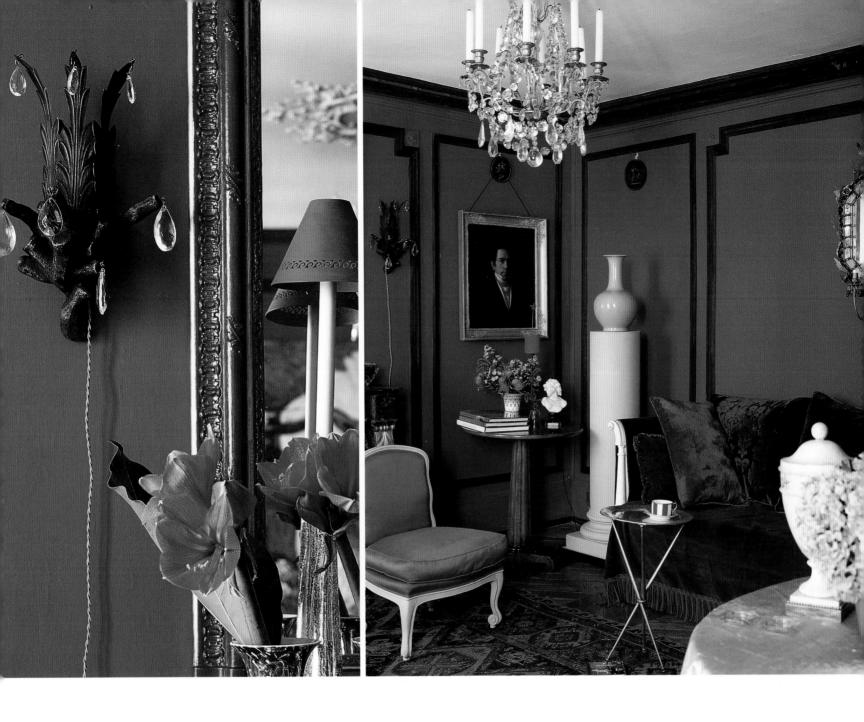

THIS PAGE In Roberto Bergero's Paris apartment, the walls of the drawing room are matt, flat, uncompromising brick red, but lifted into another sphere by the molding of the panels, which has been subtly picked out in a dragged dark burgundy. The furniture echoes the tones of the walls-a sofa in dark burgundy velvet, furnished with lustrous velvet pillows; a companion chair is covered in a brighter red silk, and the only dissonant (but important) note, is a goldenrod-yellow vase, which stands on a gray painted pedestal.

Reds used together in a room can be strident or soft, peaceful or powerful. Combine them with care, making sure that the other colors add light and airiness to the scheme.

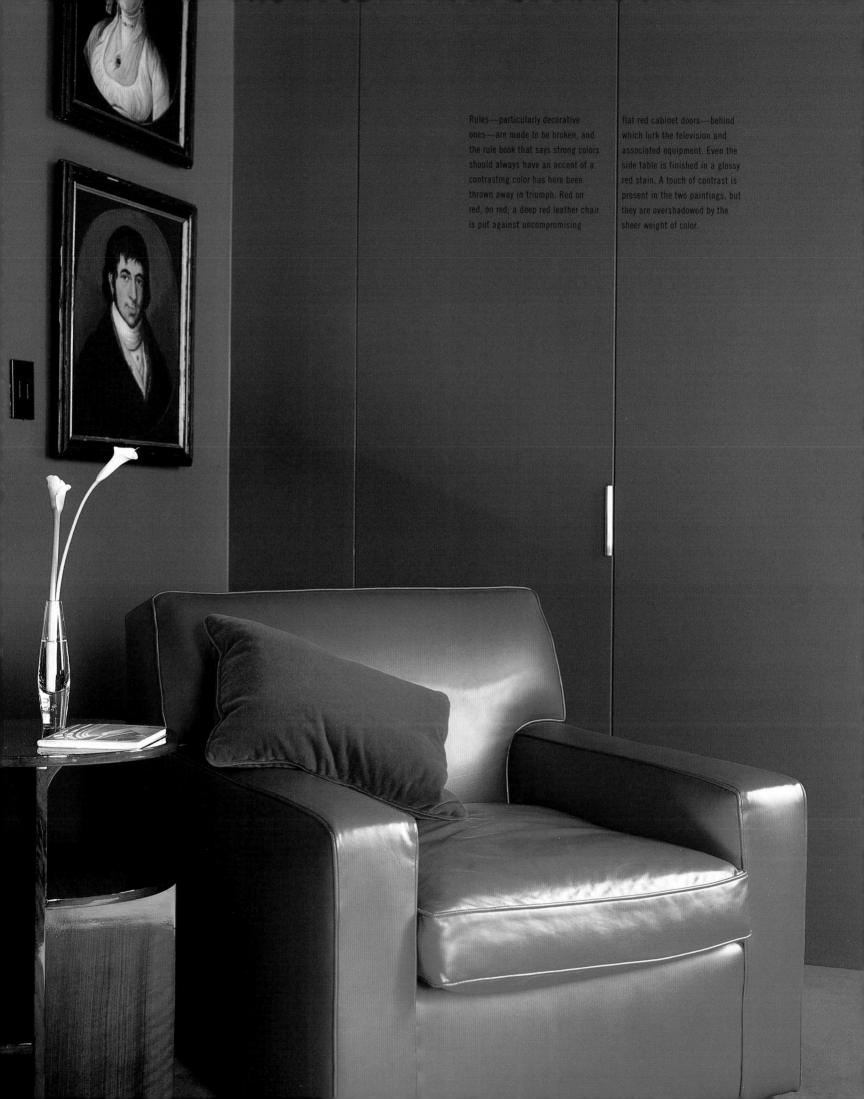

a way of sharpening what might otherwise sink into obscurity. It does this most successfully, of course, with the color immediately opposite it on the color wheel—its complementary color, green—although it should be a tone or shade of green rather than a very strong green. The eye can only take in so much, and two fierce bright tones would be too much.

WARM REDS

There is nothing warmer than a deep, warm red, associated as it is with sensuality and seduction, but also with feelings of comfort and safety. Warm red, particularly as it moves toward tones of brown, is very successfully paired with white, particularly a creamy, broken white.

Red of a brownish hue can be remarkable successful in a living room or a bedroom—think of Tuscan, warm-weather red; think of the deep brown-red of old velvet. This is a shade that has affinities in red, in brown, in black, and can be well used with any of these colors.

Warm red is traditionally thought to be a good color for a room in which eating takes place, and it is true that its air of warmth adds a sense of relaxation, that is conducive to the enjoyment of food. But, if eating is not confined to a separate dining room, red may be too overpowering. If this is the case, combine the red with less

TOP RIGHT Another view of this red television room shows how carefully the scale and proportions of the room have been planned. The bookcase and the sofa are exactly the same width, and the height of the bookcase is in perfect proportion to that of the seating below. The pair of tall reading lights add to the perfectly balanced effect, and the red leather ottoman connects with the leather chairs opposite.

stressful colors or make sure that the shade you use is not oppressive, perhaps moving toward that vastly underrated color, geranium.

These warm reds, applied in a flat matt finish, are very effective on woodwork—as it was used, both inside and out, in American Colonial architecture and decoration. (Almost any color looks good on woodwork, especially baseboards, where it can be used to highlight and contrast with the wall color, or can be painted the same color to blend harmoniously with the walls. Woodwork is an area of many homes where so much more imagination could be employed.)

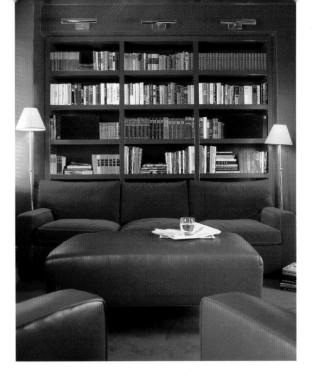

BELOW A room which is pure, condensed color such as this must rely on changes of texture to give interest and relieve the eye. A sofa

covered in warm red velvet is a comfortable foil to the uncompromising sheen of the leather furniture that surrounds it.

RIGHT For many centuries, red was the color of choice for textile-hung rooms in large houses, particular in eating rooms and for walls where pictures were to be hung. In this bedroom, the wall covering is perhaps simpler than those of the seventeenth century, but none the less effective. These cabinets have been built into the wall and then covered with material—a simple solution to what could be a boring, utilitarian piece of furniture.

When using red and green, choose subtle olive or drab green. Two bright tones will not accentuate each other; instead, they will murder each other.

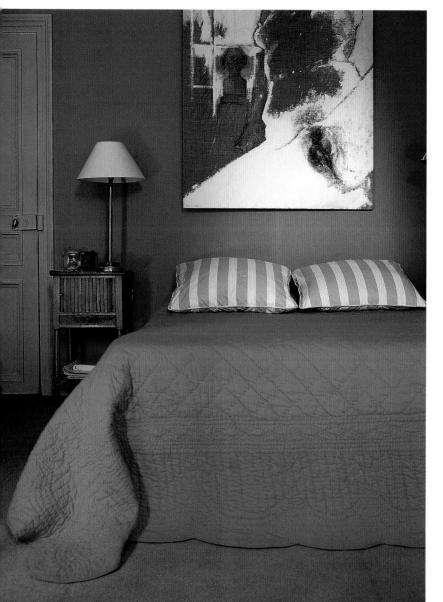

LEFT Red shades and tones are particularly effective as woven textiles. This soft fabric, with a light twill effect, is hung throughout the bedroom. Warm and soft, it has been paired with woodwork painted flat cream-green—quite similar to the useful eighteenth-century color known as "drab." The carpet is ocher with a hint of green, and the bed-cover is a cheerful, bright-red stitched quilt, that lifts the whole, clever scheme. Caramel-and-white pillows link the bed with the painting in tones of brown and white above.

RIGHT AND FAR RIGHT A period dining room, with dado-height paneling of polished wood and a wooden mantelpiece to match, has been colored in warm terracotta with a glowing, not glossy finish. Red terracotta, with its underlying brown tones, is perfect in a room filled with wooden furniture. The olive-green glazed fireplace tiles, very much of their time, might, in another setting, look less than totally attractive, but here act as a striking and pleasing counterpoint to the red walls.

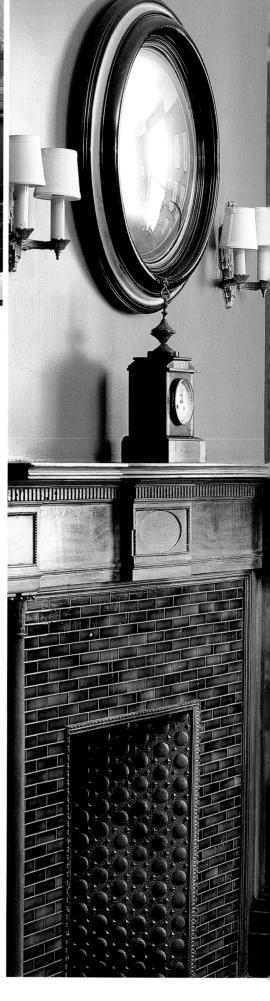

COOL REDS

Generally speaking, a cool shade of a color will harmonize best with other tones in a similar vein. Crimson, a deep rich red inclining toward purple, was one of the most expensive of dyes in early times and therefore associated with rank, as seen in the robes of cardinals and bishops. This deep, regal blue-red harmonizes with blue-green, blue, or lilac. Combined with a broken white and a splash of black or gray, it is sophisticated in the extreme. Crimson also works very well with a drab olive green or, indeed, with a flash of purple. Blue-red is not a childish color and is for use in a grown-up context only.

Somewhat easier to use are the wine reds. Deep claret is traditionally a color used to convey comfort both of surroundings and life, calling to mind all those deep-claret Victorian velvet-covered library sofas and chairs still to be found. There is something supremely relaxing about the depth of this color. A deep wine like this looks wonderful with a paler blue-pink, but is less successful with true blue, since the overall effect could be too cold.

Still red, but moving toward the pink shades, are the berry reds—loganberry and raspberry. They are, it is true, easier to handle than the deeper reds. Like the fruits they are named after, they are wonderful with cream. Experiment with cool reds; you will find that they are easier to use than you might have anticipated.

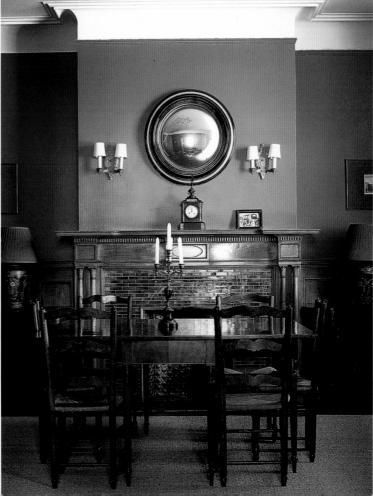

TOP The view from the dining room of designer Geraldine Prieur's Paris apartment reveals a symphony of pink continuing through the hallway beyond. Walls are washed in shades of pink, with broad stripes of palest summer melon.

ABOVE Throughout the apartment, shades of orange and subtle gilding provide clever contrast.

A gold-and-crystal floor light, designed by Geraldine Prieur, looks dashing against a paneled pink wall and bright curtains.

Pinks

PINK IS, TRADITIONALLY, A FEMININE COLOR—LITTLE
GIRLS PLUMP FOR PINK PARTY DRESSES; OLDER GIRLS
THINK IN TERMS OF PINK TO FLATTER THE FACE. AND PINKS
CAN BE EQUALLY FLATTERING WHEN USED IN INTERIOR
DECORATION, SO LONG AS YOU THINK PRETTY NOT SWEET,
BRIGHT NOT SUGARY, PALE NOT BABY.

Pinks can be hot, vibrant, exciting: think of the pinks of India and Mexico. They can be subtle and cool: think of the pinks of eighteenth-century interiors. In the natural world, pinks can be interesting, evanescent, fleeting—many pink flowers even change their tone, from bright to pale, over the course of the day. Pink, in nature, always looks its best when it is backed by another color—a perennial bed composed entirely of pink flowers has no weight and little beauty. It requires the contrast of another shade—preferably plants in tones of gray, silver, or olive green—to bring out its subtlety and depth.

Although pinks can be very effective used as the dominant color in a scheme, they can also add a note of restraint and subtlety to a room. Antique textiles, for example, that were once bright pink often fade to a particularly pleasing soft gray-pink, and it is worth looking out for old textiles or pillows to use in a scheme of rather stronger tones.

Traditional chintz designs very often incorporate a particular blue-pink tone combined with lavender or pale blue, perhaps in a flower pattern. These sorts of colors used together are particularly interesting on a white or cream background; they result in making the neutral shade appear somehow fresher and cleaner. The same effect—a group of light, cool pinks mixed with white-white or cream—can be used to effect on a larger scale throughout a room. A dash—just a dash—of a sharp strong color in the same spectrum—dark blue, perhaps—will help to anchor such a subtle scheme.

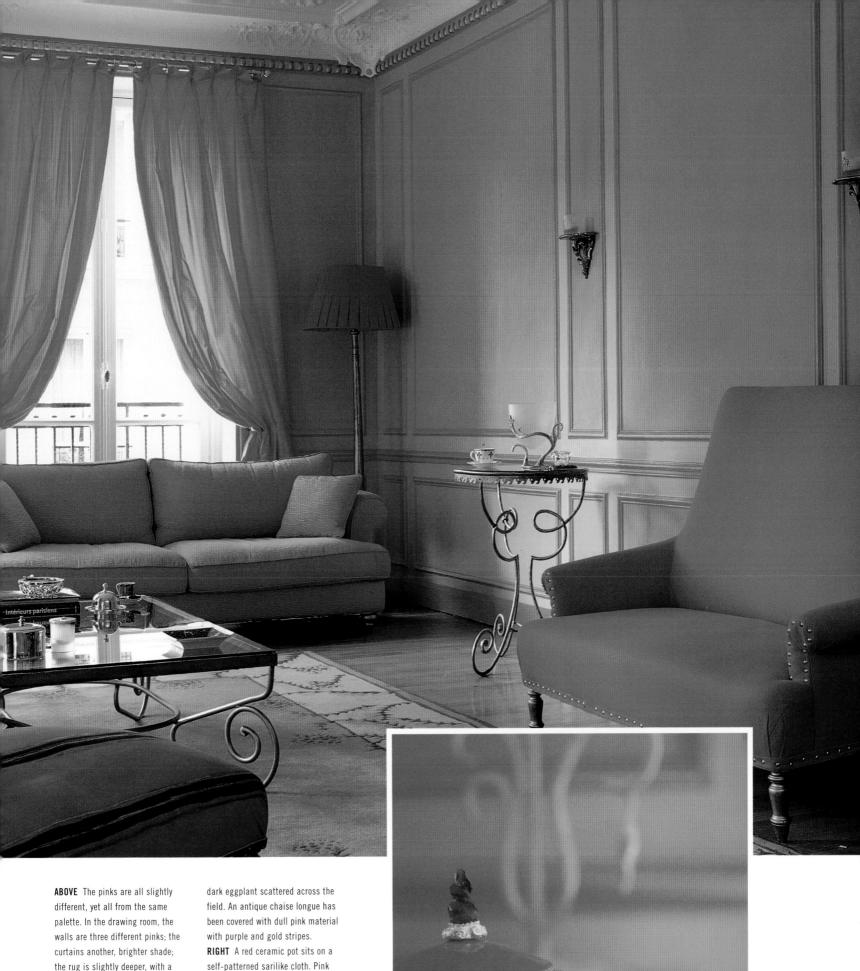

the rug is slightly deeper, with a paler-toned border and a design in

self-patterned sarilike cloth. Pink tones and gilding provide the link.

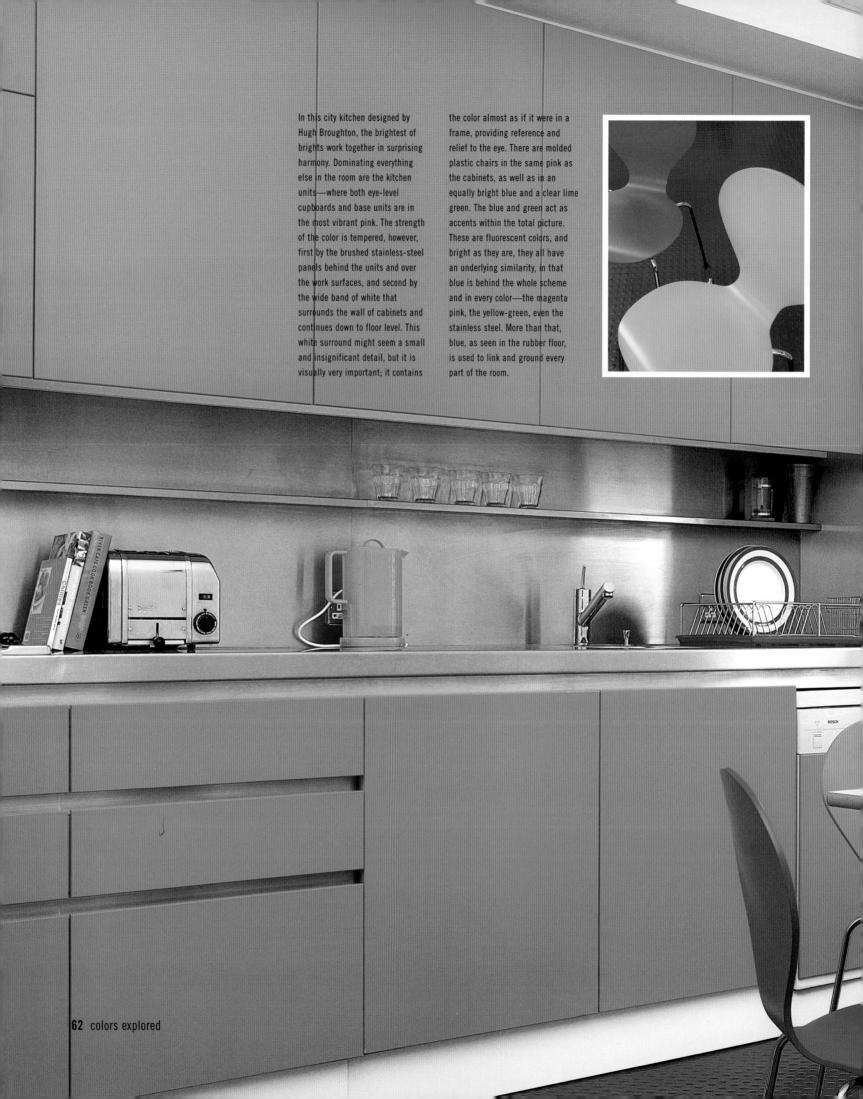

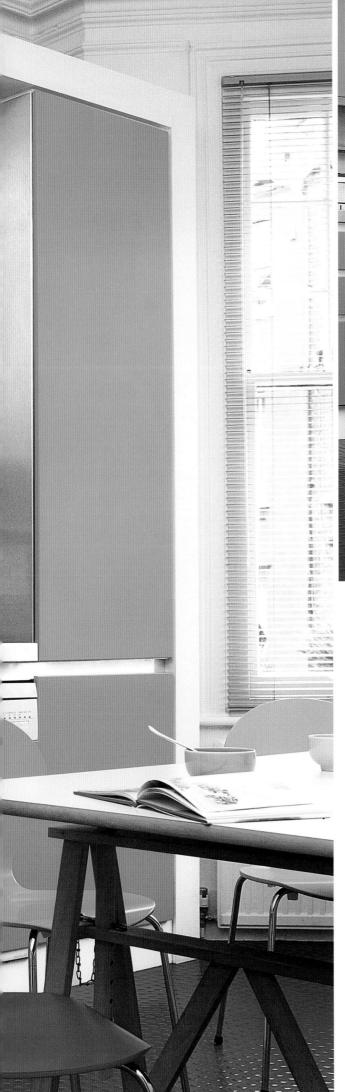

WARM PINKS

Although warm pinks are soft, all pinks can appear a little cold in a dark or cool room. They work best either when they are used in a broad spectrum of the reds and pinks or mixed with some cream. They can also work when they have a stronger color to throw them into relief: warm pink and apple green are an uplifting duet, particularly with a little warm white mixed in there somewhere. Warm pinks invite and flatter. They rarely work used on their own-a comment that could be made about many colors, but which particularly applies to these pinks. Warm pink is pleasing in a kitchen, where it can give a feeling of

purposeful pleasure or in a small bathroom, adding to the feeling of indulgence and relaxation that every bathroom should have.

One of the most popular of warm pinks is the deep warm hue that veers toward terracotta. Think of geranium mixed with brick dust; it is a welcoming, easy-to-live-with color that will work as well in a room used for eating as in a bedroom. Particularly appropriate and successful in cool lights, it looks wonderful contrasted with buttery cream or with dark, sharp forest green. A similar and equally useful shade is the chalky pale pink of fresh plaster. This is a wonderful color for walls, acting as a soft

background for greens of every description and also for much stronger pinks, even shocking pink.

Another successful shade of warm pink is apricot, which has slid quietly out of favour over the past few years, and yet has the ability to bring life to any room, to add sunshine to the darkest and dingiest aspect. Perhaps it went out of favor because it was flavored with either too much yellow or too much pink; the most successful apricot is one where neither shade predominates. If you study a real fruit, there are often at least three different shades that blush its skin—a little pink, a touch of red even, and (usually) a warm yellow.

Gold is a wonderful foil for apricot, bringing out, as it does, the warmth of the tone. Touches of gold could be introduced in the form of a gilded

Pinks bounce color straight back off the walls and make all the surfaces around them glow with a hint of pink.

64 colors explored

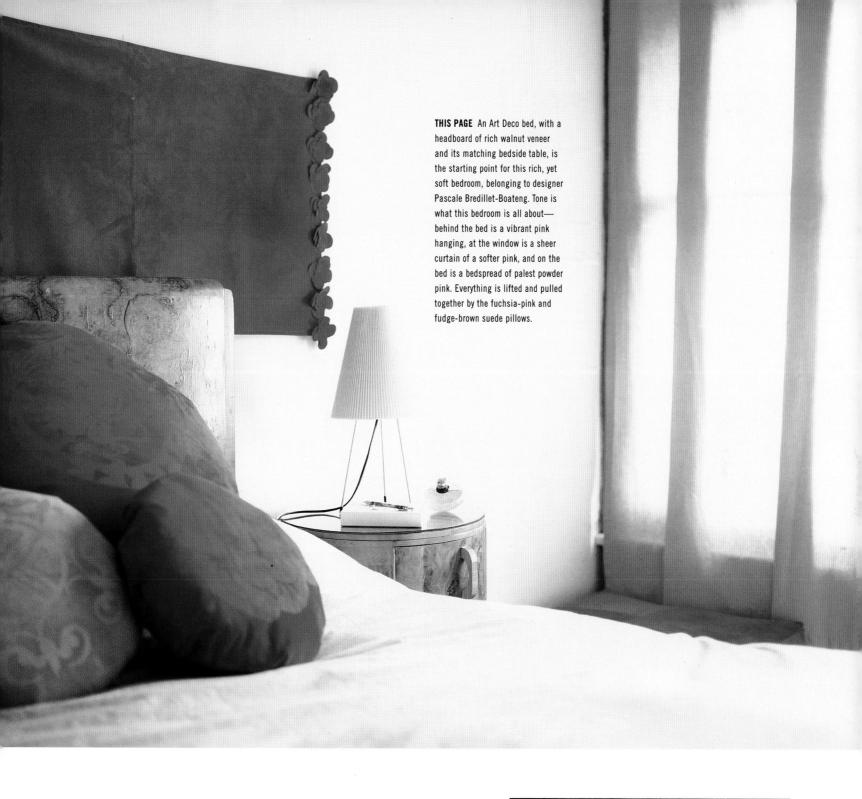

frame around a picture or mirror, or it might simply be a judicious, fine line along a dado rail or around a window. Gold tones are also, of course, perfect against any pink, warm or cool. Gold adds an air of sybaritic luxury, and can be employed not just as leaf or paint, but also as a heavier metal—brass, perhaps, in the guise of heavy curtain poles against a warm pink wall.

OPPOSITE This bedroom is a quiet retreat of diluted and softened colors. The walls are painted white, and the floor—which is laid throughout the apartment, and unifies the different areas—is powder-blue rubber with a high sheen. The main storage is in a pale pink curved armoire on one side of the room. A black iron bedhead sits behind a simple bed, which is made up with white linen and pale-pink pillows.

COOL PINKS

Cool pink is perhaps the most sophisticated color in this spectrum, its blue or gray tones giving it a striking subtlety. It is a very flattering color to live with, always useful, like the perfect blusher in a makeup box. Think dusty, dusky old rose pinks, mixed with—or set against—yellow, gray, blue, sage, olive green, or deep blue-red. These are shades that look particularly effective with warm browns of a chestnut hue. Strong cool pinks are very dramatic and work well when used to highlight or point out other

decorative features. Indeed, these tones can be so dramatic that, when used as the dominant color, a strong cool pink can quite simply be too much, veering toward the strident.

If you are unsure, a little will go a long way: think of the bright, cold pink of a pillow cover made of Thai or Indian silk. It has an immediate effect on the dowdiest of sofas or chairs. If you are confident in what you are doing, by all means combine strong pink with other colors of equal weight—deep mauve, citrus yellow, artificial grass green, or even electric blue. But

BELOW In this drawing room, a pink palette has been used, but with the emphasis on brown tones rather than blue. The walls here are colored a soft dusty pink—one of the most forgiving and livable with of colors. Against this background, the furnishings are colored tones that blend in, from pale cream to dark russet-burgundy velvet. The patterned rug—brick, tan, and stone—and even the floor cushions (embroidered velvet on a taupe base), blend and harmonize.

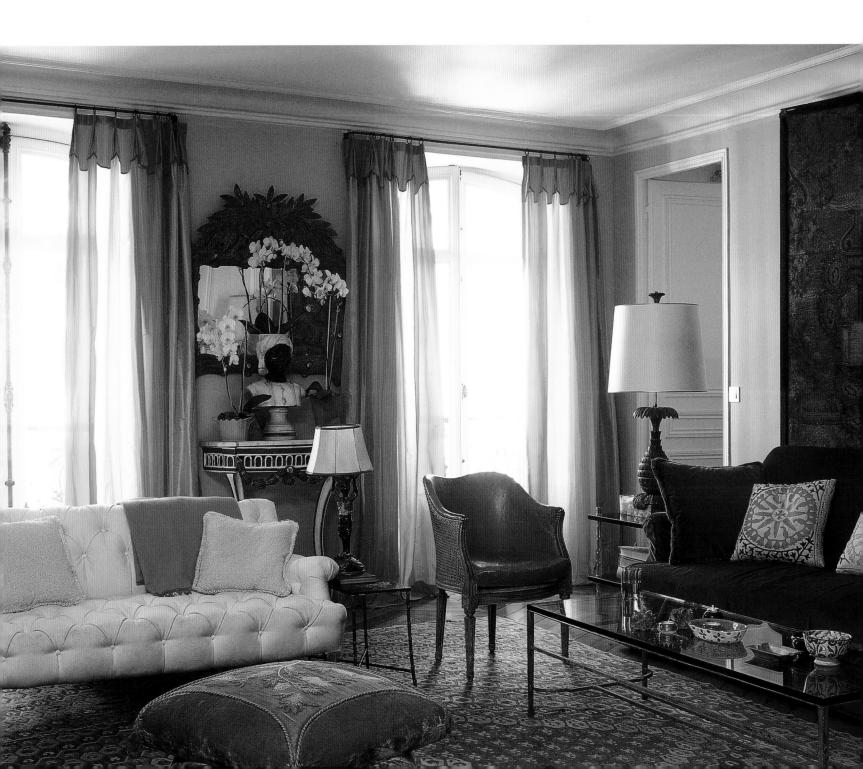

do not use them all together, and certainly do not use them without some respite, which might take the form of white, cream, or another neutral that comes equipped with its own blue note.

There are, as always, horticultural analogies—think of a dianthus or carnation—of cool pink tones, set off with a darker fringe of deep, cool red and surrounded with green-gray or just plain gray leaves. Of course, pink is a wonderful exterior color, particularly in a distemper finish that evokes color-washed, roughplastered houses, warmed by the sun.

THIS PAGE The curtains in this room of calm are unlined silk. Bold stripes of ivory, orange, and pink add a warm glow to the room as the daylight is filtered through tall windows. The woodwork and ceiling are painted white, and it is interesting to see how the pink and gold colors throughout the room are reflected by the white. This is why white should never be considered in isolation, but always in tandem with the colors that are to be combined with it.

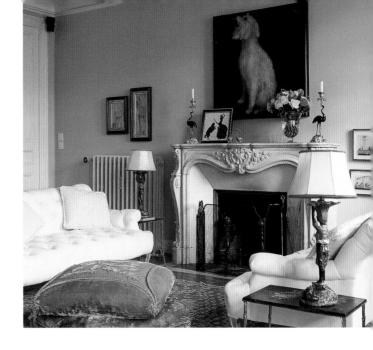

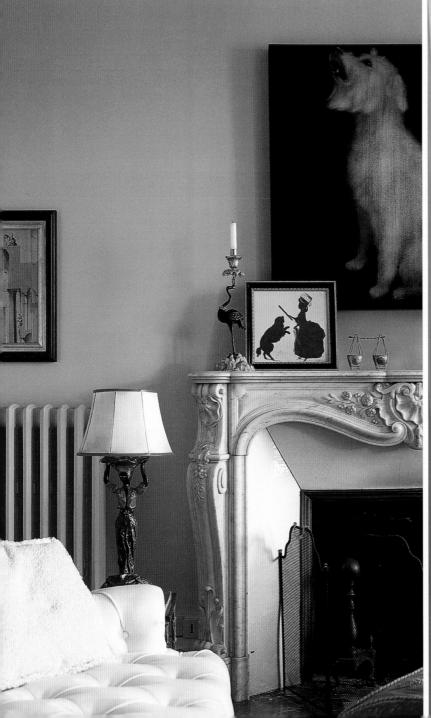

Purples and lilacs

THE FIRST-CENTURY WRITER PLINY CALLED PURPLE "THE COLOR OF HEAVEN," AND IN ITS RICHNESS, PURPLE HAS ALWAYS BEEN ASSOCIATED WITH ROYALTY. HOWEVER, SEEN IN THE LESS INTENSE HUES OF LILAC AND VIOLET, IT IS ONE OF THE MOST SUBTLE OF COLORS, DISAPPEARING INTO THE INVISIBLE BANDS OF THE COLOR SPECTRUM.

It is always important to remind yourself, when you think of a color, which primaries that color is derived from. Purple, of course, derives from red and blue, and depending on the strength of those colors, it can vary enormously, from brown-purple like sun-faded old velvet, to a rich Imperial blue-purple, like the robe of a Roman emperor.

Purple harmonizes with many colors: yellows, including lemon yellow, citrine, and maize; blues, too, both dark and light; and even pale orange—not an easy combination, but one that looks spectacular when carefully combined.

Purples, and particularly their lighter variants, mauves, went through a bad patch in the middle of the nineteenth century, when the development of chemical dyes meant that these colors—along with many other, equally harsh new bright shades—became available to all. They were immediately popular, and these new shades were

used with ubiquitous enthusiasm on textiles, walls, and floors, many of them together in a clashing cacophony. In the twentieth century, poor purple again suffered many of the same indignities: used to excess in the 1960s and 1970s, teamed with unsuitable colors, it unsurprisingly fell from favor. But today it is very much back, not only in its full glory, but also in its softer, subtler, paler variants—mauve and lilac.

Mauve and lilac are true flower colors. Think of sweet peas—pale pink, mauve, lilac, and cream, against soft green leaves. These lilac shades are so quiet that they fade almost as you look at them; and then there is the eponymous shrub, sometimes growing into a tree, whose panicles of flowers combine gray-mauve, pale blue, and white. And recall the true viola—a little bit of deep-purple velvet, a little soft, bright mauve, and a hint of yellow—look no farther for perfection.

OPPOSITE So conducive to eating, this dining room in Paris, belonging to master colorist and well-known designer Michelle Halard, rejoices in its rich-colored walls. The surfaces have been colored with a base coat of lilac, washed over with a stronger tone of the same

hue. Gilding and tones of gold are everywhere in the room, combining with golden-green accents to accentuate the warm plum tones. A soft gray-green console is home for an assortment of plates and further complements the color scheme.

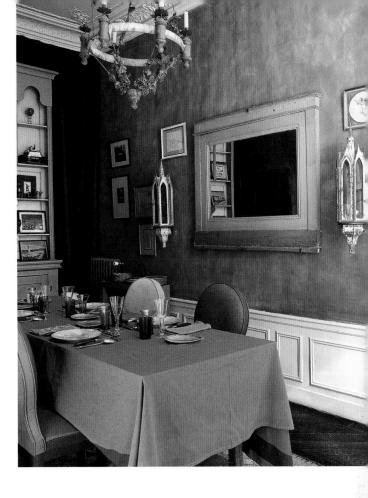

THIS PAGE Against the warm purple-washed walls, the paneled wood beneath the dado rail, like the leaves on a bunch of grapes, is colored a soft, springlike yellowgreen, which works wonderfully with the purple above. The color theme is continued with the purple cloth on the table and the dining chairs covered in either warm purple or pale-blue velvet. At the end of the room, a deep-burgundy

velvet curtain stands in front of an open cabinet, which has been painted French gray. The china and glasses on the table and stacked in the console continue the theme—either in cool glassy green or in the same complementary tones of golden-green as the dado paneling. This is a room for celebration—like the vines it is reminiscent of, it calls to mind bacchanalian revelry.

The decoration of this London apartment designed by Gordana Mandic and Peter Tyler is built up from layer upon layer of color. Throughout the space, the ceilings are painted pale lilac to provide a more gentle contrast than white to the bold, strong colors on the walls and furnishings.

RIGHT AND BELOW The bedroom is painted a quiet shade of pale lilac, both on the walls and the closet. The accents of color come from a side-shelf in deeper purple and bed-linen in sharp fuchsia pink. **CENTER** The living area, which has a dark-wood floor, is colored in shades of deep purple. The wall color was achieved by mixing purple pigment into plaster, which gives it a particularly rich texture. The plastered surface was then coated with a layer of yacht varnish, which gives it a slight sheen and an even greater depth. Purple-covered benches make a seating area, and a rug of wool patchwork introduces more accent colors, like orange, chrome yellow, gray, and biscuit.

WARM PURPLES

At first sight, red-purples are not very easy colors to use in interior decoration, though when they are used well they are instantly appealing and welcoming. Thinking about the color is perhaps easier if one envisages the eggplant, piled high on grocery shelves and looking inviting, rich, and warm. Bright saffron yellow, gray, or white—all these shades can be used to bring warm purples to life. They also look wonderful with silvery grays and gray-green, but they can be difficult to blend together with other purple tones.

Like their close associates, the red-browns, warm purples can make a room feel comfortable and warming, as well as making a large room diminish in size. They are ideal tones for an eating room—inviting relaxation and the enjoyment of food. Perhaps it is the association with the color of good wine that makes it so suitable. For a truly cocoonlike feeling, use warm purple with deep red and emulate the best of Victorian

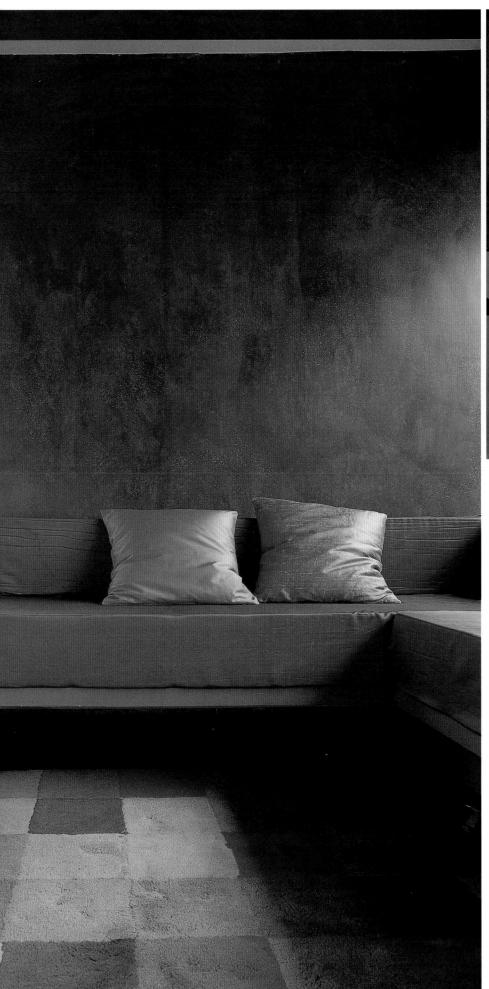

decoration—combine several different textures, making sure the deep luxury of cut, velvetlike pile is included in the mix. Warm purple is a surprisingly good color for woodwork, particularly when it is combined with neutral shades.

There are some varieties of lilac that are warm in tone. This is caused by the addition of pink, as can be seen in that coarser acquaintance of the lilac, the buddleia or butterfly bush. A sophisticated way to use these pink lilacs is to mix them with duck-egg blue and gray, with perhaps a flash of a deeper blue shot through the scheme. A warm buttery cream looks wonderful with pink lilacs, too, and they also work well with their eggplant cousins.

ABOVE One of the easiest ways to add slashes and flashes of accent color to a scheme is with scatter cushions; dependable, often expendable, they can be a good way to experiment with new and clever combinations. They can also be moved around a space at will, depending on where color accents are desired.

Lilacs and mauves enjoy popularity in every age, and their time in this new century has already arrived.

COOL PURPLES

Lilacs and mauves were much loved and much used at the end of the nineteenth and into the twentieth century. Legendary twentieth-century eccentric, Osbert Sitwell, in the first part of his autobiography, Left Hand, Right Hand, describes a house in 1900: "In the house we had taken, mauve, I remember was the colour on which each scheme was founded. Indeed mauve was the acme of fashion in all branches of decoration, whether for ceilings or wallpapers, and for coverings, of a woman herself no less than of her furniture." Perhaps as a reaction to all this centennial decorative excitement, lilacs and mauves then fell from favor and for some time seemed to be associated with old ladies—due, doubtless, to the fashion for gray-haired matrons to have a lilac rinse! But these cool tones are in reality sophisticated and clever, and as such, have always had their fans. The French, for instance, never consigned them to purdah and have always employed them with skill. Grays, deep blues, bright yellows, and sage green can all be used with lilacs and mauves. Think also of true lavender—a subtle color that is not quite gray, not quite blue. Look at a lavender field in bloom, at the waves of color that fall across it, ranging from an almost blue shade to gray lilac.

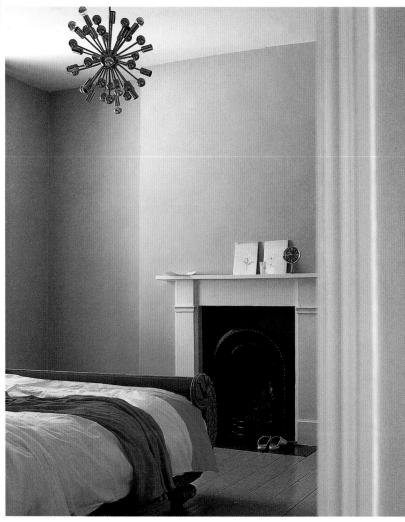

TOP RIGHT AND TOP LEFT Lilac is a soothing shade and therefore one that is good in a room dedicated to work. In this small office there is no obvious distraction: the furniture and woodwork are white, and everything else is painted the same tone of lilac, including the radiator; the only contrast is a pair

of distressed green-painted metal chairs. Even the flowerpots look good painted in shades of lilac, hiding glass jars for flowers.

ABOVE From the painted floor to the bed-linen, this bedroom is like a paint swatch card for lavender blue, running through everdeepening shades of the palette.

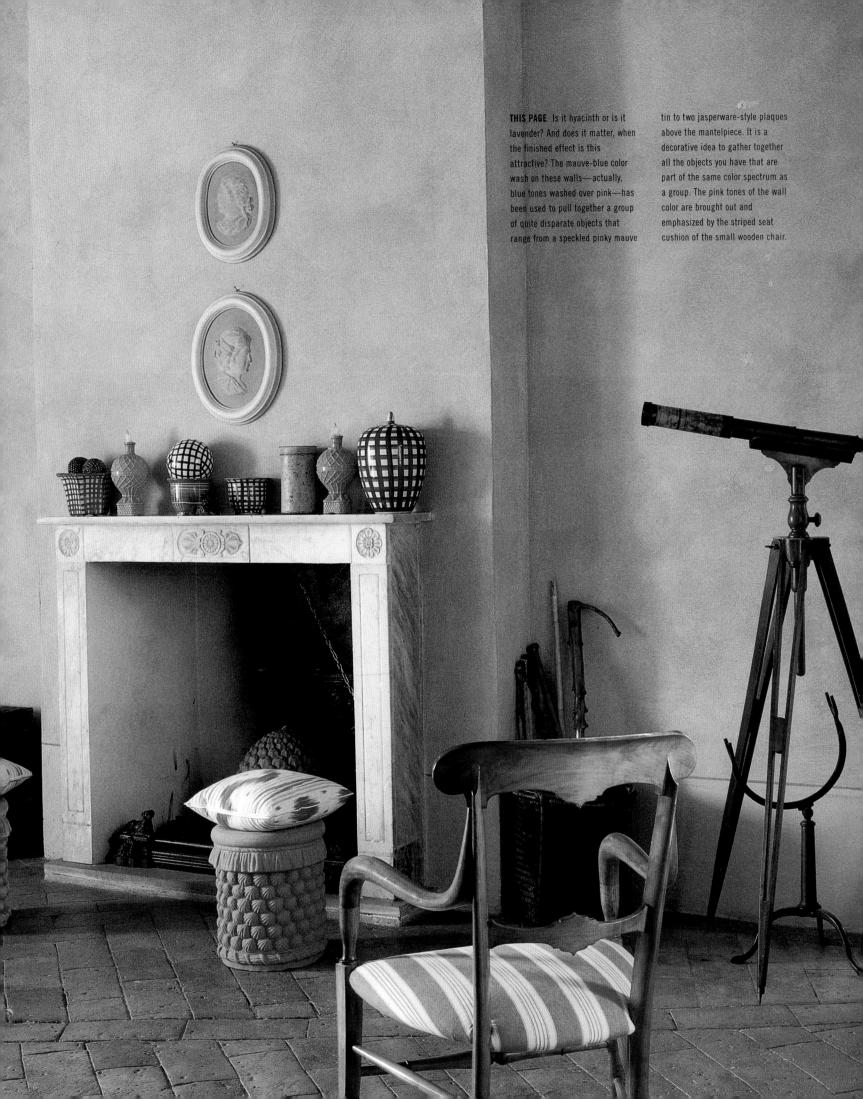

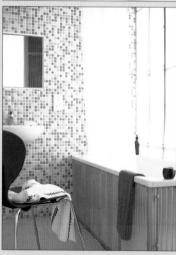

Blues: azure to aqua

What color springs to mind when you think of blue? Is it the cool gray-blue associated with Scandinavia or the rich blue of Greece that seems to reflect the sparkle of the surrounding sea? Or is it the blue of an English spring day—clear and light, neither hot nor cold? The list could go on and on; everyone has their own favorite: for one, it is sapphire blue, for another bird's-egg blue. Although this wonderful range is, in one sense, charming, in another (more practical) sense it means that it is quite difficult to pick the right shade. Not only does it have to be the shade or tone you empathize with and warm to personally, it also has to be the right shade for the particular room—which might depend on such practical and diverse factors as which way the room faces, how large it is, and how much sun it gets.

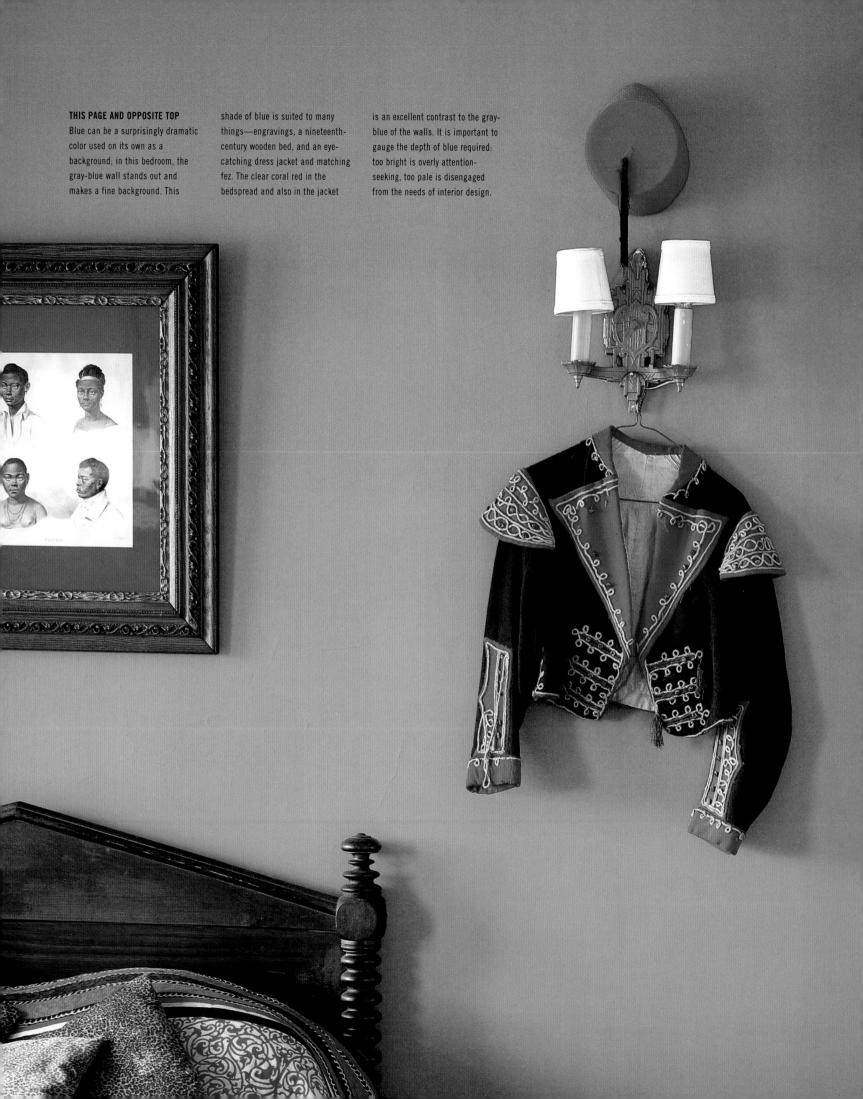

Shades of blue

OF ALL THE COLORS OF THE SPECTRUM, BLUE IS THE ONE MOST OFTEN CITED AS A FAVORITE COLOR. PERHAPS THIS IS BECAUSE OF THE MULTITUDE OF OPTIONS IT OFFERS. NO OTHER COLOR VARIES SO MUCH IN TERMS OF REFERENCE AND CHOICE, AND WITH SUCH A RANGE AVAILABLE IT WOULD BE HARD NOT TO FIND A BLUE THAT APPEALS TO YOU.

BELOW In this slate-blue room, the artefacts provide the color; the walls supply the setting. A traditional, painted wooden Indian door frame—or perhaps window frame—is attached to the upper half of the entrance, blending with the colors of the walls: pistachio green and pale terracotta pink. A sofa, close-covered in a self-patterned gold fabric, has arms upholstered like bolsters, reminiscent of Indian nineteenth-century decoration under the Raj.

Blue is not just a modern favorite—historically, the rich variety of blue tones has long been appreciated. Think of Nankeen or Nankin blue, for example, the brilliant deep blue found on the highly collectable blue-and-white Chinese porcelain exported from the Orient in the eighteenth century and which was made from a highly purified salt of cobalt; ditto powder blue, which was originally obtained by blowing powdered cobalt onto the surface of the porcelain.

Blue is a color of mystery and of subtlety; it is the color not just of the sky, but also of heaven, and comes clothed with all the many associations of that word. Early painters loved blue and used the fabulously

expensive ultramarine wherever money and art allowed. In medieval paintings, because of its cost, it was often used to paint the Madonna's robes, which is why we associate this color with her today. Medici blue is named after Catherine de Medici, daughter of Lorenzo, who in 1533 married Henry II of France and who brought Italian artists and craftsmen to France to decorate the Tuileries and work at the Luxembourg and Gobelin tapestry factories. Cool Titian blue is the grayblue of the jacket of Titian's painting, "Man with a Blue Sleeve," and the coolest of blues is what we now call Wedgwood blue, developed by Josiah Wedgwood in the mid-1700s and widely used on his popular jasperware.

Blue is the color we think of at the beginning of every day. There can be few of us who do not give a passing glance to the morning sky outside our window, and for most people the bluer the sky, the more cheerful we feel. In the color spectrum, blue is a color that appears to recede. Garden designers know this and often use blue—as they also do white—at the end of a long bed to give an air of distance and to allow the eye to travel on and beyond. As in horticulture, so in the decoration of our homes: blue used on the walls has the effect of subordinating objects, or making them recede into the background. Interior designers also know that some blues are so strong that they cannot be mixed with anything else, but must stand alone, and that purple-blue flowers look their best mixed with plants with a lemon-green hue—the analogy is obvious and easy.

blues: azure to aqua 77

THIS PAGE Artist Andrew Wallace wanted to display his paintings in this bedroom and chose the colors for the room accordingly. The soft blue walls provide an ideal background, without sliding into obscurity. He has then used the false ceilings as an opportunity to experiment: panels are ragged in blue, each slightly different in tone to the next, and the lattice work is dark terracotta red, providing balance and harmony to the setting of the paintings.

WARM BLUES

While blues can be the coolest hues of the spectrum, they can also be warm and sunny colors, and a pale blue is not necessarily an icy one. Warm blues have a little pink in them and, on the whole, work better in cooler countries (where they can help to add warmth to the whole room) than they do in sunny, hot climates. Indeed, in a cold room, warm blue can often be combined with a warm pink and cream to create a look reminiscent of a summer sunset, with pink-streaked clouds against the blue sky—think of how the pink-white of the clouds lifts both the blue and the pink of the changing sky.

Bright blues are usually warm; the ancient Chinese—who loved color—often used a bright, light blue in the decoration of the upper part of their rooms; ceilings were blue (except for Imperial ceilings, which were sacred yellow) and glazed blue tiles covered their roofs. Then there are the clear, rather confident

THIS PAGE In architect Voon Wong's apartment in a converted school in London, blues of different tones are used in the same space to delineate different areas. At the far end of the room, behind a walllong suede-covered bench, which has been trimmed in orange, the wall is painted dark blue-gray. At the other end of the apartment, the wall of the entrance hall is painted clear, strong bright blue, with a decorative and functional alcove, painted in white, cut into the wall. The glossy dark-gray painted wooden floor unites the two tones.

The sunny blues of clear southern skies lift the spirits and bring remembered warmth to colder climates.

Provençal blues, that speak of warm, bright skies, or the color of a southern sea with the sun shining on it. Blues like these can lift the spirit and are made to bring warmth to colder climates. If you want to make a real statement, pair them with an equally strong yellow, such as gold or egg-yolk yellow, maize, or corn. However, a color combination as strong as this will probably need a mediating dash of a softer color that harmonizes with both the dominant hues. Warm blues will even work with orange, although not in too great a quantity, and again if you are using an orange that is

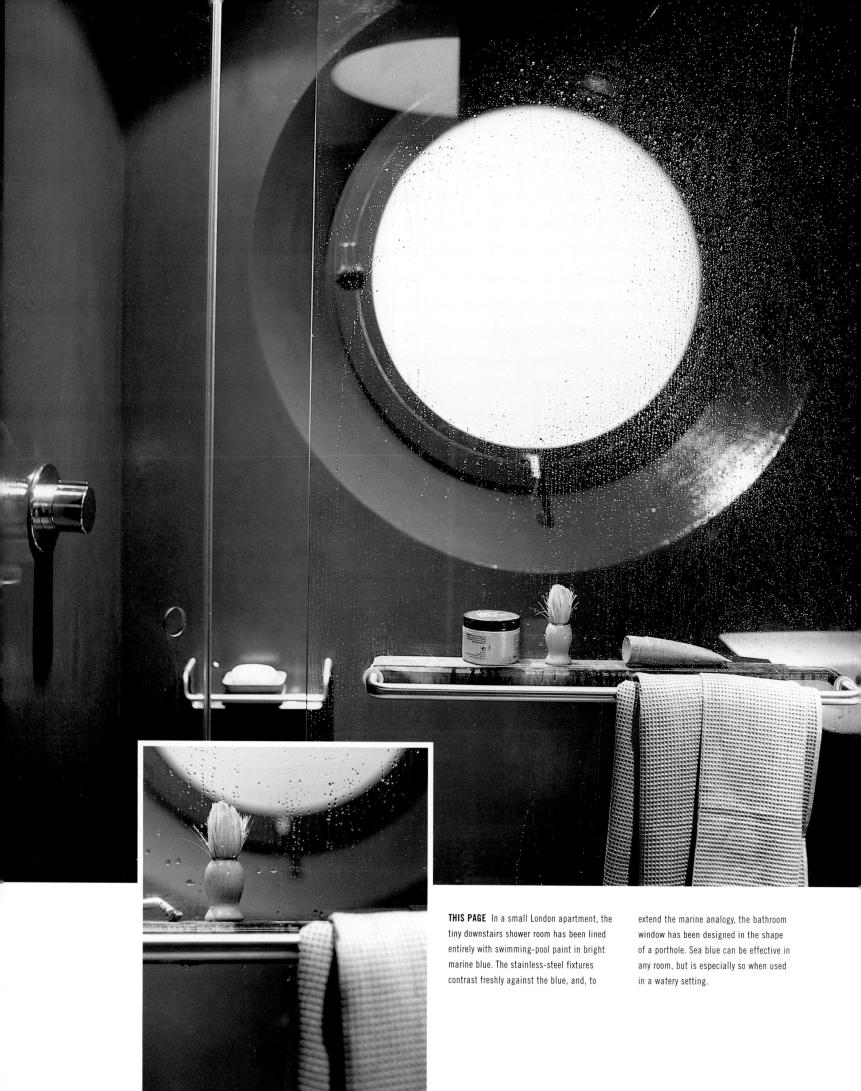

the same strength as the blue, you may well need another tone added at some point in order to ground the scheme.

One of the warmest of blues is the color that today we associate with the rippling blue of an inviting swimming pool on a sunny day, or slightly deeper—the Caribbean or Mediterranean sea. In the Caribbean, bright clear blue is often mixed higgledy-piggledy with a whole range of colors, from bright pinkish-mauve to clear yellow and bright light lime green. Very cheerful when you see them in situ, but remember that intense color has a different effect when it is seen under intense light. Strong light drains all colors of their intensity—strong as well as subtle. Therefore, very bright color combinations do not look as good in the cold light of more temperate climes—in much the same way as the grass skirt from Hawaii may not have quite the same effect in the local coffee shop as it did in the tropical beach bar! If you are going to translate bright blues into a cooler light, a calmer shade usually works better.

Although we love blue, we can sometimes be frightened by it; it seems so natural and yet, when it is on the wall, it can look so forbidding; it is a very dominant color, far more dominant than one remembers when looking at a small swatch or color card. A warm blue springs from the wall with bright alacrity and can make other colors look dirty or dull. This is possibly the main reason why warm clear blues, mixed with creamy white, are perennially popular. The

THIS PAGE In this striking New York kitchen, the work surface and splashback have been made from an unusual blue marble, which is heavily veined with lapis lazuli. This is the inspiration for the decoration of the room. The wall color behind is the most wonderful, pure hue, and was chosen to match the darkest veins of the precious mineral in the worktop below. The marble would be striking on its own, but is even more so teamed with the wall color. Each surface is strengthened by its proximity to the other. The brushed stainlesssteel appliances complement the color theme.

combination is forgiving and easy to live with, and can be used in many situations. Blue mixed with white or cream becomes a restful combination and can be well employed where such characteristics are desired—such as in the bedroom, or in a living room or study.

A blue-and-white scheme can also offer a welcome backdrop to other colors. A good way of finding colors that look their best used within this combination is to think of (or even to arrange physically) vases of flowers in different colors against a blue-and-white background. Depending on the exact tone of the blue, almost every shade can be made to look at its best in small doses—a fairly random selection might include dark colors like crimson and purple; bright colors like jade, mustard, and flame; and subtle colors like old rose, sage green, and violet.

COOL BLUES

Blues can be so cool and so deep. Blue can be the darkest of hues, as in the deepening blue of the evening sky as it slowly moves toward the darkest blue-black of night. Think mood indigo, songs

LEFT, ABOVE, AND ABOVE RIGHT This bedroom, with its walls of powder blue, is very beautiful, but also very cool indeed, as the palette of cool blues moves ever closer to gray. A collection of frosty Venetian glassware sits on the chest of drawers, and the bed is made up with snowy-white, intricately ornamented sheets—the coolness of each is emphasized by the uncompromising and all-encompassing color of the walls.

TOP LEFT AND OPPOSITE A blue as clear

and bright as this positively invites an energetic approach to life, as well as making

a luminous background for pictures and objects. In this kitchen, the blue walls are combined with so much white—on the tiles, the woodwork, the appliances, and even the floor—that the whole room has an air of freshness and light. The white tiles also act as a perfect backdrop for a collection of blue spongeware kitchen utensils. Flowered tiles in a decorative band—sometimes single depth and sometimes double—mark not only the division between plain tiles and wall, but also run around the doorway and down to the floor.

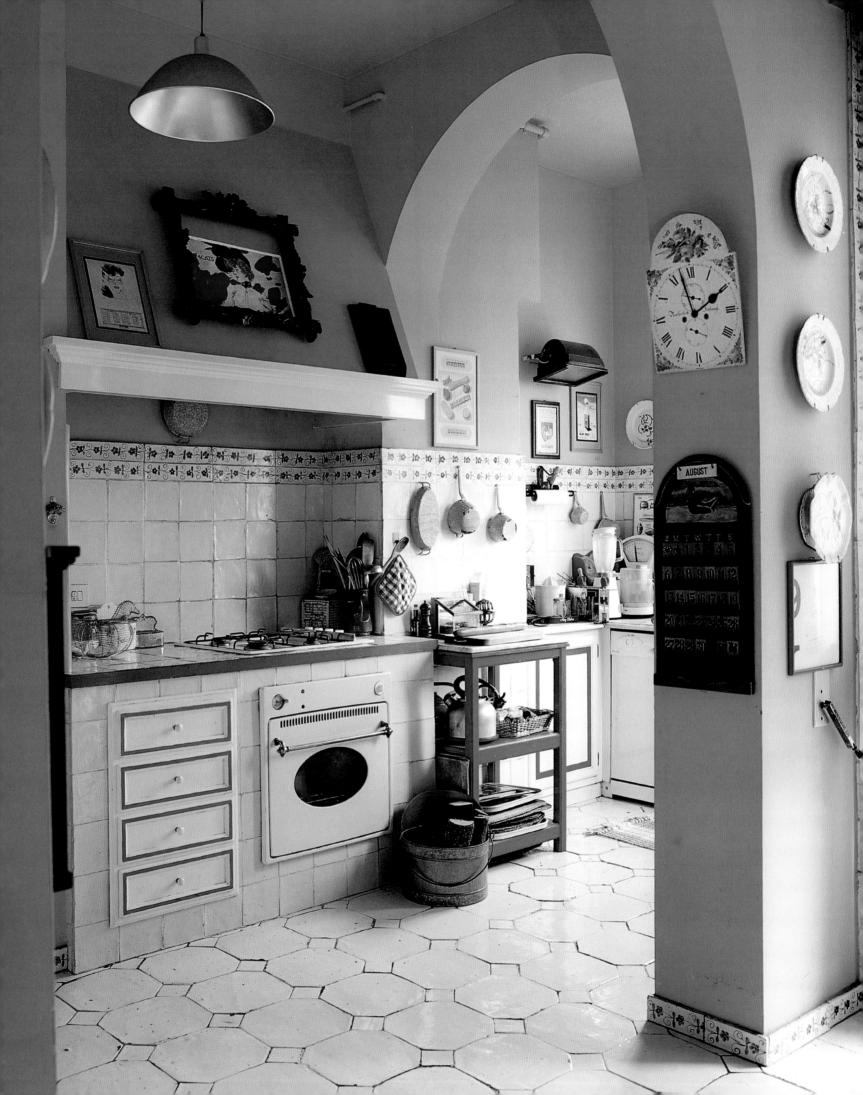

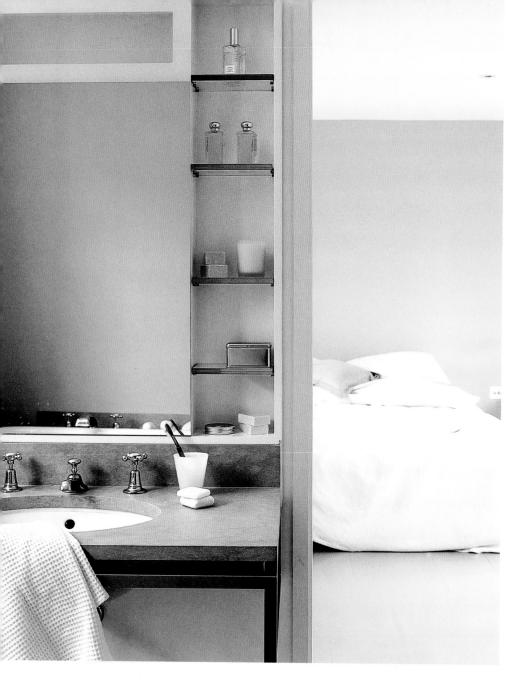

THIS PAGE Gray-blue tones have been employed throughout much of this London apartment, particularly in the bathroom and bedroom. The colors were deliberately chosen to complement the city's naturally soft-gray winter light. The effect, however, is warm rather than foggy. In the bathroom, textures of gray—using materials such as limestone and aluminum—lead to the bedroom beyond, where the painted walls and gloss-painted floor are almost gray, almost blue. The blue-gray pebbles lined up at the edge of the bathtub remind us that these colors pay homage to the natural world outside.

named after the purple-blue dye extracted from the leaves of the indigo plant and which sum up the feelings behind countless, timeless blues songs. And also think pale, cool, nearly cold, blue. There is the blue of a misty day—a blue tinged with gray. There is the blue of wood smoke and of cool gray-blue eyes. Historically, there is Wedgwood blue, a clear blue with a tint of gray. We associate cool blues with the North: ice can be blue, shimmering on a frozen pond or an ice floe; think of the children Gerda and Kay in the ice palace of Hans Christian Andersen's The Snow Queen, walking across floors of blue ice and underneath glistening blue stalactites. Actually, all those colors we now associate with Scandinavia—often putting them into a general basket of Scandinavian blues—have an element of ice-gray within them.

Cool blues are among the most sophisticated tones within the color spectrum. They are, indeed, soothing and calm, and make a wonderful background for a whole range of other colors, from those which are its

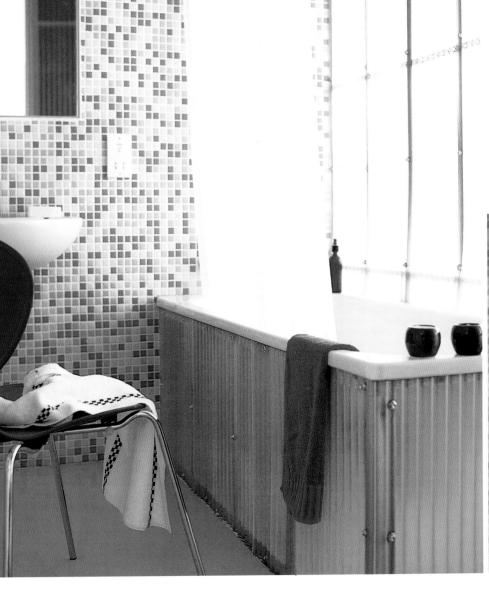

LEFT In this bathroom, the broken blue and white shades of the mosaic wall are softened by the use of clear and opaque plastics. A wall of corrugated clear plastic diffuses the daylight, while the same material, painted, is used to cover the bathtub. The clear white shower curtain reflects the colors around it, and the overall effect is one of soft, translucent

gray-blue, which brings a fresh and welcoming feel to the room. **BELOW** Blue mosaic tiles surround a recessed storage area for towels as well as pots and potions; naturally, the towels are also blue. **BOTTOM** The plastic-covered tub glows with a softer blue than that of the surrounding mosaics. A sybaritic touch comes with the blue candles.

neighbors on the color wheel, like lime green, turquoise, and emerald green, to those which are in contrast, such as dark rich purple, which still has some unseen blue within it.

Cool, pale blues are also very effective used with other light colors in a palette of pastel tones. Think of pale pink, primrose yellow, and perhaps even pale green. A good dollop of cream, and the effect will be of neapolitan ice cream. And, if you are using cool blue with white, the white must, of course, be just right—a blue-white, naturally.

Traditionally, cool blues have often been accented with gold—think of seventeenth- and eighteenth-century French interiors, where entire rooms were

decorated in a scheme of light French blue paired with ornamental gilding on plasterwork and wood, the two complementing each other perfectly. While you might not wish today to cover all your plaster with sheets of gold leaf, some fine gold lines outlining paneling, emphasizing molding or, indeed, painted directly onto blue walls or doors to suggest panels, could be most effective. The gold gives a tone of warmth that is as subtle as the color it is highlighting.

Note that the adjective that we use to describe these blue tones is "cool" rather than "cold." One is appealing; and the other is to be avoided. It is a question of degree. But

then with color it always is. Because these blues are so close to the tones of winter daylight, it is especially important to try them out first. Test them on the walls and observe them in natural light at all times of day before you commit. You will see that some will look interesting and subtle, and some will simply disappear. When you are using an inherently cool color, texture is even more important than usual. Interestingly, a flat texture gives depth and even a certain warmth to a cool blue. A cool blue in the same shade made up in a gloss finish or a shiny satinized texture—like a pond that has been iced over—immediately becomes that dreaded word—cold.

Scandinavian blue can be cooler than the equivalent gray, making it such a difficult color to use.

LEFT Shades of cool blue are mixed with white to give a calm, but never dull, look. The strong blue seat cushions and white-painted boards lift the room from the simply soothing to the definitely stylish.

FAR LEFT ABOVE Contrast—an important element when using a single color—is achieved here by pleating a darker blue-and-white fabric behind the chicken-wire panels of this large cabinet.

FAR LEFT BELOW It is the simplicity of blue that makes it so

simplicity of blue that makes it so successful. Around this traditional ceramic sink, a design based on folk-art motifs has been stenciled on a tin splashback. The painted border looks almost as if it is made of ceramic tiles.

RIGHT A freestanding hutch has been painted blue and wittily finished with gold leaf outlining the door panels—a decorative device usually seen on far grander pieces of furniture. An assortment of blueand-white china adds to the charm.

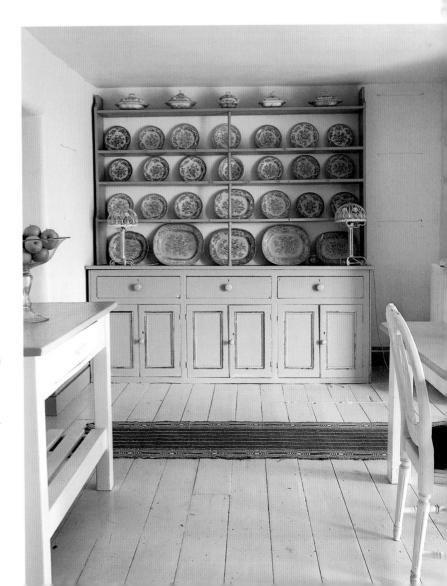

Greens: emerald to lime

For most of us, green is the color we most readily associate with the natural world around us. Just as the blue or blue-gray dome of the sky is over our heads each day, so, too, do we notice green on a daily basis. Albeit unconsciously, nearly everyone. whether they are country or city dwellers, is aware of the greens of nature as they mark the passage of the year. Bright, pale, and fresh yellow-greens mean spring is here; darker, deeper greens speak of high summer; while fading, changing greens, becoming ever more muted, take us through fall and into the long days of winter. The range of greens and their harmonious aspects means that they can be used more widely than almost any other color of the spectrum. However, this range also means that it is all too easy to choose the wrong green.

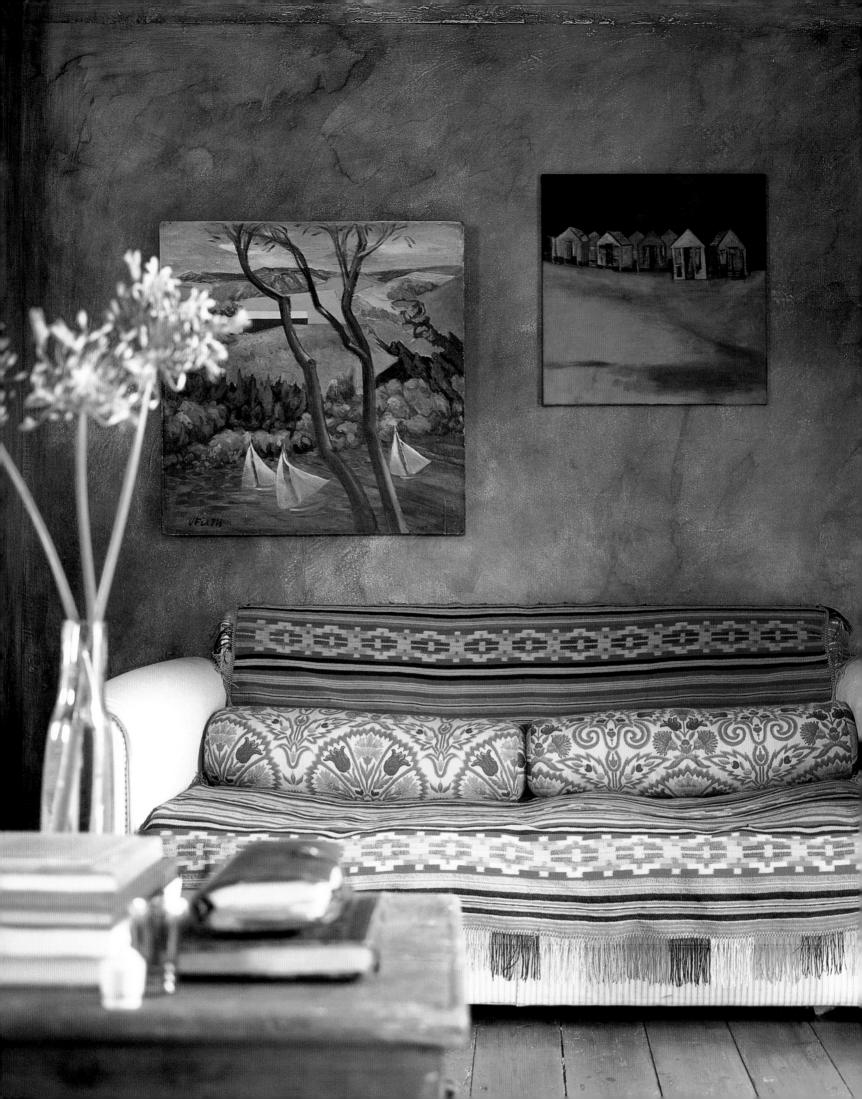

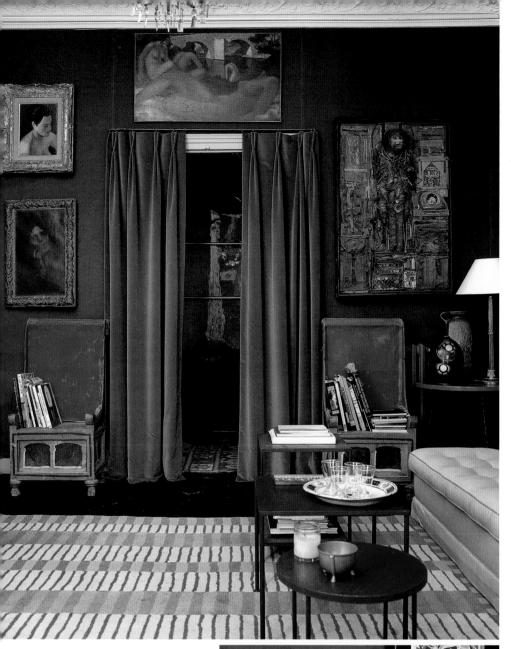

ABOVE AND RIGHT Michelle Halard is an authoritative French designer who uses color in a way that shows such confidence and originality that one can only admire and hope to learn from her ideas. In her Paris apartment, one color-filled room succeeds another; in the living room, the decorative scheme emanates from the green velvetcovered walls. Curtains across a doorway are in the same material, so there is no break in the depth of color around the room. The textural depth and richness of these velvet walls make them a perfect foil for an eclectic assortment of pictures—little wonder that green was the preferred nineteenth-century color for artgallery walls.

Shades of green

PERHAPS JUST BECAUSE GREENS ARE ALL AROUND US IN NATURE, IT IS EASY TO TAKE THEM FOR GRANTED, AND TO ASSUME THAT THEY WILL ALWAYS WORK WHEREVER THEY ARE USED. BUT A COLOR OF SUCH SUBTLETY NEEDS DECORATIVE CARE AND MUCH THOUGHT.

Green has been a favorite color since at least the Middle Ages. When we speak of Lincoln green, with its connotations of Robin Hood, we are talking about the dark-green shade that came from the yellow of a particular broom plant mixed with woad or other blue vegetable dyes. Material dyed in this green was the distinguishing mark of the English free archers during the twelfth and thirteenth centuries. And Adam green—or Adam's green as it was originally known—immediately and irrevocably conjures up those light-painted ceilings and stucco patterns inspired by the Greek and Roman ruins visited by Robert Adam during his European journeys in the eighteenth century. Greens were always the most expensive colors in the eighteenth century because many of them depended on expensive bases such as verdigris (green crystals formed on copper) and smalt (cobaltcolored glass). During that period, all greens, not just Adam green, were particularly popular and were used widely and generously in homes. Throughout the nineteenth century, too, green was used on the walls as well as the woodwork, and was woven into textiles of every description.

Although many of us feel an affinity toward green, both warm and cool greens are in fact rather difficult to use successfully in interior decoration. Green is a very subjective color, and if the tone is wrong, it can quickly affect our mood.

OPPOSITE Contrasting with the walls is a mint-green sofa, warm red-brown tall-backed chairs, with painted panels of yellow and blue; and, brightest of all—on a parquet floor painted very dark brown-black—is a multicolored rug, combining lilac,

blue, yellow, red, and white. It is a testimony to owner Michelle Halard's color sense and the clever way in which she combines tones and hues that there is no jarring note and no sense that the combination of colors is in any way too much.

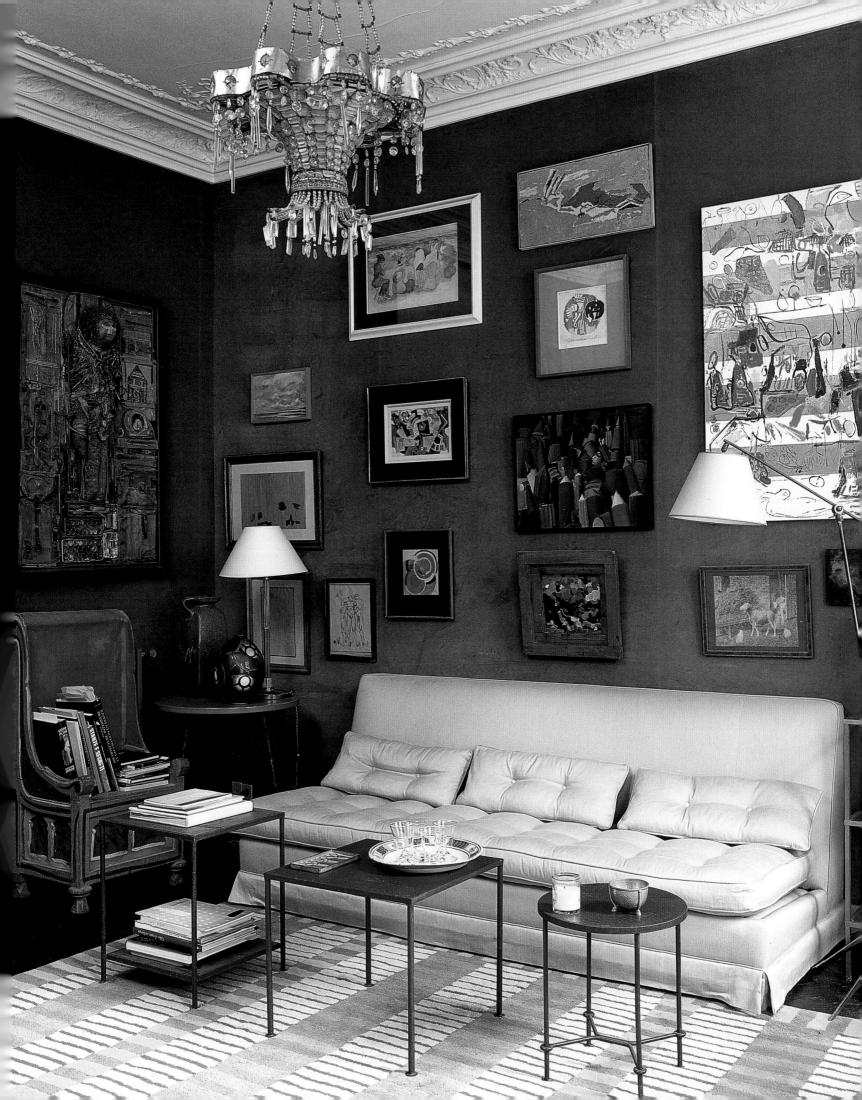

THIS PAGE This dining room in a late seventeenth-century house, which overlooks a fjord outside Bergen in Norway, is painted a strong, warm green. The walls are made from horizontally applied planks, and the color dates from the time when the house was built. The green is complemented by seats and cushions in pale oliveand-white checks and stripes, and contrasted with the heavy white door frames. The floor is uncovered —the better to appreciate the warm wood tones—and the green theme continues into the next room with a wide painted band between the ceiling and the molding.

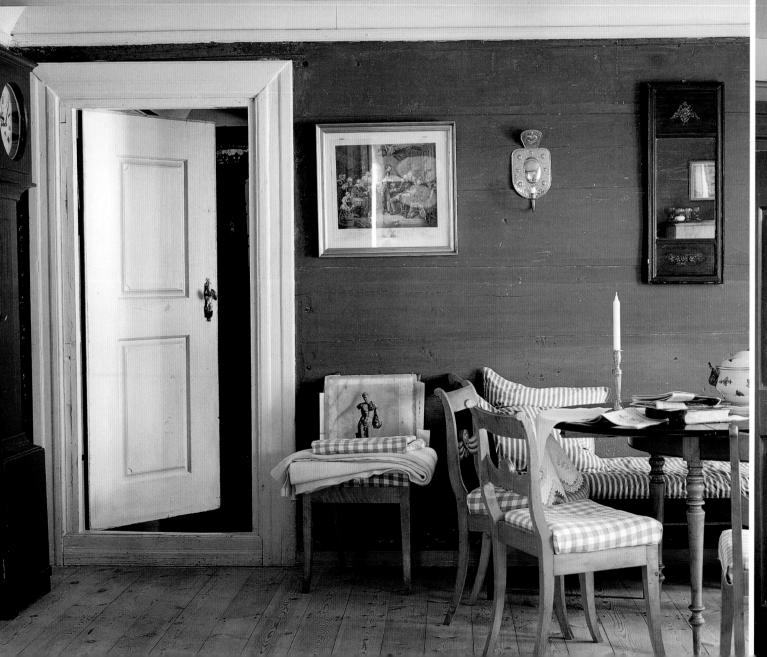

WARM GREENS

Warm greens are those with red or yellow tints. Or they are those warm muddy greens mixed from brown-yellow that has been added to blue. It is these combinations that give those satisfying warm greens that work so well when set against other colors with yellow in them, such as sharp orange or, indeed, yellow itself.

These warm greens are the color of nature, of the warm earth and the woodland. Such earth greens are akin to earth browns and look good combined with all other browns, from chocolate to chestnut and even terracotta. Perhaps because of their historical popularity, warm greens can be fairly formal in character. Objects and pictures are well displayed against a warm green background—a fact that explains the number of galleries and museums that use warmgreen paint or material on the walls; in the late nineteenth century, aesthetic souls advocated dull, dark warm green as the only possible background for works of art.

A slightly redder dark green—Forest or Racing Green, in paint-card terms—is a good color with which to present an instant air of sophistication and masculinity. Traditionally, this is the color of studies, libraries, and billiards rooms, and it is best combined with shiny black—perhaps on dado rails and baseboards—and with the warm brown of seasoned

BELOW LEFT The door, door frame, and banisters have been painted a slightly darker shade than the floor of this hallway. The horizontally planked walls are a wonderful soft, old pink-another authentic period color and one that looks absolutely perfect with the deep yellow-green. BELOW You do not need a wide color range to create differing and attractive color schemes. Here, green has been used on the floor and paired with dusty whitepainted planks. The earth-toned, red-painted bench is an important part of this harmonious trio, completing the simple but cleverly conceived scheme.

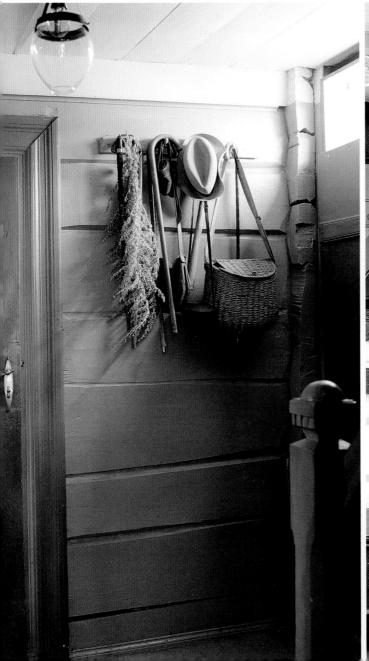

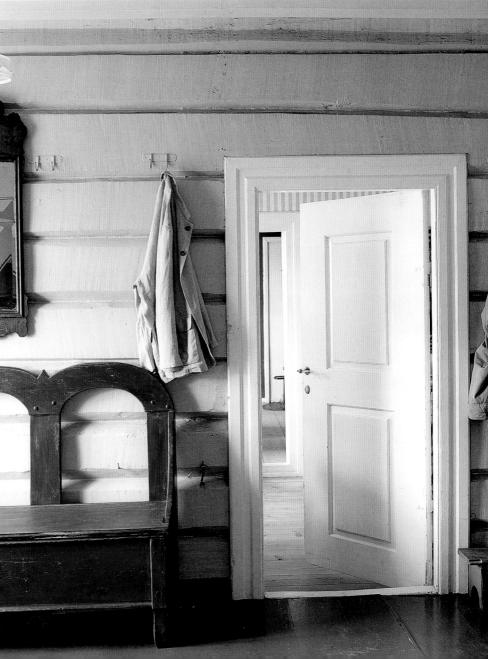

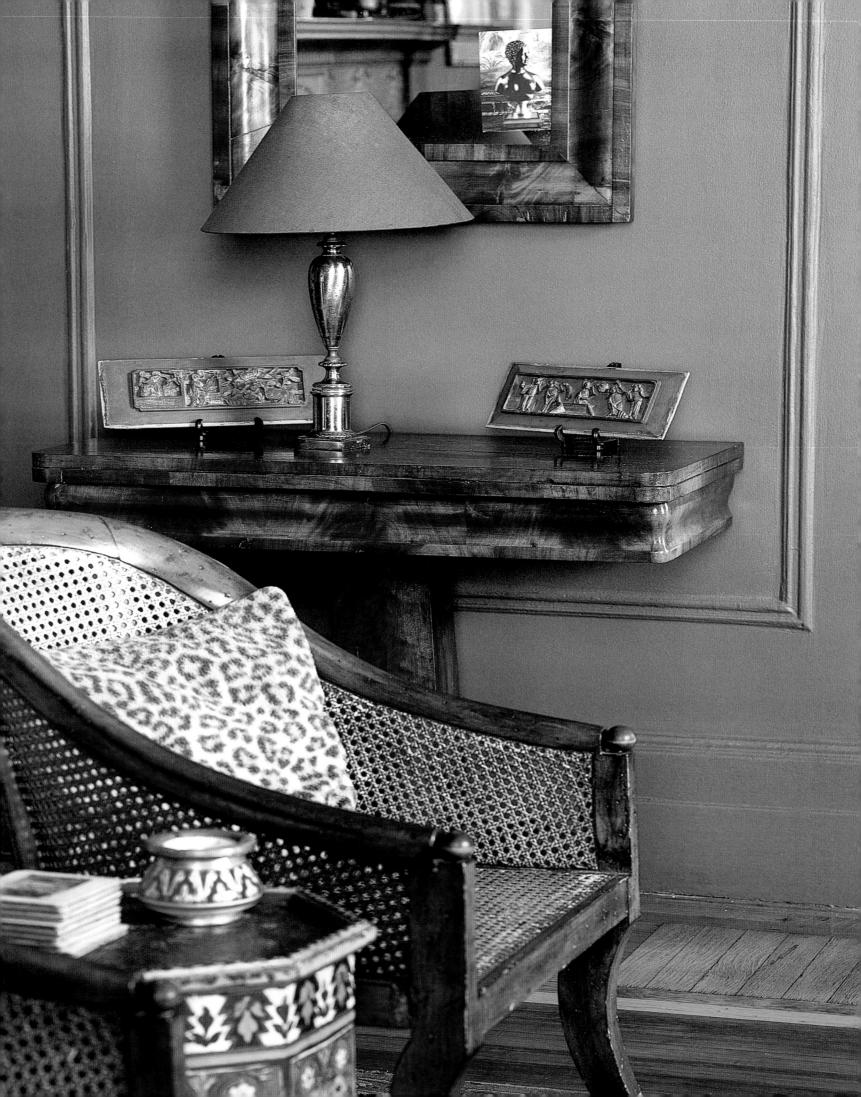

Perhaps no other color presents so many variations on a theme as green; on its own, combined or contrasted with other colors, its decorative applications are infinite.

THIS PAGE AND OPPOSITE This drawing room in a landmark building in Manhattan is painted bold blue-olive green, the sort of color that might have been used in early eighteenth-century houses. The color is so strong and so rich that no effort has been made to aggrandize it by adding ornament

or contrast to the moldings or woodwork. Everything seen against this color, from pictures to furniture, looks the better for it. The blue side of the palette has been complemented by the claret and blue tones of the Oriental rug, and emphasized by the wide claret-and-white stripes of the antique sofa.

leather armchairs and polished mahogany doors. Warm greens also work well—often spectacularly well—with warm reds. These are complementary tones, of course, and a dash (no more) of one in a scheme of the other will always be successful.

Another group of warm greens have an air about them, a feeling of what can only be described as jollity. They call to mind the Emerald isle, the precious stone, and the green of hand-rolled, striped summer lawns. This is what a warm green should be—positive and confident. Jade green also comes into this category, clear and warm, intensely sophisticated, and very dominating. Use these colors carefully—in dining rooms perhaps, or halls and staircases.

Consider what color woodwork to have with these bright colors—the conventional answers are not always best; think instead of a contrast or a deeper shade of the same color.

COOL GREENS

Greens are popular today as interior-decorating colors, but in the eighteenth and nineteenth centuries, they were wildly popular, and used throughout the home, inside and out. Inside the house, the walls were sometimes pale cool green, or pale gray-olive, and sometimes a deeper tone, a true deep olive with a hint of gray in it. There was also a lot of the muddy grayish yellow-green, known as "drab," that was used on woodwork and in more functional areas of the house. There is a shade available today which is similar to traditional drab, but slightly softer and grayer in tone, and—for me—this color works in every area where once you might have used white or cream: on doors, window frames, and shutters, for example. It is best applied in a flat or silk finish, and I even use it on the

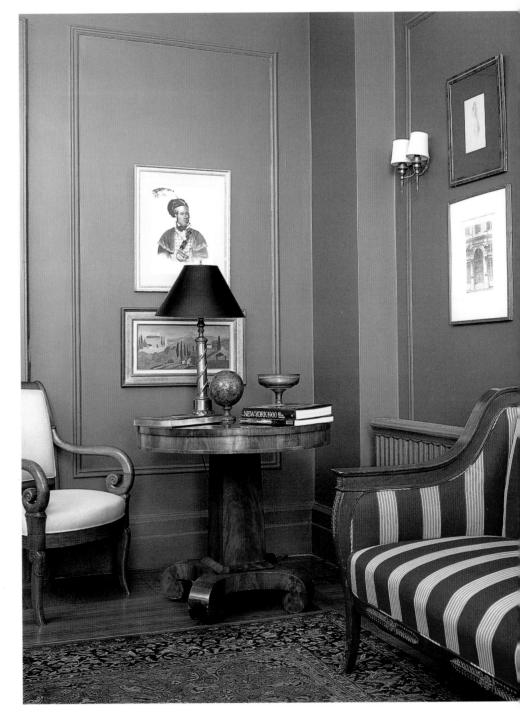

sort of wooden furniture that needs to be painted. It is never intrusive—it is actually far less intrusive than white as it melts into the background. It is, in fact, a very accommodating color.

Outdoors, in the eighteenth century, a very dark black-green was often used, both on the exterior woodwork and also on the ironwork of a house, instead of the rather boring black so universally used today. Black ironwork only became fashionable in Britain during Queen Victoria's extended mourning period for her husband, Prince Albert. This shift in opinion led people to opine that green should never be used as an external color since it was likely to clash with those many greens that nature delivered so much better. But actually, a cool gray-green, whether dark or light, works very well against a natural backdrop, as does that once-fashionable shade of dark Victorian green. The secret is to avoid clear or bright green—the sort of green that children's toys are painted with. Any tone that looks as if it is trying to vie with nature can only come off second-best.

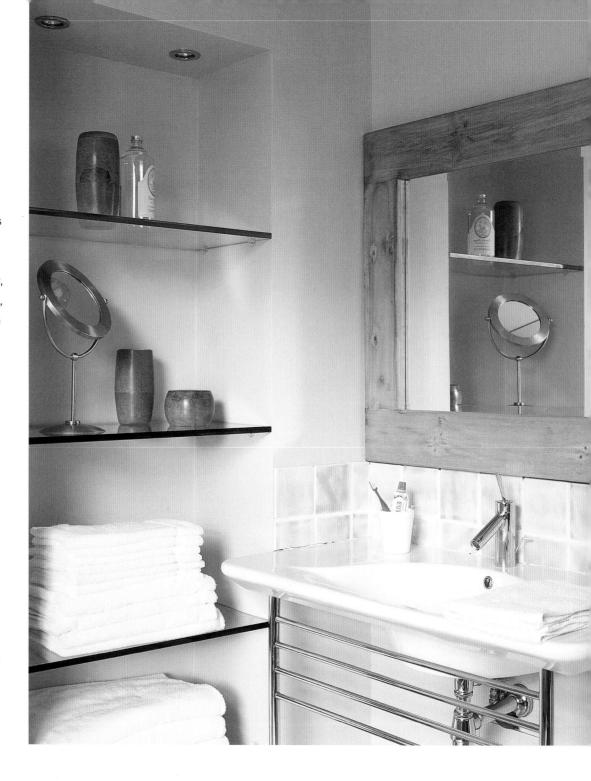

ABOVE Pale spearmint green with a touch of soft cream makes this one of the most difficult of colors to achieve—a warm, light green. The warmth is underlined by the woodframed mirror and the soft green tiles over-glazed with cream.

LEFT The best place to learn about pale, warm greens is outside, where they are at their best and softest, be it as painted, weathered wood or as the natural, almost silvery tones of lichen on a piece of bark.

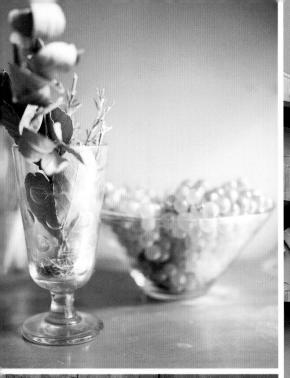

Dark green absorbs light, and the more black there is within the green, the more light it absorbs, so it should be used with care. That said, a really dark black-green is a very useful color, decoratively speaking; thought of as a predominantly French color, it really does look like black, flecked with darkgreen lights. It is sometimes called invisible green, and is very effective

and sophisticated on a glossy front door, or used inside on baseboards and around door and window frames.

For many people, the cool greens that are easiest to use are those with gray in them: think of the leaves of ivy and myrtle, olive, sage, and willow. Garden designers often balance a garden that has too much pink in it by using liberal plantings of gray-green

THIS PAGE In the Paris apartment of designer Michelle Halard, the kitchen exudes an air of tranquility as well as efficiency. It is painted in the softest, most attractive shade of sage green. The walls, doors, windows, and even the paneling below the dado are all painted the same shade, which adds to the air of calm. Set against the glossy black-painted parquet floor and behind the blackpainted shelves and table, the

combination is at once both sophisticated and easy to live with. The kitchen leads directly into a stunning, strongly colored purple-and-lilac dining room (see pages 68-9) with which the gray-green is in perfect harmony. A zinc work surface, plus the glassware and steel utensils on show, continue the cool tone, while, behind the working area of the kitchen, the walls are covered with warming wood.

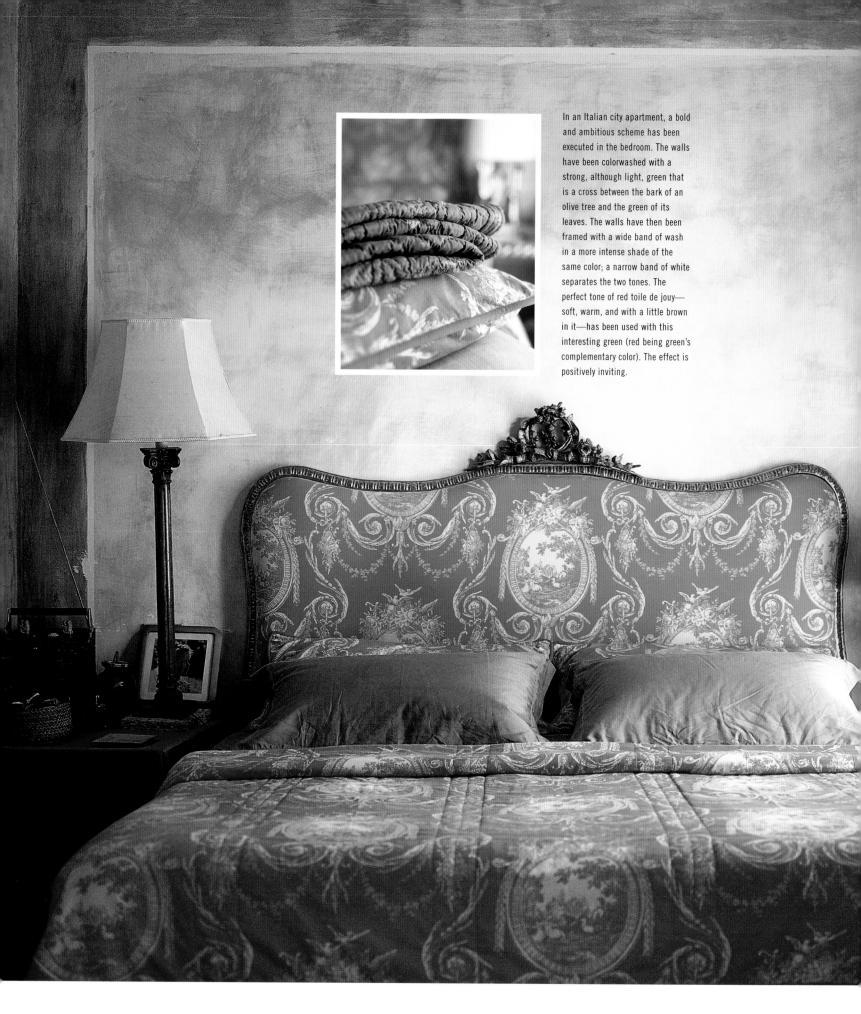

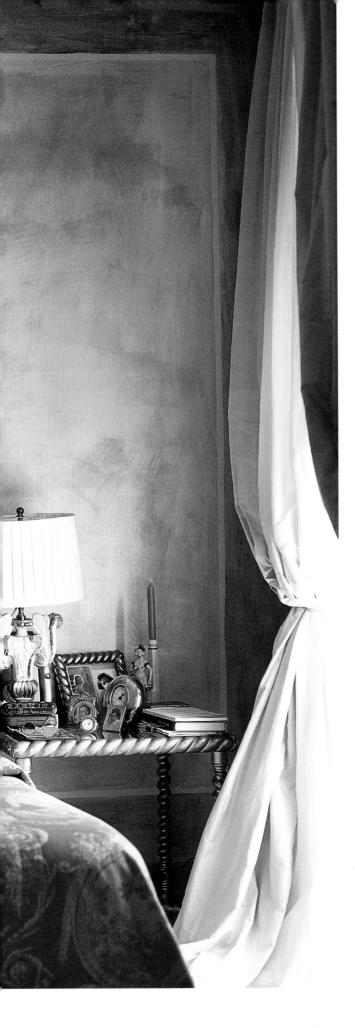

or silver-leafed plants; they also make full use of gray-green plants in beds of gardens that are predominantly white—the gray-green tones soften the white and give it a subtlety and depth that it would otherwise lack. Both these horticultural ideas can be well employed inside the house as well. Think of how well gray-greens would work in a scheme that included blue-red or hot pink tones. And a room of neutral whites would benefit enormously from the addition of pale gray-greens. As with so many colors, it is the subtlety of shade that counts, as well as the subtlety of contrast.

Other cool green hues include the yellow-greens; to identify these greens, think of the natural world in spring, when so many new, young yellow-greens vie for our attention. Think apple, lime, young box, and daffodil stems. And, in

the vegetable basket, think of fresh green salad leaves: lettuce, celery, and the acid green of young radish leaves. For me, these yellow-greens, fresh as they are, look best combined with other clear bright colors, such as yellow and sharp pink. White—or, better still, cream—is important when you are combining these tones. In fact, in some cases, it is an essential ingredient, because too many fresh colors can tumble and knock each other over, each shouting to be recognized.

As already observed, greens can quickly swing from the calming to the depressing. When used in the wrong way, they can make one think in particular of all those institutional acres of public areas that surround us. Eau de nil, for example, a color which was very popular at the beginning of the twentieth century, and which has

RIGHT A clever three-dimensional illusion-like a picture frame or an open book—has been given to this room by running the wide band of washed green on both sides of the inner edges of the wall, edging it with white on each side. It looks like a piece of antique French ribbon. And, rather than detract from the impact made by the soft red and creams of the toile de jouy against the varying greens of the washed walls, the curtains are a soft, unobtrusive plain cream material. The cream matches the background color of the toile; hence sharp contrast is avoided.

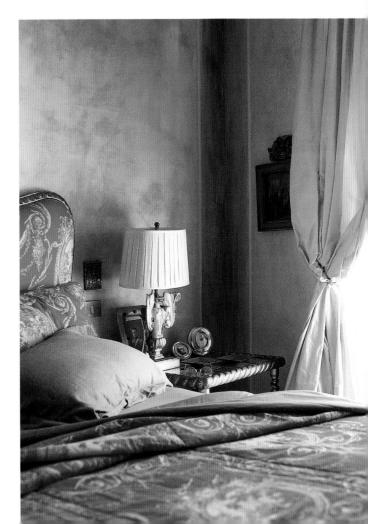

a certain blue-toned, chilly charm, is actually a very difficult color to get right. Unfortunately, its popularity then meant that it—and its near neighbor, a yellowtoned pale green—were taken up in the mid-twentieth century, by those who decreed the colors for school and hospital walls. Presumably, it was thought that "cool" and "pale" were synonyms for "calm" and "reflection." Too many public rooms and corridors, restrooms and waiting rooms have been painted these cold blue-green shades as well as that particularly obnoxious shade of bilious yellow-green. Even more misguidedly, a gloss finish was often used to cover large areas, presumably because it was considered more durable. Durable it might have been, but it also was even colder than the same color in a flat finish, reflecting the light in a particularly chilly fashion. In addition, while many light colors do not work particularly well in a gloss finish, cool, pale greens work least well of all. Dark glossy green, on

THIS PAGE Apple green—cooking apples, for preference—is a fresh and bright color for a kitchen, so long as it is combined with other colors and textures that stop it

from becoming acid. In this New York kitchen and hall, it has been teamed with the warm tones of pale wood, both on the floor and the

with an interesting pale blue-gray on the doors leading off the hall, which is again taken up by the steel splashback and kitchen table and chairs

the other hand, can be very striking, and can be used in strong and effective contrast with any number of colors: mango and guava, powder pink, French mustard, pale lilac, for example, as well as white and buttermilk or cream.

Cool greens can be the clearest and most refreshing of shades, and greens used in conjunction with other greens can be extremely effective. That said, I think that the chilly coolness of very cool, light greens means that it is actually very difficult for these colors to work effectively in a cool climate under a chilly natural light. Almost all cool, light greens need accent colors—pink, mango, terracotta, lemon, or sunshine yellow. It is these that point out the depths of green and add a necessary reminder of warmth. Cool greens work better in some rooms than others—they are not colors for a bedroom, for example, since morning light and cool green do not make the happiest of companions.

RIGHT A small shower room has been made into a room of bright green wit. The walls, even within the shower area, have been roughly plastered and then colored with a soft apple green—probably Granny Smith this time. The fixtures are stainless steel, and the sink has been dropped into a yellowgreen plastic surround; this almost neon material is also used for the shower screen.

BELOW, LEFT AND CENTER Walls painted a bright, uncompromising fresh lime green are complemented by straight-backed chairs upholstered in warm terracotta russet shade.

BELOW RIGHT To many, these sharp greens look artificial and unnatural. But you only need glance around you to see that they are the most natural colors of all: here, spring green at its most vivid—after the rain.

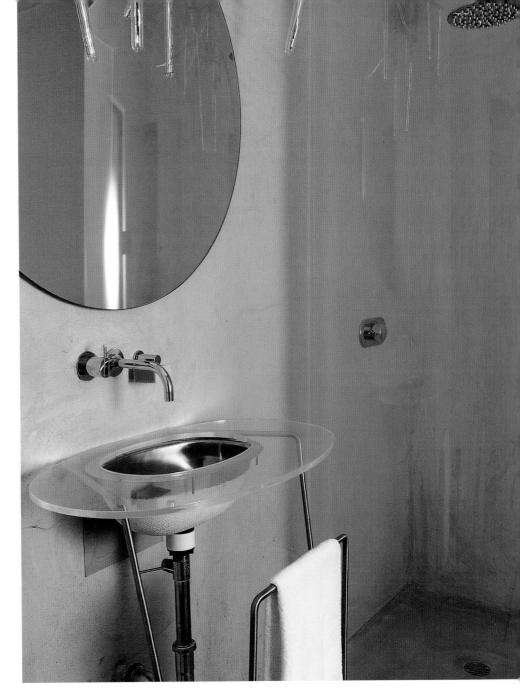

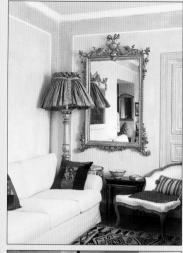

Yellows, oranges, and golds

Yellow is a primary color—a fact that has its advantages and disadvantages. Stronger than most other colors, it can dominate a scheme and make the colors around it seem dull and dirty. The other primaries—red and blue—are strong enough to stand up to a bright yellow scheme, yet the colors tend to sit uncomfortably together. At its most basic, orange—a most underestimated color—is made from mixing red and yellow. That said, the tone of orange is very reliant on which yellow and which red are used, and how much of each. Bright reds and bright yellows make a brighter orange, while those colors mixed with white produce a warm peach. The bolder of these tones—along with gold—make wonderfully flattering accent colors. as well as being successful in their own right.

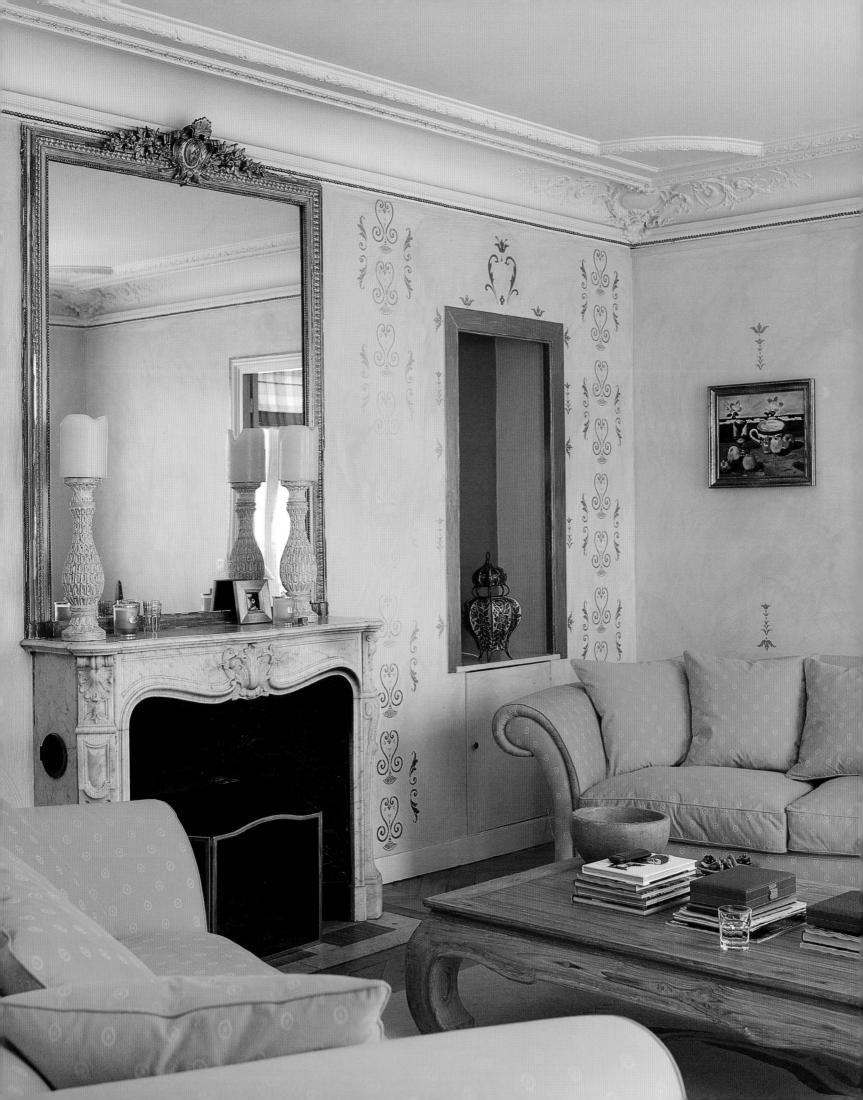

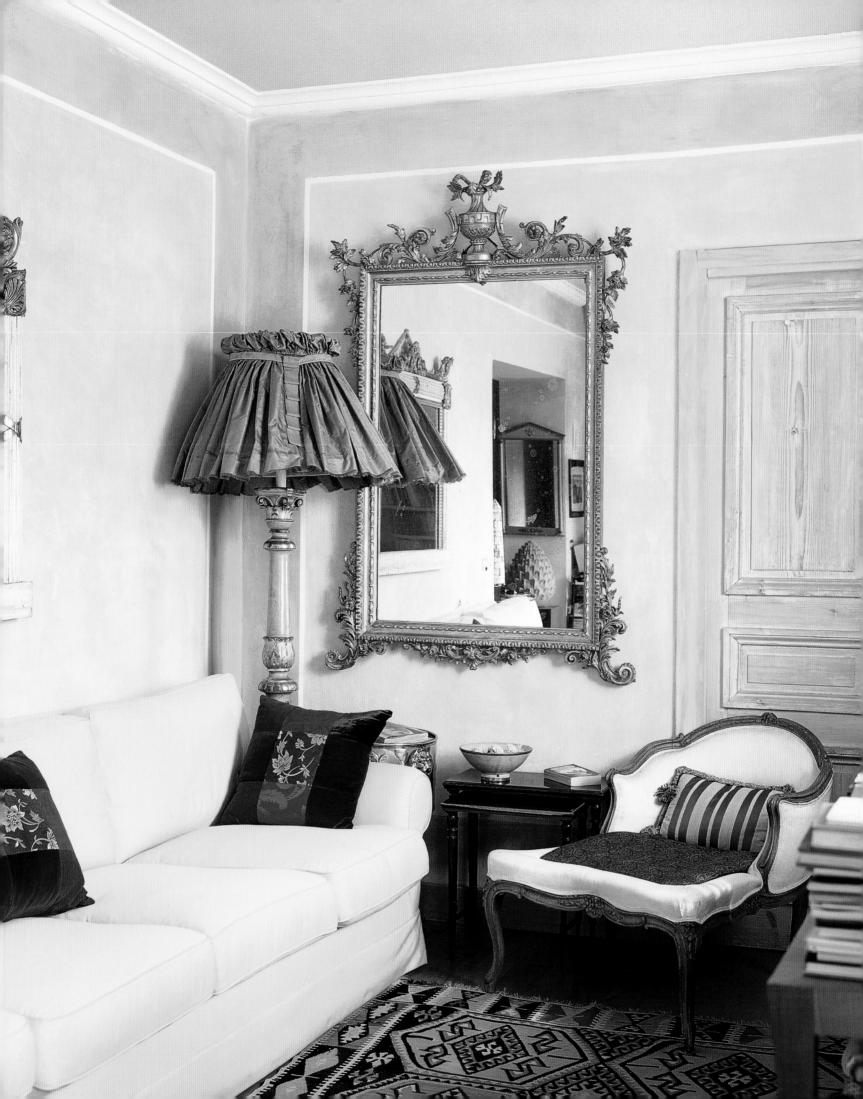

Yellows

YELLOW IS SAID TO BE TOO EMOTIONAL A COLOR FOR SOME, BUT THE FACT IS THAT IT IS A STIMULATING COLOR, AND CAN, WHEN USED PROPERLY, BRING WARMTH, COLOR, AND WELCOME INTO COLD ROOMS LACKING IN SUNLIGHT. IT ALSO HAS THE PROPERTY OF ADVANCING INTO A ROOM, SO IT CAN BE USED TO GIVE PROMINENCE TO OBJECTS WHILE DISTRACTING THE EYE FROM OTHERS.

The variety of sources from which yellow dye has been laboriously made demonstrates the versatility of tone available. Yellows were extracted from pomegranate and lemon rinds, safflower petals and buds, and primroses. The very first yellows were made from the earth pigment ocher, a clay colored by iron oxide, and the warm yellows we use today still have the same elemental feeling to them.

Yellow has long been revered in different cultures; it was the sacred color of the Royal House in China, whose members were the only people allowed to wear yellow in their elaborate woven and embroidered silk costumes. Today it is used with more abandon, yet it still requires a certain confidence to get yellow right.

COOL YELLOW

Yellow is far more versatile than is often thought. As shown in medieval decoration, cool yellow harmonizes with white, purple, blue, violet, and deep crimson.

Many people are wary of yellow, because, while a warm yellow—one with red in it—is exactly that (warm), a cool yellow can chill an atmosphere as soon as it is on

OPPOSITE In a Milanese living room, tones of yellow have been used particularly imaginatively. The clear yellow on the walls has been left in its pristine state, but each wall has been outlined by a wide all-round border of a deeper

yellow wash that frames the wall. The addition of a fine white line separating the colors pulls the whole scheme together. The door frame is similarly colored, while the door, unusually, has been stripped and bleached.

the wall. Think of the color of lemons (in particular, the closeness between a lime and a lemon) or even of primroses. There is very little sunny warmth in either of these; their green tints make them interesting, even luminous, but they could never be considered warm. Canary yellow and daffodil yellow are also cool hues, and go with green-based tones as well as cool blues. In countries with a cool natural light, many yellows have a tendency to look greenish because of the slightly blue daylight, and they certainly reflect the outside light within their tones. Therefore, cool yellows, more than any other color, should always be tested first on the walls before making a choice. They

ABOVE This palette of yellows is warmer and more subdued in tone than those used in the living room. Everything has been arranged to harmonize—the yellows have been combined with deeper, warmer shades from the same palette. The chair seat and even the tone of the floor fit into the same scheme. BELOW, LEFT AND RIGHT A bedroom in the same apartment has been outlined with the same technique as that of the living room. Panels have been suggested by using a deep orange wash over the yellow base coat, to suggest a frame around painted panels.

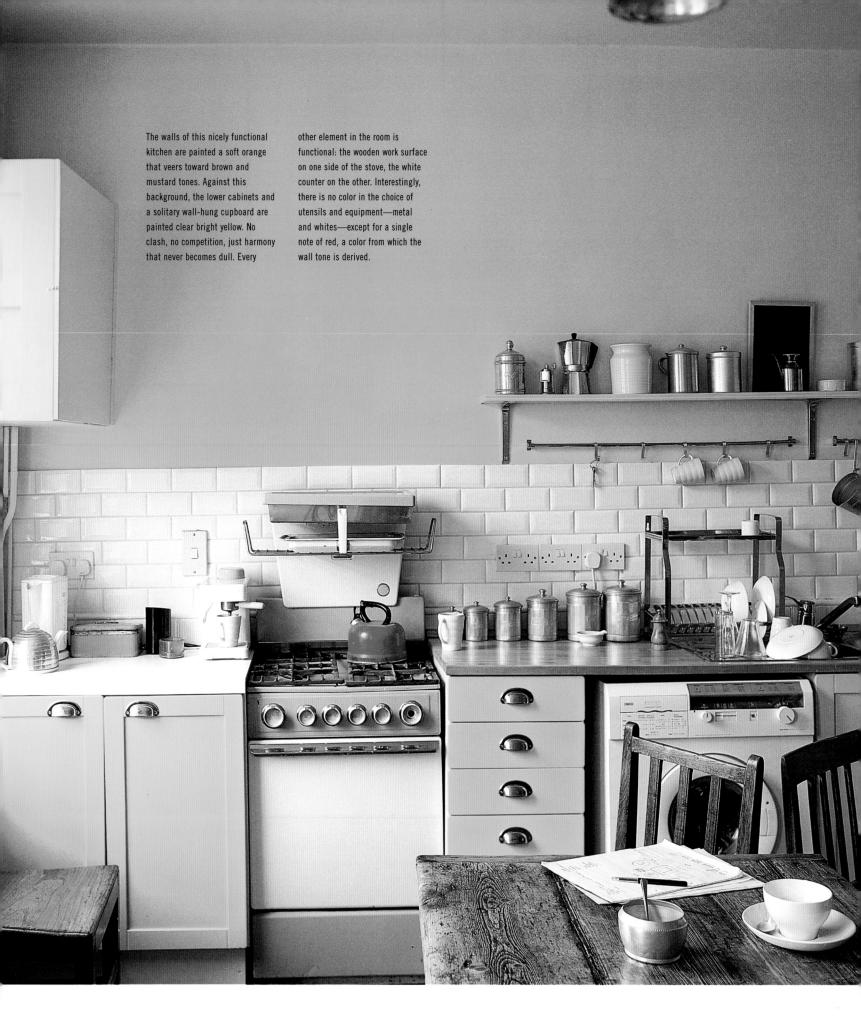

RIGHT This kitchen that clearly demonstrates how tones of a color taken through a palette can be used to striking effect. The yellows and oranges of the walls and units perfectly complement the wooden furnishings as well as the functional elements of the kitchen. BELOW AND FAR RIGHT These details-shiny chrome handles on a yellow background, a used wooden chopping board, and an antique enamel pitcher—show how clever a background color this subtle yellow is, and how suited it is to a functional role.

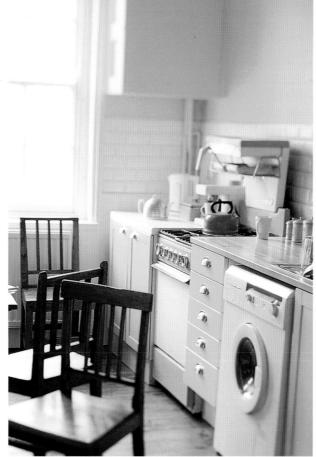

should really be used in sunny rooms but, that said, a classical Scandinavian combination is cool yellow with cool blue and a touch of white—supremely elegant, if rather chilly.

WARM YELLOWS

Of all its other connotations and associations, perhaps the most important by far is that yellow is the color of the sun. One cannot help but want to be warmed by it and respond to its air of hope and clarity. One of the most striking uses of yellow ever, and now to be seen in its newly restored glory, is Sir John Soane's drawing room at his house in Lincoln's Inn Fields in London. First conceived in the eighteenth century, the walls are colored a brilliant, confident yellow that gives everything in the room a meaning and a life without any feeling of domination. Other famous warm yellow rooms include the dining room in

Claude Monet's house in Giverny, France, where the yellow walls work particularly well because of their close association with blue—perhaps one of the happiest of color combinations.

Bright warm yellow is also interesting with dark warm colors such as chestnut or chocolate, and in particular with black. But softer warm yellows can also be very effective when they are used with equally soft contrasting shades.

Warm yellow also reflects other colors in the light source, so it is, again, important to try the shade you favor on a wall and see how it looks, as all yellows vary greatly as to character, intensity, and hue. Although warm yellows are probably seen at their best in cold climes, where the light is cooler, yellows that are recognizably touched with warm light browns to create colors like straw and saffron can be very effective in strong light, like that of the Caribbean.

BELOW In this living room, yellow beckons the visitor in. Appreciated for at least three hundred years as a color against which to display paintings and objects, yellow is often best allowed to dominate a scheme, with every other element subordinate to it. Here, there is no other color, only natural and neutral tones in the wooden furniture and floor, the black-and-white prints, and the old leather armchair.

Yellow can be a demanding color; a strong,
Chinese lacquer yellow, for example, would simply be
too much in many rooms. But it does depend greatly
on the size of the room—a small room, like a
bathroom or small kitchen, can look wonderful painted
with lashings of flat, bright, sunny yellow, while a
larger room, such as a bedroom or a living room, is
happier when the yellow is toned down with a little
cream. A yellow that has mixed into it a little brown
and a little orange, as well as a dollop of cream, is

both welcoming and subtle. This is a color with which to decorate and against which objects and ornaments stand out—the final effect is like ripe corn.

Warm yellow also looks good paired with wooden furniture—particularly the warmer shades like maple, walnut, and waxed pine. It also makes a good background for black-painted or ebony pieces. A warm yellow that has more brown in it—more earth tones, in fact—looks best when used with other earth tones and set against a polished wooden floor.

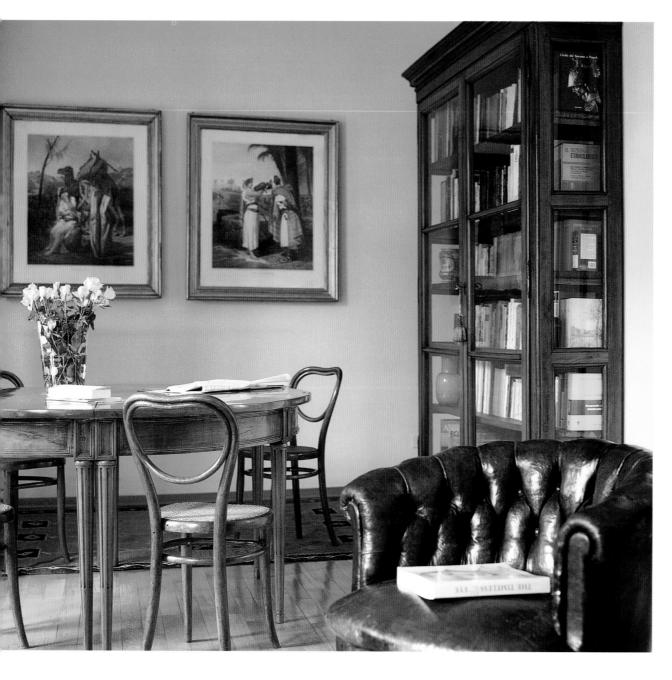

RIGHT Yellow is an interesting color in that, although it can be very dominant, it is also a very welcoming color, in whatever guise. Like the color of a double-yolked fresh farm egg, this rich yellow on the wall is warm and welcoming. Sensibly, there has been no attempt to match it or to fight against it. The woodwork is impressively white, and the mantelpiece and fireplace have also been painted whitealmost painted out. The only contrast-which is still in the same palette-comes from the portrait on the mantelpiece, in a pickled-wood frame, and the covering of the rounded stool, as well as the naïve, brightly colored mat in front of the fireplace.

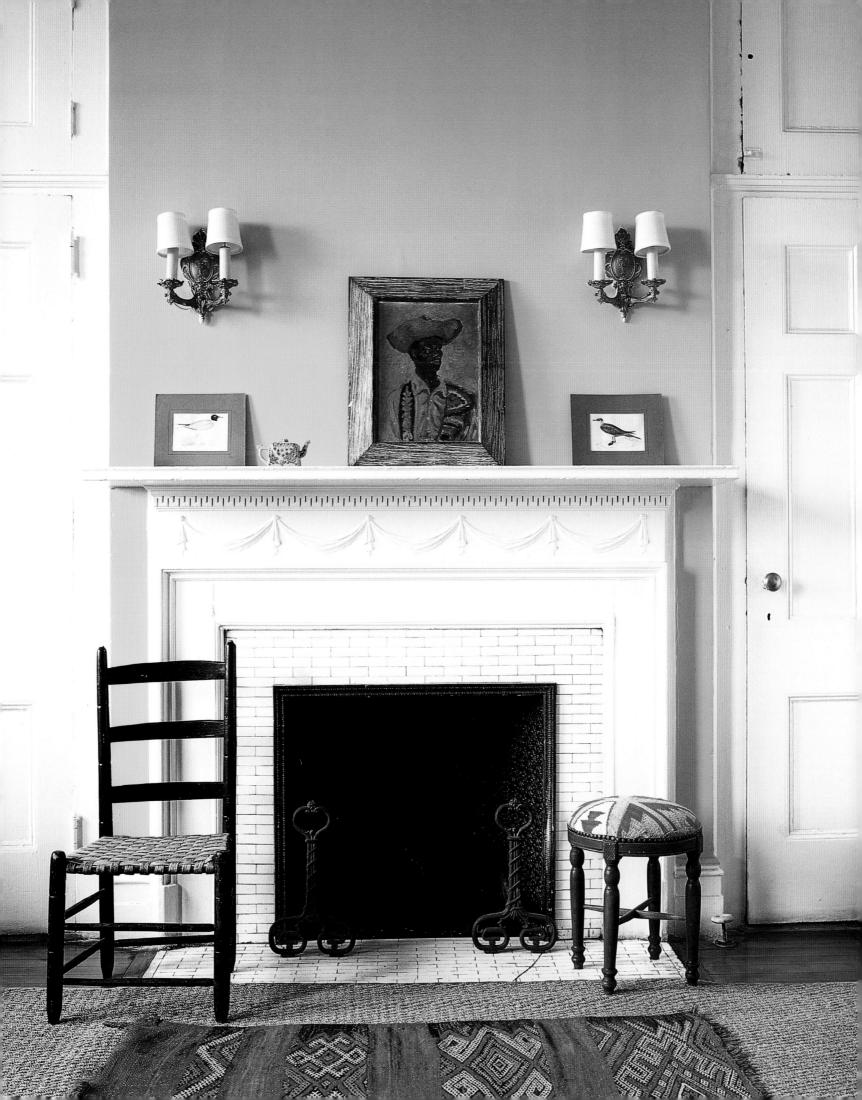

Oranges

ORANGE IS A MIXTURE OF THE PRIMARY COLORS RED AND YELLOW.

A BRIGHT RED AND A BRIGHT YELLOW, SUCH AS CADMIUM, GIVE THE
CLEAREST ORANGE; A BLUE-RED AND BLUE-YELLOW WILL GIVE A
QUIETER HUE, WHILE BROWN-REDS MAKE A MORE TERRACOTTA TONE.

Although, as explained above, mixing different tones of the two primaries, yellow and red, will give softer or deeper oranges, it is still the case that, because these two primaries are so strong in themselves, in a decorative context orange must be employed with care. This is probably why—although it has enjoyed short periods of favor over the years—orange has not been more widely chosen as an interior-decoration color. But today, once again, the color orange is being appreciated for what it is—a life-enhancing color that can bring light and warmth into rooms and evoke feelings of sunshine and fire and pleasure.

New subtle paint colors and paint techniques mean that the orange seen today is very different from the dead, almost neonlike color we associate with the 1960s. Perhaps the key to using orange successfully lies with the word itself. Unlike the names of other colors—red, for example, where one person might see deep cherry while another sees hot fire-engine—to most people, the word "orange" immediately summons up the bright, glowing, strong color of the eponymous citrus fruit. So perhaps instead of thinking about

opposite Bottom Perhaps one of the most obvious—and certainly one of the most successful—color combinations is orange and blue. As a couple, these two will rarely misfire. That said, the ratios of each must be considered with care, as they can easily overpower. In this cheering shower room, encouragement to get up and go in the morning is given with the bright orange tiles, emphasized by the soft blue of the tiles surrounding the shower as well as the blue door.

MAIN, ABOVE, AND BELOW In a relaxed and friendly room, tones of yellow and cream predominate, complemented by pale, polished wooden floors and furnishings and white walls. The calm colors are brought into relief by the single slash of color—an orange sliding partition that separates the bedroom from the living room. This room is a good example of orange used as an accent color: any more would simply be too much; any less, and the room could slide into the mundane.

how to use orange in a room, it would be easier to think first of other words that conjure up some of the many tones and shades that are also part of the vibrancy of pure orange. One could imagine, for example, the rich orange-brown tones of African earth; the almost-brown, textured feel of dark chrysanthemums; the flickering, fugitive tongues of a flame; the milky tones of orange icing, or the watery tones of orangeade. There are hues of orange, too, in other fruits and flowers, like ripe apricots and golden-orange plums, and richest of all, the juicy deep tones of red orange flesh; think, too, of fragile Iceland poppies, the delicate petals of Oriental poppies, and the autumnal fiery and russet tones of late summer dahlias.

With these images in mind, suddenly the range and scope of orange becomes apparent, and the numerous ways in which it might be used in the home can be explored to the full. And, once an idea of a

In earthy tones or tangerine bright, orange is the color of life—of light and warmth, of sun-filled days and roaring fires.

subtle tone or shade takes hold, the sophisticated paint techniques available today mean that the color can be applied, perhaps as a soft watery glaze or even in deep, rich enamellike layers.

But, however much you adore these new oranges, it is still important to choose carefully where to use them best in the home. Orange is far more suitable for some rooms than others; many people, for instance, would probably not care to have orange in a bedroom, however light in tone and whatever the shade. In the wrong light, it could either appear bilious and cold, or else far too strong and unforgiving. But orange in the dining room or kitchen, now that would be a different matter altogether. With its rich warm tones, orange would benefit the coldest kitchen and would make an already-warm room appear positively womblike. It works well, too, with many contemporary kitchen combinations, particularly those ubiquitous cooking and working surfaces, such as stainless steel, shiny

OPPOSITE INSETS A kitchen as warm as this would simply not look right with all its tools hidden away behind doors. Hung, propped, or stacked against the walls, their shapes and tones contrast with the deeptoned wall behind.

OPPOSITE MAIN There are no halfway measures here. This kitchen has been painted in unequivocal orange. Although the traditional flagstoned floors, old

wooden tables and counters, and enamel scales and pots and jugs all look very much at home, so equally do the professional range and broiler—more homelike here than industrial—fitted into the original stone fireplace.

ABOVE This clever color works just as well in a contemporary setting as it does in a more traditional and rural environment. Here the deep burnt orange background throws the kitchen

furnishings and appliances into sharp relief. The brushed-steel hood and shiny stainless-steel tools above the burners combine with the pale wooden cabinets and rough slate surround and countertop to give a clear contrast to the tones of walls.

RIGHT Even the simple kitchen faucet here looks striking against this strong contrast of textures and colors. Is there no end to orange's versatility?

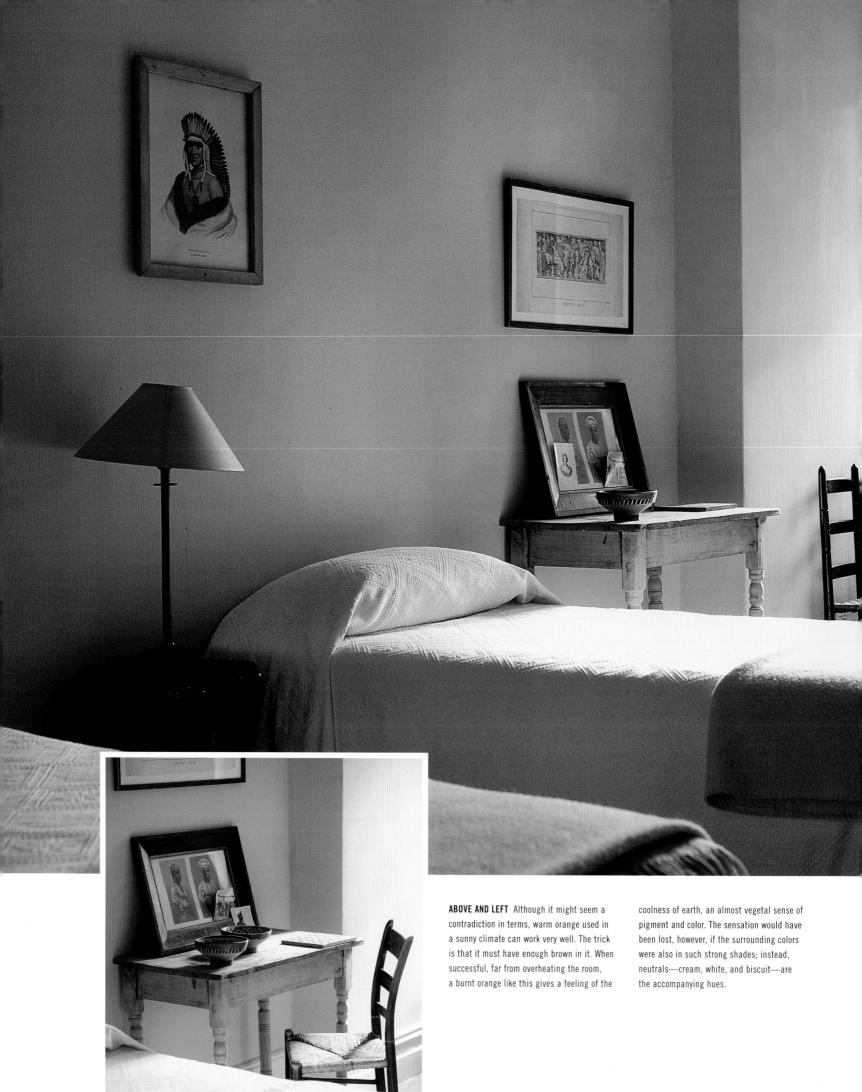

metal, rough slate, and bleached wood—they all appear in wonderfully sharp and edgy modern contrast to orange's rounded tones.

Orange dining rooms may, at first thought, seem to be a bit much, but actually, in its deeper, darker incarnation, orange can be about as good a dining color as you can hope to get. Consider the traditional reds used in eating rooms—they tended to contain a lot of brown, bringing them closer to terracotta. And a similar brown-orange will look as successful today. Many people like to eat by candlelight in the evening, and deep-orange walls will make the most of the candles' glow.

In a living room, too, although it might not be the color that is first thought of, orange can be just the thing to lighten and warm a coolly lit room, and will make a sunny room positively subtropical.

Surprisingly, remembering the decorative faux pas of the 1960s, orange is a very forgiving color: it can look deeply traditional, as well as boldly contemporary. The browns and reds of antique furniture, wood, and

Oranges that are melted down and whipped up with paler tones become the most useful and adaptable of colors.

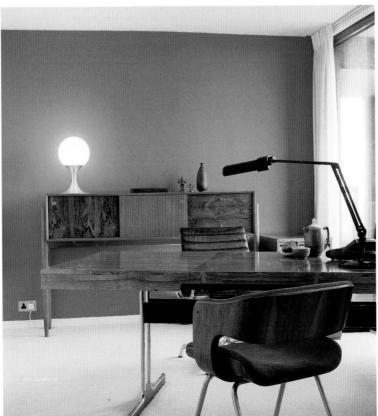

ABOVE AND LEFT In some situations, deep orange can be considered an over-stimulating color—too vigorous, almost. However, it can also be a color that encourages concentration and production. It is peaceful and calm, without being soporific and, in the same way that deep orange is successful in the kitchen, it can give a sense of purpose to a workroom. In this home office, for example, there are no disturbing contrasts—all the elements are chosen to work together in harmony. The palette is very much a combination of earth and fall colors and textures, with polished wood, dark-brown leather, and a neutral, natural floor covering that all harmonize perfectly with the walls. The overall effect is one of industry rather than stress.

THIS PAGE This Paris bedroom is the color of a basket of ripe apricots. On the walls is flat peach paint; behind the bed is an elaborate, embroidered headboard in pale tones of peach, green, and warm cream. The heavy luxury of a silk bed-cover in a color like a ripe melon adds even more richness to

a sybaritic scene. Although difficult to get right, these soft tones of pink-orange can be very effective when they are mixed with care. There should be no apology for unabashed femininity, and they work best with accents of slightly deeper pink-orange tones, like those of the pleated silk lampshade here.

brick complement it well, due to its affinity to the red-earth color used in traditional decorating, from ancient Pompeii to contemporary Tuscany. Orange has within it many of the tones of warm wood—from pine to mahogany—and, as such, is a color that can look very fitting in a room with paneling or a lot of wooden furniture, or in a room where a wood floor is dominant. Simply add an accent of bright red, perhaps in cushions or a rug. Orange also has the ability to warm a room that is paneled in very dark wood. And, surprisingly, this color can cool—with the addition of some white—a room that is overly yellow in feeling, one furnished with stripped pine and floored with pine boards, perhaps.

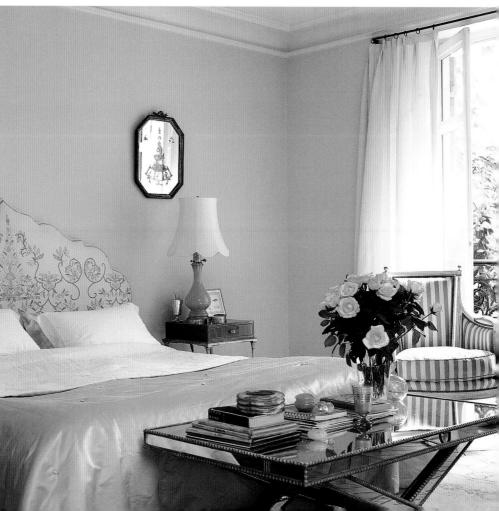

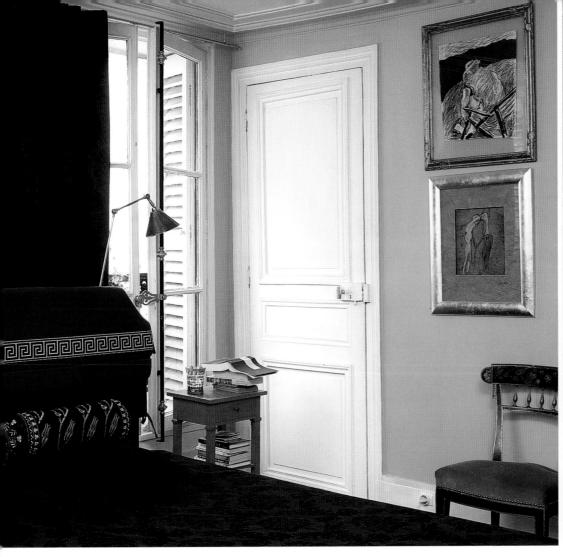

Orange, like its stronger sister red, also works well as an accent color, pointing out the merits of other colors within a scheme, such as various purples and mauves, as well as darkest green, gray-olive green, and warm flannel gray. Ideas for working with orange this way-like so many other color ideas for the home—can be lifted from the garden, where orange is used by garden designers to add sophisticated accents in a bed. Think of a late summer flowerbed: warm oranges, moving toward red and russet in hue, with touches of dark green, eggplant, and purple. Again like red, orange is used in the garden to lift other color schemes—particularly palettes of blue, and even some pinks; and oranges and russets mix well with purple-leaved shrubs, as well as with silver- or gray-leaved plants.

Learn from the ways in which nature uses oranges, from earthy brown tones to fiery hues, the soft apricots to the tangerine brights. The decorating world is, it could be said, your orange!

THIS PAGE Orange is again used in a bedroom, but this time in strong masculine contrast to the femininity illustrated opposite. Almost neoclassical in style and context, this room has deep flamecolored walls, which make a vibrant background for the groups of pictures set in bold, gold frames. Many of these pictures are matted on flannel gray, and in a subtle color-considerate touch, the fringed silk lampshade in front is also gray. There is deeper contrast, too, in the dark-blue self-patterned bed-cover and curtains, and the deep purple headboard with a Greek key design. An orange color scheme nearly always benefits from a shot of green-which can, and should, vary from cool to warm green, depending on which shade of orange is dominant. The upholstery on the chair provides the perfect accent.

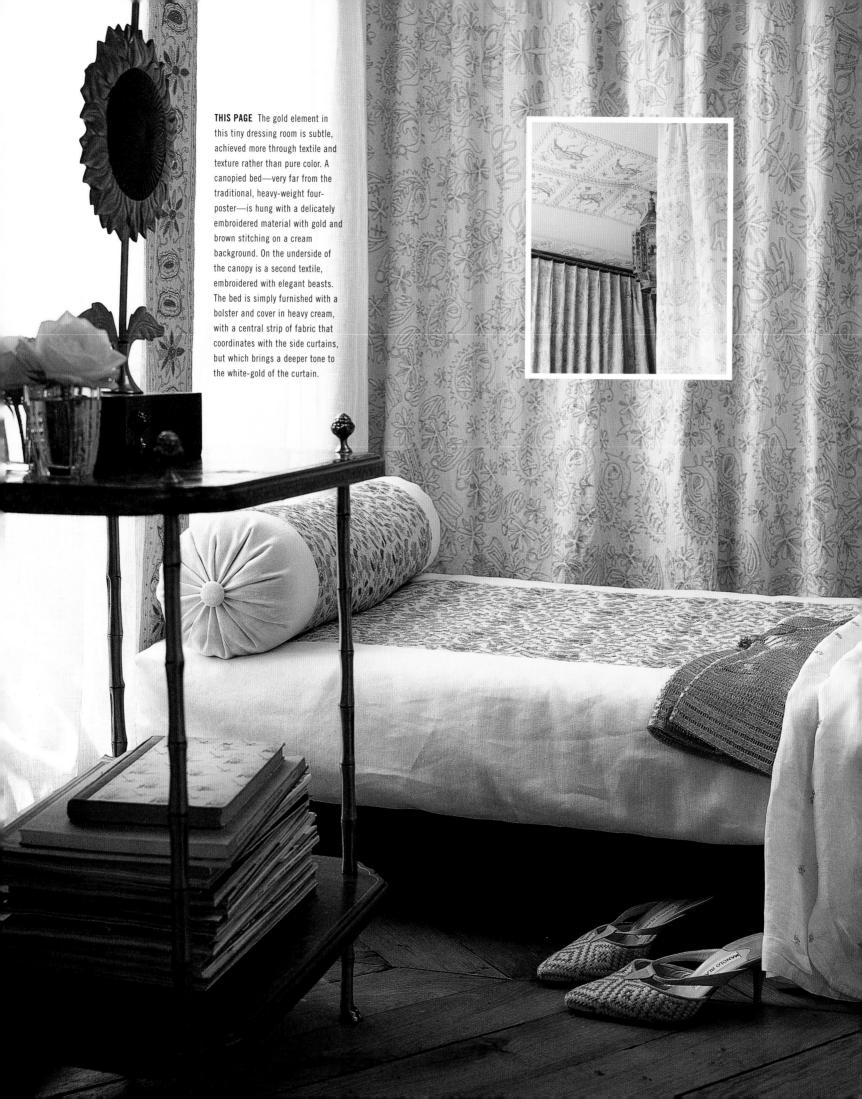

Golds

NOT ONLY HAS GOLD BEEN A COLOR OF ROMANTIC AND HISTORICAL SIGNIFICANCE IN ITS OWN RIGHT, IT HAS ALSO ALWAYS PLAYED AN IMPORTANT PART, IN DECORATIVE TERMS, IN ALLEVIATING THE STRENGTH AND BRIGHTNESS OF OTHER COLORS.

From medieval times to the present day, gold has been used to break up blocks of other color as well as outlining and underlining color combinations. Gold—even a fine line—gives a richness and depth to a scheme that cannot be achieved with other colors alone. An edging, a soft touch, highlights and gives an air of more or less subdued splendor in a room. Of course, gold can also be used resplendent in its solitary glory—fantastic in a receiving room or a dining room, where candlelight flickers against the burnished surface. In the eighteenth century, they understood the romantic, almost magical atmosphere engendered by gold. What often seems to us too much, when we look at carved and gilded furniture from the past, should be imagined as it was more usually seen then, lit by candlelight, with every surface twinkling and shimmering, caught in the wavering light. Use it thus today, in areas and arrangements where its magical subtlety can be appreciated and seen at its best.

THIS PAGE Even when gold is used subtly, it has an air of the exotic, and when it is displayed in all its glory—as it is here—it is breathtaking. In this Manhattan apartment, walls have been completely covered in gold leaf, which has immense depth of tone and a gleaming luster. Against this exotic background, artefacts and furniture of some strength are needed—and are supplied with a tribal carving on one wall and a simple, dramatic African bench with a jute-covered pillow on the other. There is not even the intrusion of a door frame; the door is practically invisible except for a brightly beaded key tassel-in keeping with the ethnic theme.

The best combinations of color—in no matter what color spectrum—have an element of surprise. This idea of a surprise is an important one. On entering a room you should think: how nice, how interesting—and how unusual!

In one sense, all colors should only be used in combination, for a single color on its own is meaningless, only acquiring meaning when it is juxtaposed with another color, however subtle the contrast. Our eye and brain respond to color relationships rather than to absolute color.

Most people know well enough what, in their wardrobe, goes with what. They know through trial and error that a certain sweater works better with one skirt than another, and which shoes work with which outfit. And the reason they know is because they devote some time to thinking about it—and they look carefully and truthfully. That is what you have to do when combining colors in interior decoration, too.

To continue with the wardrobe analogy: in the same way that just a touch of red, say in the shoes, might work with an otherwise

green ensemble, when you combine colors in a room, it is important to think about the proportions in which two or more colors should be combined. When you are going to combine colors on the walls, you probably try them on a piece of board to see how they look together. But remember that the relative size of the surfaces to be colored should also be taken into account—two chosen colors may look fine as small dabs, but if one is used over an entire wall and the other is merely covering the baseboard, the relationship may not work. Remember, too, that the changing light source also affects the tone of the color, which in turn affects what we see.

The most important thing, as with every aspect of interior decoration, is to think bold and to think broad—which is not, by the way, the same as harsh or strident.

OPPOSITE Milky-brown walls mixed with a little purple—a color sometimes called taupe—are gentle and welcoming. Hung against this warm background, above the wooden bench, are three perfectly placed paintings of subtly changing color painted by the owner, artist Andrew Wallace. The final effect is an essay in softtoned harmony.

PREVIOUS PAGE This apartment exhibits a brave contrast of bright color that works wonderfully. The tangerine and electric blue have been diffused with a wall of glass bricks and a translucent corrugated plastic screen, which serve to dilute any stridency the combination might have had.

A lesson in tone

THERE IS REALLY NO SUCH THING AS AN UNUSUAL COLOR SCHEME. EVERY COLOR SCHEME IS UNUSUAL IN THAT EACH IS INDIVIDUAL—A LIST OF THE COLORS USED SAYS NOTHING ABOUT THE SUBTLETIES OF A PARTICULAR COMBINATION. SUCCESSFUL SCHEMES WORK BECAUSE THE COLOR HAS BEEN CLEVERLY USED RATHER THAN CLEVERLY CHOSEN.

ABOVE AND BELOW In the bedroom, irregular horizontal bands of color are pulled together by the color used on the tall windows. The floor-to-ceiling frames have been painted pale gray-green, as have the paneled internal shutters and the woodwork beneath. The color is not cold—a small amount of yellow has been added, which acts as a

link between the woodwork and the yellow-toned colors of the walls. When several different colors are being used together in one room, it is very important to take into account what color the different areas of woodwork are to be and whether they will blend or contrast with the scheme. They do not all have to be the same.

There are some who understand better than others how to use color, and Lindsay Taylor's apartment represents a comprehensive course in lateral—as well as vertical—color thinking, in addition to providing a knowledgeable lesson in color combining. Her palette includes gray-blue, lilac, mint green, sun-faded terracotta, pale yellow, and ocher, and is used to fascinating effect.

The apartment is not a modern one and therefore benefits from high ceilings, large windows, and self-assured wooden frames to the windows and doors, as well as bold plaster ceiling cornices—all the sort of architectural detail that was common in the nineteenth century, but which is rarely found today in more modern spaces. These structural elements give an extra depth to her painting schemes, transforming the walls from flat canvases, as it were, into three-dimensional works.

It is not just that every room is painted in different imaginative and subtle color combinations, but even more interesting is the wit and imagination she has employed in the way that she has arranged the color on the walls. In the kitchen, for example, there are wide vertical panels of color—lilac, butternut squash, purple—

sometimes with a panel divided from the next by a straight edge, sometimes by an edge of waves.

In the bedroom, a more muted scheme uses wide—very wide—horizontal panels of color. From ground level, an ocher panel is mantelpiece height; then a central band of pale gray rises to envelop the picture molding; and, between that and the ceiling molding is a band of terracotta pink. Other woodwork is painted gray-green. Although complex, this palette, based on earth-toned colors, works together in a wonderfully soothing combination, conducive to sleep.

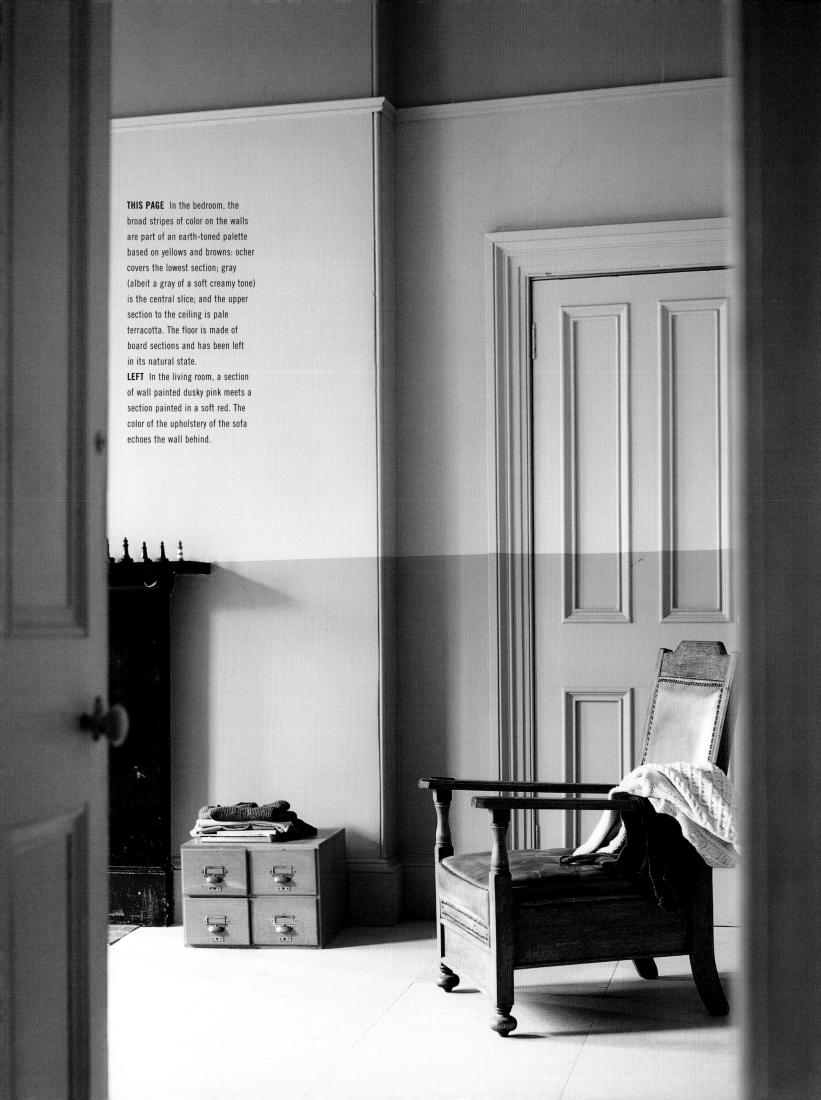

In the living room, aquamarine marches across one wall to the fireplace. The colors throughout the room are inspired by the earthy rich tones of India and Indian miniatures, so dusty pinks, soft reds, and saffron yellow are all included in the mix. At the fireplace the color changes to yellow. Yellow takes up the baton across the remainder of the wall, turning the corner onto the window wall where, two-thirds of the way across the window, yellow suddenly stops and a dusty pink takes over, sliding around the next corner to be met halfway across by a deeper soft red. The ceiling, its molding, and the upper section of the wall are all colored in the same pale lilac, and the sofa, which sits in front of the double pink wall, is covered in fabrics that exactly match the background. Grounding this quiet explosion of color is a carpet in a neutral gray—the "mouseback" shade endorsed

The contrasts do not—as you might expect—give a feeling of jumpy energy; rather they engender a sense of extreme relaxation, like a sunny June day.

ABOVE Once again, color lessons can be found in the natural world. The range of colors that have their base in yellow tones is, in nature, wide and rich, and can encourage us to combine them boldly. RIGHT In the kitchen-dining room, the walls have been painted with vertical bands of color, some of which look as if they have been attacked by a giant pair of pinking shears. The wavy edge was in fact hand-painted by the owner. The success of the lilac and vellow combination is due to the fact that both colors are of the same strength. Because these colors are so bright, the woodwork has been painted neutral cream.

by designer John Fowler, perhaps? The overall effect is soothing rather than jarring.

Another subtlety, that is not immediately apparent in the clever color ways of this apartment, is the fact that, although color is presented in the same way throughout the space—using wide connecting bands of different shades—each room is slightly different in its application. In the bedroom, the color is divided vertically, in the sitting room horizontally, and in the kitchen with humorous handpainted touches.

Lindsay Taylor's glorious apartment is one that should be studied carefully by all amateurs—and, indeed, experts—of color and interior decoration.

Seemingly so simple and understated as to be almost naïve, there are in fact enough clever and dynamic touches and ideas here to inspire even the most sophisticated of decorative artists.

LEFT The sunny aspect of this room is emphasized by the pink and yellow window wall. The handsome windows, as well as the shutters, are painted in three different colors, matching the horizontal stripes and vertical bands and blending into the total scheme.

BELOW A vertically striped wall—part aquamarine and part orange-toned yellow—meet above the fireplace, but not at the obvious halfway mark. A single, well-chosen bowl and the veined marble of the fireplace emphasize the color combination.

RIGHT Nothing in this corner has been left to chance, and all the features combine to produce a completely harmonious group. Not only are the colors of the chair soft, Irish-inspired, and heather-toned, but also the checks on the tweed act as an element of definition. The lichen gray-green of the wooden paneling is exactly right as a background. Nothing jars or is ill-at-ease—even the colored glasses on the side table pick up the moorland mood.

BELOW The truth of this color scheme is verified by seeing the real thing. In this attention to detail lies the success of the decorative plan. Texture and pattern are as important as the colors themselves in creating a harmonious—and believable—color palette taken from nature. Outside, rough is paired with smooth, soft with hard; texture is all-important, and it is essential to introduce that element to an interior color scheme.

Gaelic blend

NATURE ALMOST ALWAYS GETS IT RIGHT—THAT IS WHERE COLOR DESIGN STARTED, AFTER ALL. IN THIS PARIS APARTMENT THE COLORS OF AN IRISH MOOR ARE TRANSFERRED TO THE CITY WITH CHARM AND SUBTLETY.

To copy nature's color combinations is not to be undertaken in a slapdash manner; instead it requires application and study. "Subtlety" is the key word here—just throwing different shades together and hoping they will look like a wildflower meadow or a misty-toned moorland will rarely work. But in this apartment it works brilliantly, because its designer-owner has transferred the memories of her Irish heritage to a range of furniture and textiles and then combined them with Celtic inspiration. Lilacs, mauves, clover pinks, moss greens, lichen grays, and heather honeys are the textile colors; linens and tweeds, plaids and voiles are the textiles themselves; and all work together in the center of Paris just as they do on the moors. And, although the fabrics and colors work well on their own, what really pulls the look together are the soft, beguiling paint tones on the walls, all different, but still remaining within the moorland palette. The effect is overwhelmingly evocative.

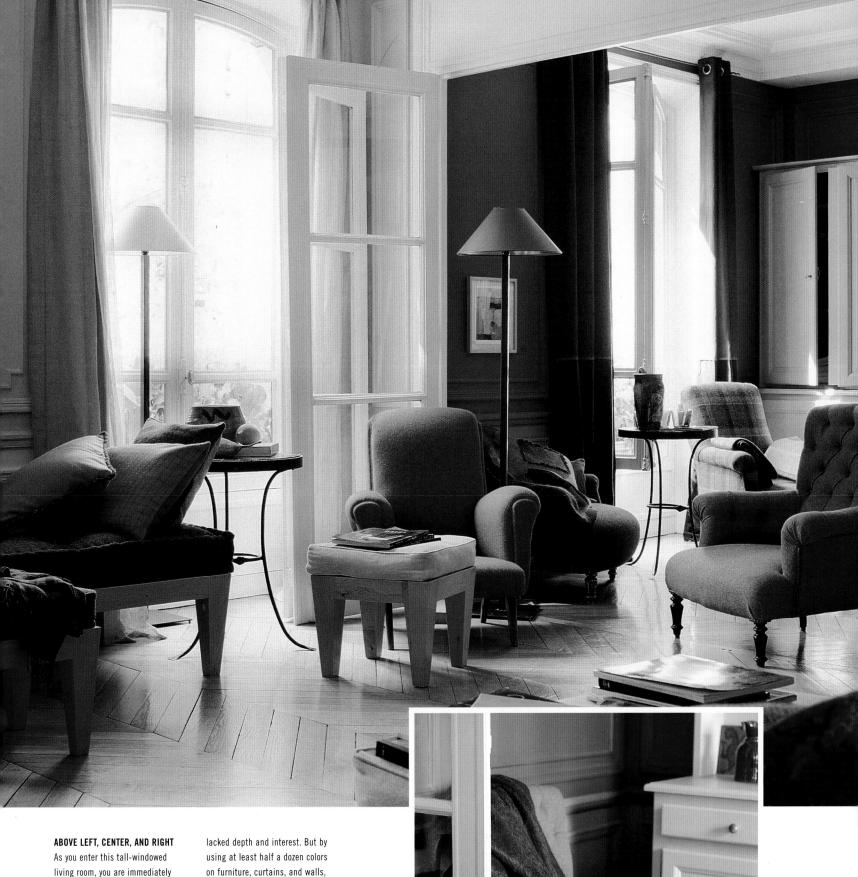

As you enter this tall-windowed living room, you are immediately transported far away to the traffic-free uplands. The whole picture shows that it is important to lavish color and to use a broad-based palette. If the colors used here had been limited to two or three of the heather tones, the room would have

using at least half a dozen colors on furniture, curtains, and walls, the eye remains interested and involved, and the desired harmony is achieved. If all the tones are taken from one palette, even if they are used in deeper strengths, then they can all be mixed with abandon and added to at will.

ABOVE AND ABOVE LEFT Against

a white wall, a series of seemingly randomly placed niches have been cut into the plaster and painted in different and contrasting tones, from soft white to deep chocolate. In each space a small simple object is displayed. It is a simple but ingenious idea that both breaks up a large area of wall, as well as becoming a focal point of real decorative interest.

LEFT In the foreground, in front of the white wall, a slate-topped dining table is partnered by chairs upholstered in lilac. The colors sit comfortably together without sharp contrast. The wall that leads away from the dining area is colored deep mushroom brown.

Nearly neutrals

ALTHOUGH PERHAPS THE MOST ESSENTIAL CHARACTERISTIC OF A NO-COLOR OR NEUTRAL SCHEME IS THAT THE FINAL LOOK SHOULD BE WARM AND RICH AND TEXTURAL, THESE RATHER NEBULOUS QUALITIES ARE PROBABLY THE MOST DIFFICULT TO ACHIEVE. THE DESIRED EFFECT MUST BE INTERNATIONAL JET SET, NOT INSTITUTIONAL WET SET.

LEFT Texture is used to avoid any suggestion of monotony: an armchair is upholstered in heavy white, dressed with a soft, gray mohair throw, to which is added the luxury of a striped fur pillow.

BELOW A seating area, with large cushions in differing tones of brown, is arranged beneath a series of wall panels that range from milk chocolate brown to taupe, and pale eggplant to palest lilac.

No-color colors—boringly known as neutrals, a term that gives no hint of their richness and diversity—are colors that are most associated with the natural world, like stone, sand, and pebbles, biscuit, mushrooms, wheat, and ivory, mole and mouse. They generally stem from brown or gray, and the variations are infinite.

As a rule, grays are cool neutrals and browns warm neutrals, the luminosity of the former being higher than that of the latter. A pearly gray compounded with a brilliant white is far more lively and luminous than a brown in which there is not enough yellow.

Neutrals are much affected by the light around them, so each must be considered in its own right. Texture is also important when no-color colors are used—matt surfaces should be paired with shiny, rough with smooth, soft with hard. These differences are important because a room decorated in neutral tones should glow and shine, each surface both complimenting as well as complementing the others.

However, texture alone is not enough. Even the warmest neutral scheme really needs a dash of color in its life: something sharp, bright, and strong that will bring the scheme to life; for unrelenting neutral tones do run the risk of arriving at insipidity rather than the desired elan.

The apartment seen here is not large—in fact, it is small and the choice of neutrals is the right one, since they expand the space in a subtle way. Although they may be allowed to predominate in a scheme, neutrals should not be all-prevailing. The neutral color palette here includes soft gray, gray-lilac, and mushroom with, where appropriate, some deeper shades within the same palette, like eggplant,

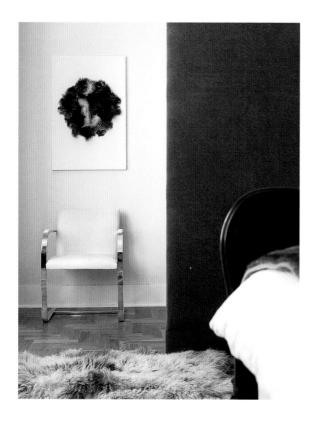

THIS PAGE The sleeping area is surprising and pleasing in its conjunction of comfort with rigorous color principles. At the foot of the bed and against pale lilac walls and cream woodwork is a gray

velvet upholstered board that conceals a clothesrod. A dark-wood antique bed on an oak parquet floor contrasts with the pale lilac walls. Sheer curtains of a gray-silver weave diffuse the natural light.

chocolate brown, and slate. These darker, stronger shades emphasize the appealing pallor of the lighter neutrals. Note that the stronger colors are not contrasting; they are all darker shades of their paler cousins, which is why the overall effect is so happy.

There should always be a touch of color somewhere within a neutral palette.

The planes of soft color are used to extend the eye and to suggest volume and area where none exist. They work also to direct the eye elsewhere— around a corner perhaps, toward a new point of interest. Incidentally, decorative clutter is also kept to a minimum, and a clever and practical idea, which keeps flat surfaces free

as well as adding decorative interest, is the display alcoves of different sizes cut into one wall. Painting some alcoves in contrasting, dark colors, all within a brown palette, makes a further strong decorative statement.

In the living room, floorboards are painted dark, gloss brown, which, with its hint of purple, looks warm rather than institutional. Painted floorboards are a useful way of bringing color into a room, but the choice of the color itself should be carefully considered. Stay away from any color or finish that smacks of institutional working or living spaces.

Once again, texture is cleverly used: a screen in the bedroom, rather than being painted, has been upholstered in gray velvet. A table top is made of slate instead of wood; a pale armchair has a mohair throw in gray as well as a warm fur throw pillow. All these touches add warmth and personality to this sophisticated color blend.

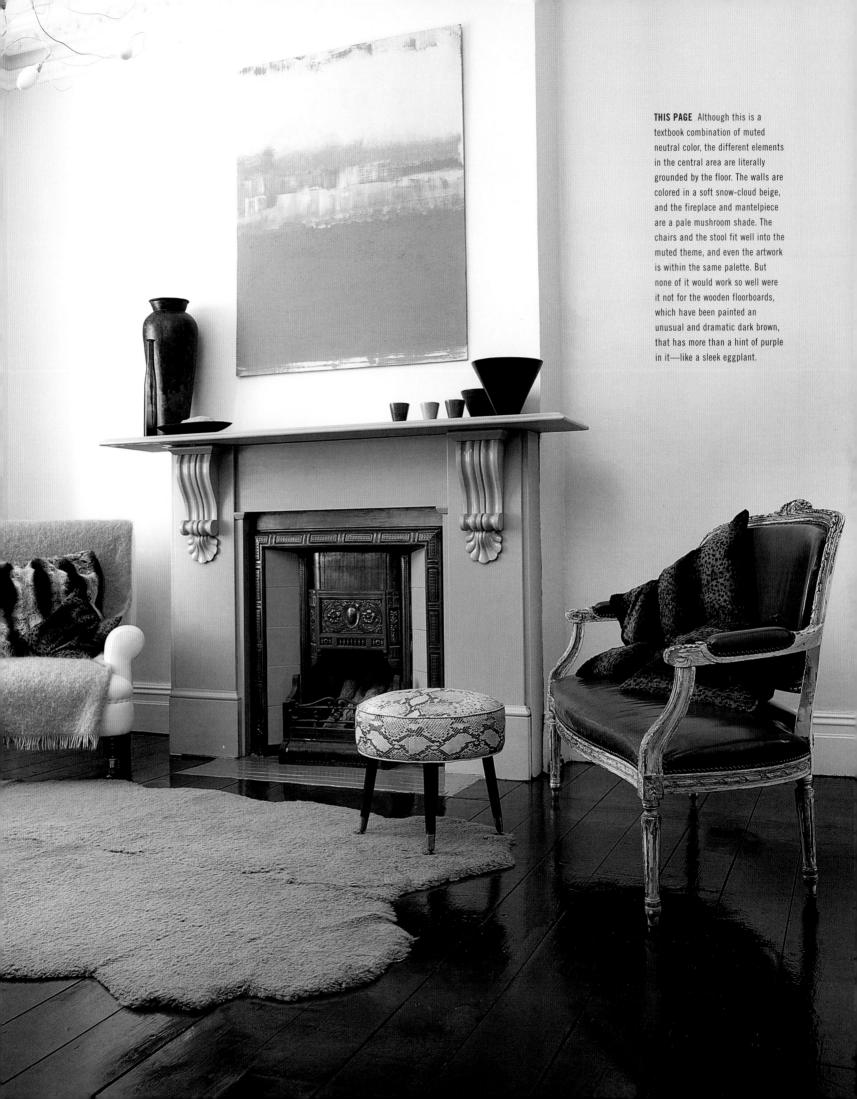

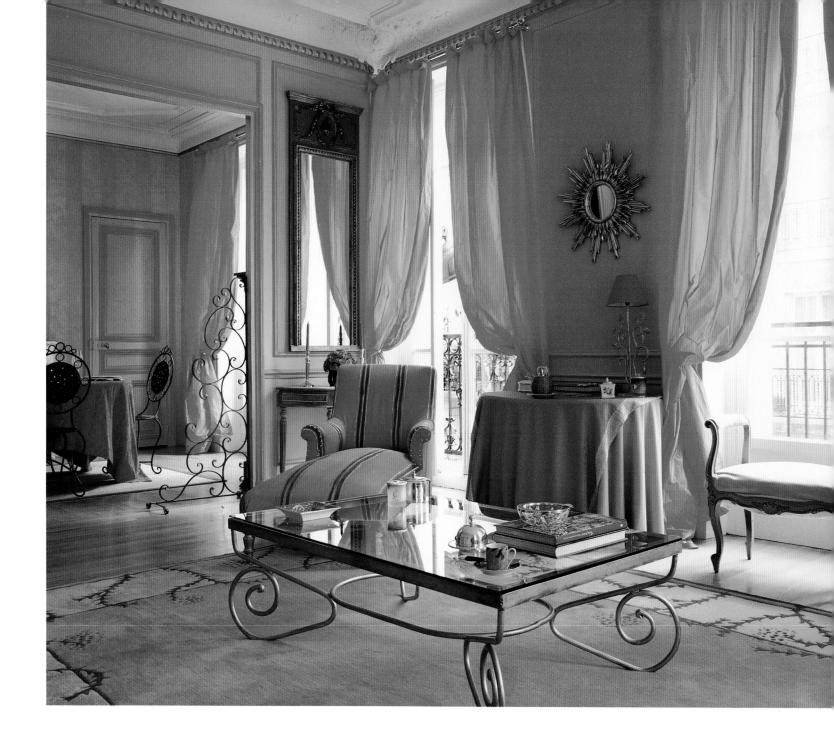

Harmonious hues

A LARGE SPACE, BLESSED WITH NATURAL LIGHT, CAN TAKE A MORE DRAMATIC AND CONFIDENT USE OF COLOR THAN A SMALL ONE. AN EFFECTIVE TREATMENT IN SUCH A ROOM IS TO COMBINE MANY HUES, EACH WITHIN THE SAME COLOR RANGE AND OF SIMILAR STRENGTH AND TONE, YET EACH SLIGHTLY DIFFERENT FROM THE NEXT.

Although, in theory, any range of any color could be used in a generously proportioned, well-lit room, the fact is that care must be taken not to choose a tone that is too much of anything—too bright, too dark, too strong, or too light. Dark shades, for example, have the effect of seeming to make walls recede, so in a large room too dark a tone would make the room seem as if it were the interior of an endless cavern; equally, too vivid a color—bright purple or the brightest of oranges—would be too strong, without respite, and too difficult to live with. It is, as always, a question of appropriateness.

OPPOSITE Pink, unlike red, is a feminine color; it gives a feeling of light, warmth, and welcome, but it requires confidence to allow pink to predominate in a room. Harmony is essential: of color, of line, and of texture. Here the tone is just right. This room is not painted in solid, flat color. Everywhere there are variations on a colored and textured theme. On the living-room walls, for

example, paneling is used to make a point: within the panel there is one tone of pink, the panel molding is itself a brighter pink, and the wall on the other side of the molding is a softer coral-tinted pink, which has been dragged. The curtains also add a textural contrast, made as they are in unlined pink silk, which filters and diffuses the light.

When combining hues from the same section of the color wheel, success comes if the majority of the colors are of the same strength—that is, if each one has the same amount of white in it, since the eye accepts with ease colors that have the same amount of tonality. This not only works when you are trying to use different colors in one range; it also works when you are using colors that are in contrast to each other—like yellow and blue, for example. As long as they are the same strength—that is to say, neither one is much deeper nor much paler than the other, and both are warm or cold—they will tend to work together.

That said, schemes using hues of one color family rarely work well unless there is one shade within that scheme that is deeper and stronger than the others, even though it is in the same color range. It is as if that one slightly discordant note ties everything together. Often it need only be a single line of color: a painted dado rail—real or trompe l'oeil—or a raised molding on a shutter or door panel; no matter how seemingly insignificant, it has an influence beyond its presence. This effect is demonstrated in this Paris apartment, where shades from pink through coral to orange are brought to heel by the clever use of gilding.

THIS PAGE In the dining room of designer Geraldine Prieur's Paris apartment, the walls are washed in dusty pink with overlaid washed stripes of pale melon. The bureau is painted soft peach, and the ornate gold chandelier above has soft pink shades. On the bureau is a selection from the line of ceramics and glassware designed by Geraldine Prieur, combining gold and berry pink—a theme echoed throughout the apartment. It has all been done with a lightness of touch that is essential when one color is dominant.

Complementary clash

COMPLEMENTARY COLORS ARE ALWAYS INTERESTING WHEN USED TOGETHER, ALTHOUGH IT IS IMPORTANT TO GET THE PROPORTIONS RIGHT, WITH NOT TOO MUCH OR TOO LITTLE OF EACH. HERE, ORANGE AND BLUE ARE CUT WITH A TELLING DASH OF PINK.

ABOVE Orange and blue are contrasted but also diluted by the plywood work surface, as well as by the multicolored mosaic tiles.

RIGHT The kitchen area of this apartment is designed with curves and color; an undulating work surface of polished plywood has bright orange cabinets beneath and angular orange open shelves above. Behind the counter is a panel of mosaic in assorted blues, and above that is a wall in blue—the signature color of the apartment.

In the days when clean white cotton gloves were de rigueur and hats were worn with the shoes that matched the handbag, there was a rather cruel fashion dictum on color which extolled the combination of pink and navy as being "the plain girl's last hope"—meaning, one presumes, that the combination was always, and in any circumstance, a flattering one.

As in fashion, so in life, and in this open-plan city apartment, pink and deep blue—the navy of today—as well as orange, are used in combination with other structural and visual elements to define and shape the space.

Although at first sight the liberal use of color seems almost indiscriminate, there are clearly defined color stories throughout the apartment. First is the relationship between blue and orange, which, as they are complementary colors on the color wheel, will always work together and emphasize each other—although to achieve success it is important to use such definite colors in equal strengths, as has been done here. Next, and just as important, is the use of soft pink—first, as we mentioned above, in its role as a harmonious partner for deep blue, and second, playing its part in a subtle, familial combination with orange. This shade of pink is also used in

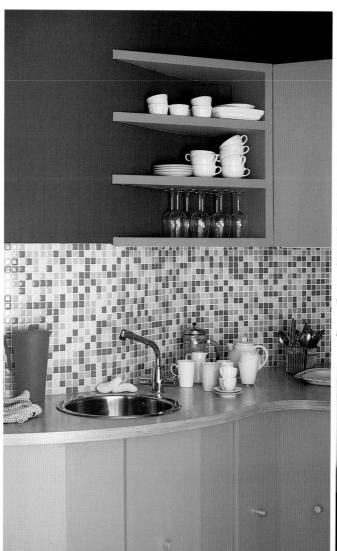

136 colors in combination

LEFT In the eating area, the clover-pink wall in the kitchen is echoed in the surface of the table, which links the two areas. The wall of clear glass bricks that runs beside the table is studded—seemingly at random—with bricks of blue glass. This wall plays an important part in the overall design of the apartment since it diffuses the bright colors and gives them a necessary subtlety.

ABOVE This overview of the living area of the apartment and the kitchen beyond shows the way the colors are combined and contrasted. When colors as dominant as these are used in such close combination, it is important that other details and elements are refined to an almost spartan simplicity. The curved partition wall is unadorned, and the floor is almost industrial in appearance.

its pale entirety in the soothing bedroom, where it is simply combined with white.

Perhaps more important than either the orange or the pink is the blue: bright but deep, welcoming but sophisticated, it is used as an architectural tool to give solidity to a curved wall, as decorative punctuation on chairs and accessories, and as a unifying element set as random insets in the otherwise clear glass wall, as well as in the mosaic tiles that figure in both the kitchen and bathroom. The clarity and strength of the ubiquitous blue is both emphasized and

The painted curves, the architectural curves, and even the curves of the moulded chairs, add fluidity to the whole painterly effect.

OPPOSITE The far side of the living area with a view into the bathroom beyond, partly hidden by a sliding door. Again, all the colors, although so bright and strong, work together as a composition. The bathroom, in an echo of the wall of glass bricks, has a wall of opaque corrugated plastic mirrored in the panels surrounding the bathtub.

LEFT A detail of the curved design and the contrasting blues of the apartment's dividing wall which

masks the kitchen.

complemented by the rubber floor, which is powder blue with a quiet sheen—soft enough to work with the very pale pink of the bedroom, it is modern enough to act as a foil for the strongest of blues, and subtle enough to put the orange firmly in its place.

Comparing or referring a designer's architectural use of color with the work of the late Mexican architect Luis Barragán is almost now a design cliché, but in truth Barragán's use of clear, bright color as an architectural tool is, in this apartment, acknowledged. A sliding door is painted bright orange, a curved wall in strong blues. Like some giant contemporary canvas, the colors constantly carry the eye from one area to another. It is worth pointing out that although the colors here have been used with such exuberance and, indeed, flamboyance, great discipline has been shown in any extra decoration. All accessories are limited to a strict palette of blue, white, and chrome, and it is this attention to detail that insures the success of such a strong scheme.

The way that light has been employed in this apartment is also very important. Throughout the space, the natural light is diffused—first with a wall of glass bricks, and second with an internal wall of clear corrugated plastic between the bathroom and bedroom. Light is softened and reflected. Every color benefits, taking on a warm soft hue that would not necessarily be apparent in the cool northern light.

LEFT A further view into the bathroom shows that the wall opposite the plastic screen is also covered with mosaic tiling—appropriate and practical for a bathroom, but also serving as a visual link with the other parts of the apartment; particularly the kitchen, which has the same tiling

for the splashback and the glass wall inset with blue bricks.

Although the use of strong color throughout this apartment is daring, it is also extremely disciplined—no other colors are allowed to intrude into the scheme, nor are there any irrelevant details of any description.

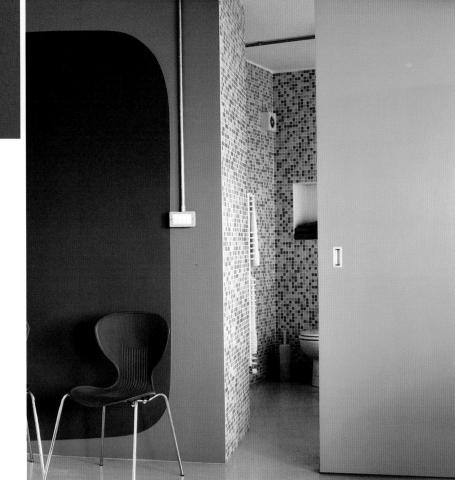

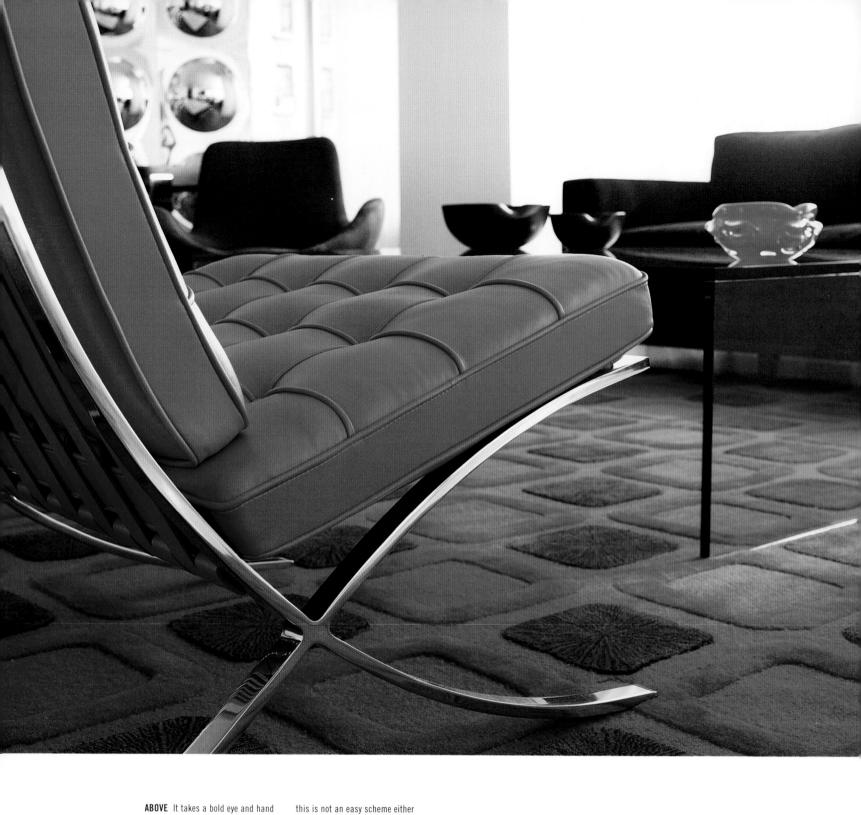

to use red on red like this, broken only by the glimmer of the chrome, the depth of the black and the brilliance of the white. Once again, strong color must be arranged and selected with the utmost discipline, without any outside distraction. It must be said that, for many,

to emulate or to live with.

RIGHT The coffee table is made from three simple pieces of clear glass so it does not offer any distraction from the dominant color theme, and its only decoration are three bowls—in black and red, naturally.

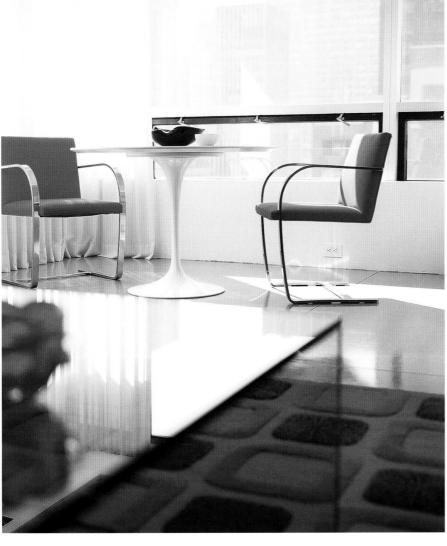

Twentieth-century tone

ALTHOUGH IT IS NOT EASY TO DO SUCCESSFULLY. WHEN IT IS EXECUTED WITH AS MUCH PANACHE AS HAS BEEN USED IN THIS LIGHT-FILLED MANHATTAN APARTMENT, RED AND BLACK AND WHITE, FILLETED WITH SLIVERS OF SILVER, IS POSSIBLY ONE OF THE MOST EXCITING COLOR COMBINATIONS IN CONTEMPORARY INTERIOR DECORATION.

ABOVE LEFT Contrast of texture is an important—indeed, a vital theme in this dramatic apartment. The raised motifs on the thick, red rug not only contrast with the cool, glossy furniture and floor surface, they also add a vital warmth to what could otherwise be a rather chilly atmosphere.

ABOVE RIGHT The cool shiny surfaces are an admirable foil for the sculptural lines of the pieces of twentieth-century furnishing classics-as well as for the elegantly beribboned dog!

The three primary colors are, as every good schoolchild knows, red, yellow, and blue; by definition, they are pure colors—the brightest and when mixed together in pairs they can produce three other colors: the secondary ones of purple, orange, and green. In principle, the three primaries, with the addition of the all-important black and white, can make up every color that there is. This educational preamble serves to emphasize the point that these pure colors, because of their intensity, should be used with relative caution and skill in interior decoration.

Of all the primaries, it is red that is the most challenging. Red has an intensity that can swing from welcome to war in a moment. It is an exciting colorfor some, perhaps too exciting. When you use red decoratively, it can either be diluted and pared down, or used at full strength, although there are not many who have the confidence to use red in this manner. However, John Barman, American interior designer and owner of this Manhattan apartment, is one who has no such qualms.

The vast living and dining area in Barman's apartment—measuring 26 x 32 feet (8 x 10 metres) is surrounded by huge windows that flood the space in natural light. An area as large as this, and filled with windows, is, in fact, one of the few decorative situations where bright and strong colors can be used together with impunity. Red, black, and white, which would be overpowering together in a space of more modest dimensions, are uplifting and energizing here. The sharp splashes of brightest red come mainly from

White is offset by touches of black and positively vibrates with the red, giving an instant feeling of pleasure.

the iconic pieces of twentieth-century furniture that John Barman collects. Eames, Saarinen, Mies van der Rohe—examples of their work are to be found throughout the apartment, where they thrive through being displayed in so simple a style.

In medieval decoration—those brilliant flights of contained fancy that covered the walls and ceilings of Gothic buildings—bright colors such as red were either painted on, or separated from, other colors by areas of black or white. John Barman has taken this principle and used it to great contemporary effect in this high-flown setting. For him, white is not a neutral shade, but a color in its own right; although it is so often mistakenly used as a safe no-color color, white is actually far harder to live up to than a more forgiving off-white such as cream, ivory, bone, or stone. Pure white looks best as part of a very positive color plan; it needs a setting of drama and style, so if you are frightened of color, don't even think about using it.

The other important aspect of this apartment is the way that texture has been employed: the strength of the various reds is made more acceptable to the eye by the fact that they are all in different finishes.

Leather, cloth, glass and woven wool all add depth and interest to the scheme, which would not be there were the color presented at one simple level.

More texture of a different nature is provided by the surface of the multidimensional 1970s screen with its slightly disquieting design of mirrored hemispheres, and the floor made from poured concrete which has been polished. As they quietly shine, both these elements—coupled with glimmers of chrome and stainless steel—all add a light-reflective quality to the entire scheme.

This Manhattan apartment is a hymn in praise of the pleasures of seemingly obvious, but nonetheless dramatic and striking, twentieth-century color combinations. These are emphasized by classic pieces of furniture that could stand alone as sculptural pieces.

OPPOSITE TOP The spectators of this dramatic Park Avenue vista can enjoy the experience seated on chromeand-red chairs around a 1950s white circular table by Eero Saarinen. Even the urban landscape seems

specially designed to complement the scheme. No other decorative accessories are necessary.

OPPOSITE BELOW The silver-coated screen with its mirrored hemispheres provides more than enough decoration and color for this area of the apartment. Dark-gray upholstered chairs sit in quiet contrast.

BELOW It is interesting that, although everything in this room exudes self-confidence, each element works well together with the next: the red wool rug from the 1970s

complements the red leather chairs designed by Mies van der Rohe in 1929, while the black sofa and the smoked-glass coffee table cool the hot color combinations.

Accessories are also in period—mid-twentieth-century collectors' pieces of glass and ceramic that confirm the room's iconic status.

ABOVE Even the bookshelves in this apartment are incorporated into the warm blend of colors.

This shelf, which is used to display a collection of classically modern Keith Murray ceramics, has been painted rusty orange and stands against a dark-brown wall, the tone of which has been taken from

the color palette featured on the wall of broad stripes.

BELOW In the living room, continuing the theme of seasonal colors, the curtains are made in two separate shades of green—one of deep olive and one of paler lime. A light lime-colored lamp highlights the contrast.

Autumn light

ALTHOUGH CLEVER COLOR COMBINATIONS CAN BE ACHIEVED BY USING CONTRASTING COLORS, THEY CAN ALSO BE REALIZED WHEN DIFFERENT TONES FROM THE SAME COLOR RANGE ARE COMBINED, AS ILLUSTRATED IN THIS DARING, YET SUBTLE, SCHEME.

When done well, combinations based on different tones of one color can go far beyond simple, graded tints to become a symphony of colors that harmonize with and subtly complement each other.

This apartment in the Scottish city of Glasgow is lucky to have huge windows, and the owner took the exciting and rather brave decision to take advantage of so much natural light and to use color that in less confident hands might have been thought of as too dark and light-absorbing.

In the living area, over one wall, wide, horizontal bands of deep rich color are painted—five different colors in actuality: pumpkin orange, gloss black, slate, chocolate, and gloss

burgundy, the inspiration for the particular shades coming from the pages of an enamel and car-paint catalog. Dark and darker, each is different but with underlying similarities; each shade imperceptibly merges into the next without drama. There are no strong contrasts and, though immensely sophisticated, the arrangement gives a warm, comfortable sensation, the overall impression being that of a rich patterned velvet—designed by Fortuny perhaps.

These are the colors of fall and winter, of earth and harvests—think of eggplant, hazelnuts, and Chinese lanterns. All the shades have black or brown as the underlying color, and

RIGHT The long wall in the living room has been painted with generously proportioned, very wide horizontal bands of striking dark, rich color. The general rule when using colors in a room—but especially when using dark colors—is that the darker colors should be closest to floor level, with the brighter, lighter colors closest to the ceiling. Although here each color is different, there is a tonal harmony between them that overrides any contrasts.

although they are satisfying together, they need, in order to stand out, a sharp accent to provide contrast and bite. This has been achieved by using orange as the color nearest the ceiling. The intelligent positioning of this broad, bright band carries the eye up and opens out the room.

The width of the different bands of color is important—too narrow would be overly busy and would distract the eye from the overall effect. The greater the expanse of wall, the wider the bands of color should be. It is, as so often, a question of proportion, for it is that which gives harmony to a scheme.

If you want to combine colors as closely in tune as these are, then texture and finish are the elements that will make the difference between the boring and the breathtaking. Were all these colors to be applied in the same finish—flat or high gloss, for example—the result would be very different, and not pleasing to the eye. But instead, the difference in finish supplies contrasting texture and adds a tension between the colors as the eye travels from glossy to matt as well as from one subtle tone to another. At the tall wide windows, the curtains are green in two different shades—one olive toned, one lime—thus continuing the idea of tone on tone running through the whole space.

Such a definite color statement needs decorative details that do not detract from the subtle whole, and any accessories must be carefully chosen. Here it is simple design in the form of a twentieth-century ceramic collection in sculptural shapes, many of them designed by Keith Murray, known for the clean lines of his designs.

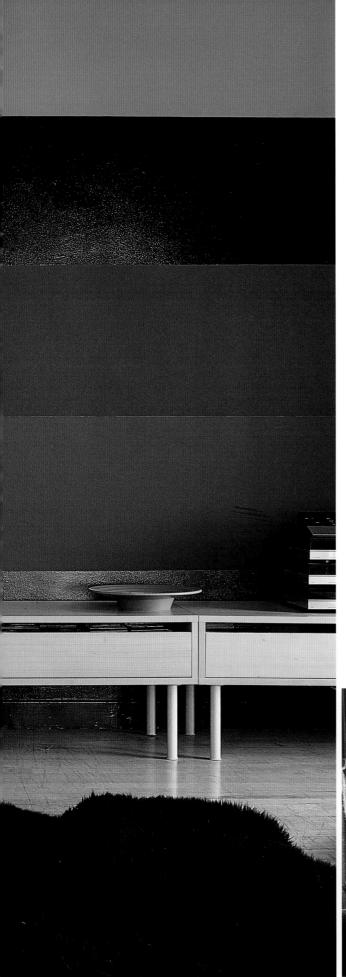

LEFT The broad stripes of color on the wall, the low long wooden unit, the clean lines of the twentiethcentury ceramics, and the polished wooden floor all combine to make a most dramatic setting. Many people would have been content with using subtle colors and shapes in this manner, but there are two further touches that take this color feast an inspiration farther. One is the visual surprise of having such a bright band of clear orange immediately below the ceiling; the other is the constant contrast in texture and finishfrom flat matt to shiny gloss and metallic luster, the eye is constantly taken by surprise.

Throughout the apartment nothing jars; the colors change, merging from one into the next, but the palette remains the same.

ABOVE Forget the advice always to paint hallways in bright welcoming colors—this hall is dramatic and mysterious ... and painted flat black. Even more perverse, the woodwork is painted in a glossy black finish rather than the more usual contrasting color. But there is another unusual aspect to this flat-black scheme—the paint is made for blackboards, and as such has a practical as well as a decorative aspect.

LEFT Not only the walls but also the windows are graded in bands of color; behind the dark-toned sofa are hung curtains made in two different shades of green—olive and lime.

Soft simplicity

THE ARTS AND CRAFTS MOVEMENT AROSE, TOWARD THE END OF THE NINETEENTH CENTURY, FROM A DESIRE BY DESIGNERS AND ARTISTS TO RETURN TO WHAT WAS SEEN AS THE PURE AND THE REAL, AWAY FROM THE OVER-PRODUCED HODGE-PODGE OF VICTORIAN TASTE.

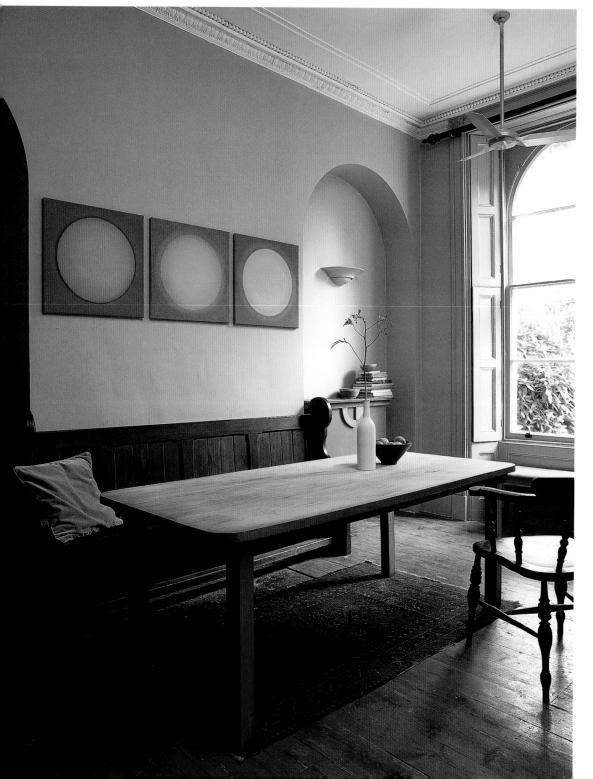

The designers and artists who followed Arts and Crafts principles promoted, as well as a much simpler style of design, a completely new field of soft deep colors, very far from the garish hues produced with the chemical pigments so loved by the Victorians. These were colors that seemed to come from the woods and fields. They included a deep sage green, a dark red, a teal blue, and a brownish purple, often combined with black.

Andrew Wallace is an artist, and in his London apartment many of the colors, as well as some of the internal architecture, are reminiscent of the Arts and Crafts movement, crossed perhaps with the tones of a seventeenth-century Dutch painting, as well as the colors the nineteenth-century Shakers developed from natural pigments. The result in Wallace's capable hands is one of naturalness of tone, of an

ABOVE LEFT Every room is a palette of muted harmonies. These soft, almost rubbed, colors slide easily from room to room—here the soft blue-pink walls, framed with gray-blue woodwork, merge easily into the pale yellow walls and sage-green wood of the kitchen.

LEFT A color that is almost indescribable covers the walls—the color of a fading lilac flower perhaps, or of chocolate milk. Many would have used a bright color on the woodwork, but the pale blue-gray tones that Andrew Wallace has used to outline the windows are far more subtle.

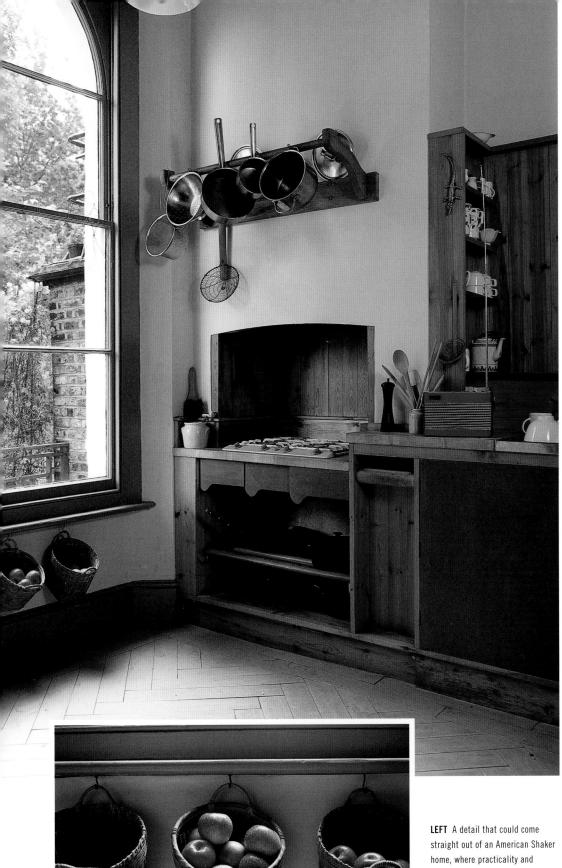

LEFT A detail that could come straight out of an American Shaker home, where practicality and function—beauty through simplicity with no unnecessary ornament—were the aims, and colors were made from natural ingredients. These baskets, used as instant storage and hung by hooks from the low windowsill, become decoration in its purest form. The

earthy quality, and a softness of hue. Throughout the apartment there are unexpected color combinations. Wallace's colors are cool, and in each of them—even the yellow—there is a hint, a touch, even the faintest idea, of blue or gray. This color connection means that all the combinations work perfectly, contrasting but never clashing. Nothing is glossy or glittery; everything, whether woodwork or walls, is flat and soft, often giving an almost velvety appearance.

A color has little or no meaning on its own. It is only when it is set against another color or colors, when thought has been given as to how the different shades or hues will work together, that you produce a scheme with any depth. When using color in a relatively small space, it is vital that harmony is present, that each area, each room, links with what is around it, as well as the color of the adjoining space. Here, even the varying colors of the woodwork in each room are carefully chosen to act as a frame for other colors present, working together with an indefinable charm. It is a lesson in using color. But then, from an artist, you would expect nothing less.

glow of the red apples highlights and emphasizes the flat tones surrounding the baskets.

ABOVE Rubbed maize-yellow walls are a background for watered Wedgwood windows and sage-green cupboards, and the stripped, original parquet floor becomes part of the same soft palette. Every surface is powdered and soft, except the polished pots and pans.

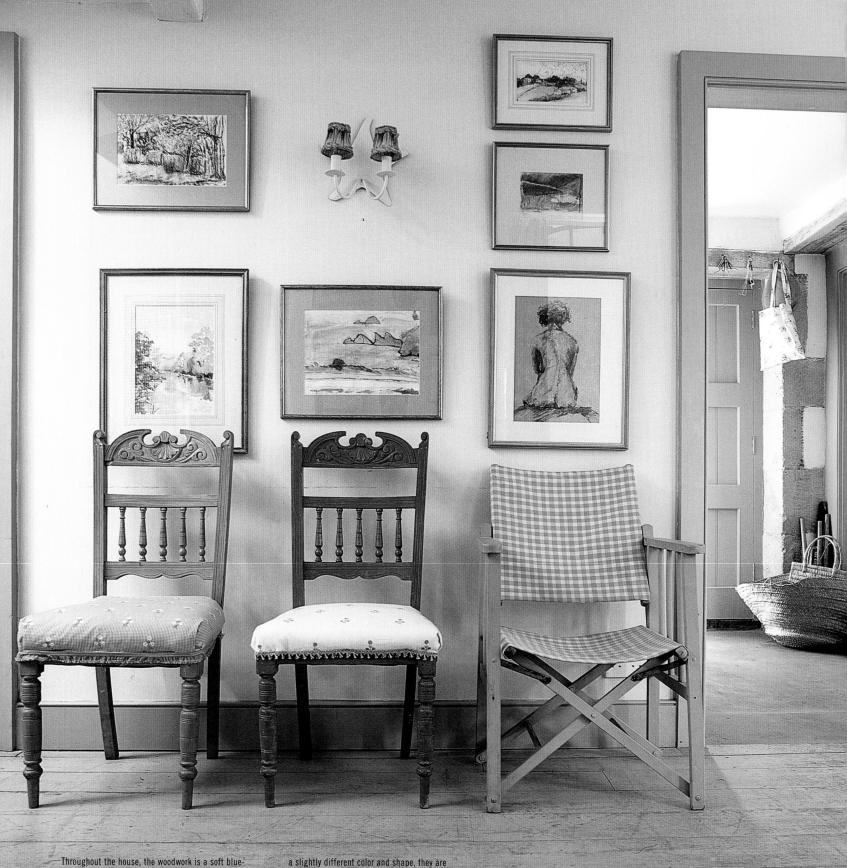

Throughout the house, the woodwork is a soft bluegreen, sometimes combined with blue and sometimes with yellow. In the central half, three wooden chairs sit, like a group of sunbathers. The arrangement looks informal, but is actually carefully worked out. Each a slightly different color and shape, they are transformed into a group with the aid of the pictures arranged above them on a yellow wall. The woodwork echoes the color of the chairs and again pulls the seating together.

Ice-cream cool

LIKE ITALIAN ICE CREAM, ALL THE COLORS IN THIS COUNTRY HOUSE LOOK AS IF THEY SHOULD BE SCOOPED OUT OF TUBS AND OFFERED IN CONES. AND IN EACH GROUPING, AMONG THE COOL, PALE COLORS, THERE IS ALWAYS A DASH OF ASTRINGENCY—A SLIGHTLY SHARPER TONE.

Although it is not always considered, appropriateness—the sense of place—is all-important in choosing which colors to use in a house. No matter how perfectly conceived the scheme, how sympathetic the colors, or how carefully chosen the tints and shades, if the color combinations and finishes are not sympathetic to the architecture, the scheme will fail miserably. In this pretty, converted cow barn in the English countryside, designed and decorated by Nicholas and Vanessa Arbuthnott, a neoclassical scheme, for example—all black and gilding and Pompeian red—would have been ludicrously misplaced. An extreme example, perhaps, but one that makes the point.

But as it is, this house is a miracle of appropriateness: all the colors are light and fresh—the sort of colors that used to be called pastel, but without the slightly insipid connotations that word sometimes holds. Most of the wood, including furniture and floors, has been painted and colorwashed—much of it a cool duck's-egg blue—and this is an integral part of the overall scheme. Too often the color opportunities offered by woodwork are thrown away or ignored, but this colorist embraces the opportunity with enthusiasm. Colored woodwork can be used as punctuation—a gentle comma or a sharp period. It can be used to emphasize or accentuate, and it can be used to ground a scheme and soften it. It can also play an important role in changing architectural perceptions.

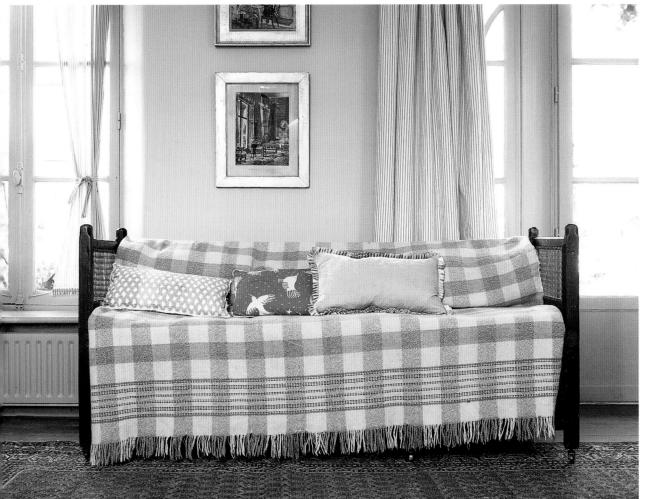

ABOVE LEFT In one, huge openplan room that combines the kitchen with a living, relaxing, and eating space, the same blue-green woodwork that is found in the rest of the house pulls the look together. Clear yellow walls ("Hay" by Farrow and Ball) are the background for different blue and green combinations, from the blue check cloth to the painted wooden chairs and the ubiquitous woodwork. LEFT Here an astringent touch of brighter color is used to stop the ice-cream colors from becoming saccharine. A wooden daybed is covered with a red-and-white check blanket, and the curtains are made from white and peony-red ticking.

LEFT Another example of nature's color sense: these roses, while quite different in hue, are each of similar strength and depth, and so they go perfectly together. They illustrate just how much inspiration for color schemes can be picked from the garden. The Arbuthnotts have used this natural lesson in all the colors throughout the house, which is particularly important since the garden seems almost to be part of every room, flooding in through open doors and windows.

Using pale colors together in a house is a bit like dressing all in pale colors. It works when the colors are in similar tones and have the same depth to them; so pale blue, pale pink, and pale lilac will work together without trouble, although they may need to be rescued from insipidity with a bright accent—sharp red, bright yellow—or a flash of white to pull them together. And, although they should all be equally cold or warm, there must be some variation—some of the tones should be slightly deeper or darker, lighter or paler.

Here, there is nothing insipid, nothing dull—all is sunny, accessible, and uplifting.

It looks simple, but in fact using these faux-naïve colors requires confidence and discipline of choice. The colors here—mostly cool and pale—have been used in ravishing combinations that never slide into the naïve or the dull. The color palette is almost Scandinavian—or what people often think of as Scandinavian—cool pale blues and blue-greens flow over the walls, floors, and furniture. The sympathetic furnishings are mainly checks and stripes in clear pinks and blues. The necessary astringent touch is provided by the odd yellow and red that makes it all so much more complex an idea.

Using a fairly limited palette means that there is harmony from space to space, and through each door the next area beckons. Spatial harmony is doubly important in a house where the outside is brought in through numerous French doors. This is a proper country house, and the colors that are used reinforce this feeling.

LEFT The living end of the large all-purpose room is an area of comfort and leisure, suggested not only by the continued use of the same soft ice-cream color, but also by the softening effect of the textiles used on the table and daybed. It is interesting how many patterns have been used together; because they are largely geometric, there is no conflict of design.

RIGHT A range, particularly an original model such as this, will always hold center stage, and here

a definite effort has been made to work the woodwork in with the cream-colored beast.

BELOW A small, awkwardly shaped bedroom in the eaves has been given a toning neutral treatment, with walls and wooden bed painted a soft stone color, and the eaves and beams painted white. So that the scheme does not disappear into neutrality, the nighttable is little-girl pink and pillows on the bed are made in assorted pink tones and patterns.

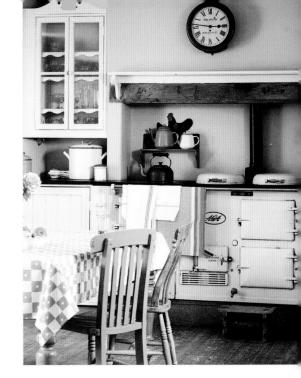

Sharp contrast

IT MAY SEEM OBVIOUS, BUT THE COLORS THAT YOU CHOOSE TO HAVE AROUND YOU SHOULD BE THOSE THAT SUIT YOUR TEMPERAMENT. ALTHOUGH MANY PEOPLE PROFESS TO LIKE BRIGHT COLORS AND TO FIND THEM CHEERFUL, NOT EVERYONE CAN ACTUALLY LIVE WITH THEM; SOME PEOPLE ARE SIMPLY HAPPIER WITH MUTED TONES.

For the many who do love bright tones, using them in combination with each other can produce the most stimulating schemes and original rooms. Because of their strength, bright colors cannot simply be mixed together in any old way; success comes either by building a scheme around one strong tone with sharp contrasts or by taking a family of colors and using them in all their variations. The apartment on these pages—small and compact, but with plentiful natural light—brilliantly demonstrates the use of color in a limited space.

Secondary colors are, generally speaking, easier to use than primaries; they are not as intense and have a little more subtlety. In this apartment, purple is the starring secondary—it purrs and hums, and all other colors defer to it. In some areas, many tones of purple are used together, from deep blue-purple to lilac. Elsewhere there is contrast: sharp yellows, pinks, and oranges highlight and accent. These colors work in this role because yellow, pink, and orange are themselves interdependent—part of a group sitting adjacent to each other on the color wheel—and so work together without fighting.

Throughout the apartment, whenever a bright color is used, it is softened by being set against a dark one: bright acid pink against dark blue on the cabinets or against a wall built up from layers of blue and purple. In all, an astonishing total of fourteen colors have been used in an instructive display of disciplined bravura.

LEFT A detail of the plaster finish of the living area walls; the tones of the wall are emphasized by the carmine pink shelf and the softer blue-purple cabinet doors. In a space as small as this, it is important to pay close attention to detail. Every surface should be considered.

TOP In the kitchen, the most unusual materials—as well as colors—have been used. Wall cabinets are faced with perforated metal and hung above a reflective

splashback made from mirrored glass, which adds a sense of space. Against the mirrors is a vibrant pink counter, which contrasts with dark gray-painted kitchen cabinets.

ABOVE Dividing the living area from the kitchen is a pillar unit in purple faced in yellow, which leads the eye to the kitchen beyond. Pink chairs make a connection with the bright pink countertop.

Colors to transform

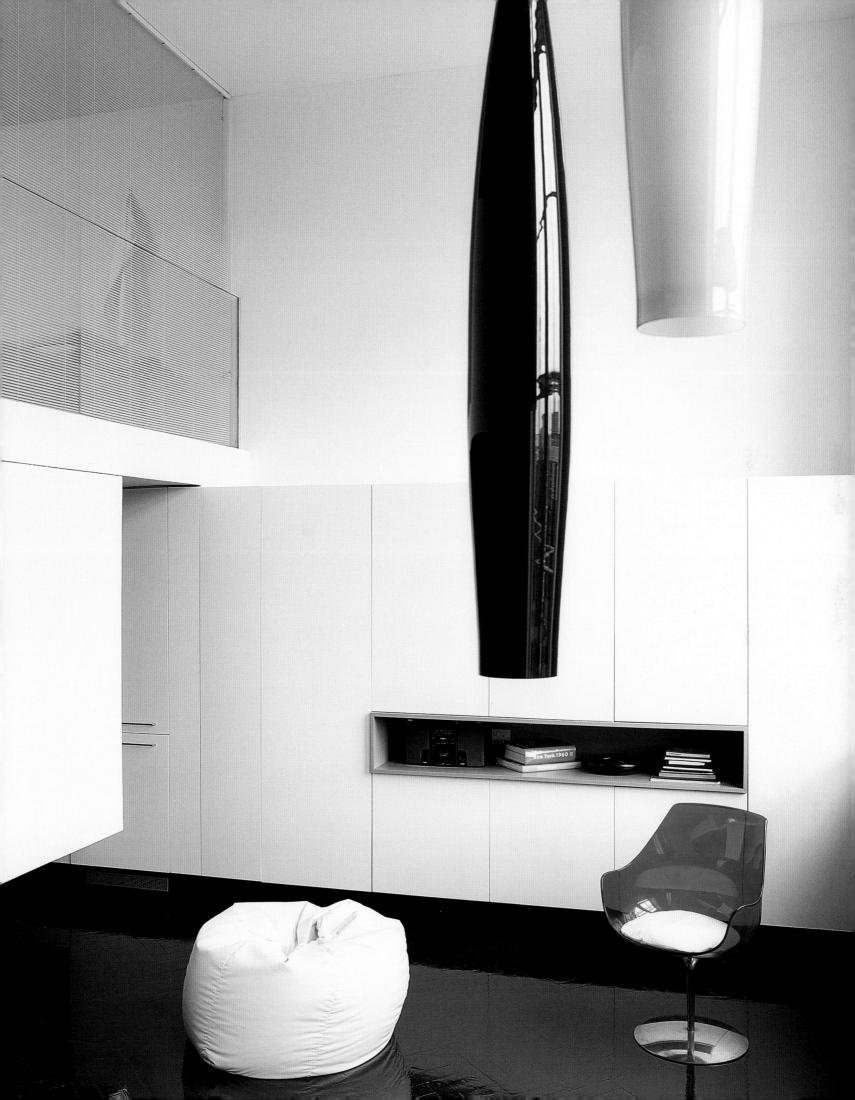

Color is subjective—no two people see any one color in the same way. However, there are some basic principles which mean that color can be used to hide, disguise, deceive, and repair. For this reason, it is an important weapon in the armory of interior design.

Not many rooms are perfect; in fact, most rooms have their share of imperfections, be it the shape or size of the space, or the quality of light. However, much can be done both to disguise and to visually correct them, with the judicious use of clever coloring.

We all know that strong color draws the eye inward, and that light color moves the eye away. This means that, in a relatively uncluttered space, the right application of color can be used to accentuate one feature and minimize another, with accents of other colors used as punctuation marks within the total plan.

Color can work in several different ways: by visually accentuating or diminishing an architectural flaw or flaws; by suggesting partitions and demarcation lines; or by altering the atmosphere of a room through the suggestion of a function or a mood.

One of the best pieces of advice that an interior designer or decorator can give is that, in general terms, it is better by far to have one good idea and be able to follow it through boldly than to have several quite good ideas, none of which are executed with complete confidence and clarity. And this rule applies particularly where color is concerned. Color is there to be looked at—it is the first thing one notices about a room. Therefore, when color is being used to say something—to convey an idea or a mood, or to delineate an area or a space—it is important that it is allowed to speak with a clear and confident voice. Likewise, colors used for this purpose should not be presented in a confused or overcrowded way—they should be allowed to make their points, and do the work that you are asking of them.

OPPOSITE When black and white are used together this way, they become colors as opinionated and as strong as any others. A third color introduced into the equation—in this case, an exuberant green-tendriled plantautomatically emphasizes the contrast between the other two. PREVIOUS PAGE The most confident color combination of all is probably red, black, and white, particularly when all are presented in a high-shine gloss. Each element in this room makes its point—in a particularly strong and telling way.

Color zoning

COLOR IS A DECORATIVE TOOL IN SEVERAL WAYS: IT CAN BE USED NOT ONLY TO BRING INTEREST, WARMTH, LIGHT, AND MOOD TO A ROOM, BUT IT CAN ALSO WORK TOWARD MORE TANGIBLE, PRACTICAL PURPOSES, SUCH AS THE DELINEATION AND DIVISION OF SPACE AND FUNCTION.

Color can be a powerful weapon when it is used to define and mark out space. Once again, the work of the legendary Mexican architect, Luis Barragán is called to mind. As Barragán's designs illustrated so forcefully, flat planes of color can break up a space as effectively as any solid, closed door. Color used thus should contrast or complement—what is most important is that the colors, when seen together, should work in harmony. When you look through one room into another, or from a hall or passage, you should feel a sense of calm and of place—of one space leading effortlessly into another.

Once houses were always designed as whole spaces—to be looked on in their entirety. But modern conversions of large areas into smaller ones, including apartments designed for open-plan living, mean that many homes have architectural or design anomalies. Such anomalies, whether structural or decorative, can

On one wall of the living area, shades of yellow, ranging from bright to light, subtly color and break up the extended space of this large city loft apartment. Everything is integral to the final effect, including the chairs, almost sculptural objects in their own

right, and even the pillows and throws used with them. Sand-blasted glass—although not technically a color—is also used in the design plan as a surface and a divider, as well as providing another change in tonal definition across the space.

FAR LEFT In the enclosed but open kitchen space, the appliances seem to float in a sea of glossy red. A respite from the density of color on the wall and counter has been achieved by seemingly random shapes impressed into the surface. The compact wooden kitchen table tucked behind a pier and the open-work metal chair also serve to break up the space. LEFT The accent color—not an obvious choice at first sight—is blue, ranging in shade from pale to bright, and is used throughout the space.

often be absorbed with correct color use. It is useful, rather than looking for problems on a room-to-room or corner-to-corner level, first to look at the area in total. Sometimes a problem in a room seems to resolve itself when you work on the whole space rather than the specific.

The oversized loft apartment seen on these pages illustrates this perfectly. Here, color is efficiently and cleverly used to delineate space and function while also being part of a sophisticated color scheme that pleases the eye on more than one level. In the living area of the apartment, yellow is used, in all its variants, as the unifying tone, while the kitchen, which leads directly from it, is shiny red broken with sand-blasted glass and raw brickwork. Accents of blue—from the pale blue-gray of the glass dividers to the warm tones of the kitchenware—are used in small doses throughout the apartment, linking the bright red, clear yellow, and orange.

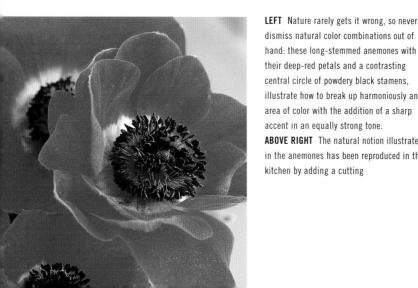

dismiss natural color combinations out of hand: these long-stemmed anemones with their deep-red petals and a contrasting central circle of powdery black stamens, illustrate how to break up harmoniously an area of color with the addition of a sharp accent in an equally strong tone. ABOVE RIGHT The natural notion illustrated in the anemones has been reproduced in the kitchen by adding a cutting

edge of black to both the cabinets and the geometric lines of the painted window frames. **RIGHT** Although it is fun and stimulating to use bright colors together, it is important to know when to stop. Here, outside the cooking

area and against a sand-blasted glass dividing panel, the dining table, its matching high-backed chairs, and even the low-level hanging lights are as neutral as the glass and so provide a cool, harmonious link.

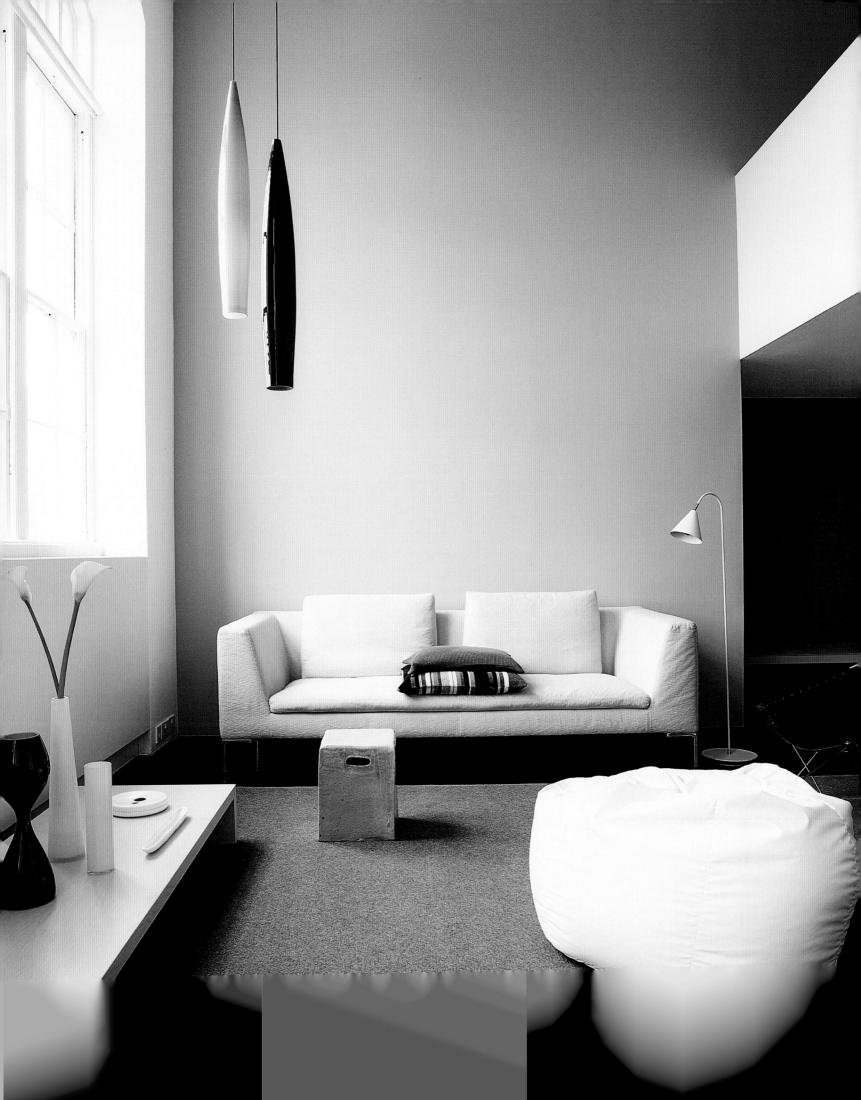

Planes of color demarcate space and function, while maintaining harmony throughout the apartment.

Shaping a space with color is as much to do with creating a mood as with architectural precepts. It is always important that there is enough of the dominant color to make the point, but not so much that it is uncomfortable to live in. Nearly all colors need contrasts and accents of other colors or textures. You may expect red to be overpowering and too "hot" in the kitchen. But, when it is combined with a large space, it proves to be energizing and stimulating. It gives—perhaps surprisingly—an air of efficiency, while also being a good background against which to eat.

In the converted school space seen here, architect Voon Wong has employed the same principles, but with an altogether quieter, more subtle palette. A single, relatively small, but high-ceilinged room has been masterly converted into a spacious apartment,

OPPOSITE On the walls of the central living area, a pale mushroom color predominates and leads around the corner to a wall of dark air-force blue-gray that delineates the eating area. LEFT Against the end wall, a bench covered with suede is trimmed with an orange metal strip. The simple wooden table with gray legs is reflected in the glossy dark-gray floor. ABOVE Color is used here to make sure there is no jarring of tones. The sofa against the mushroom wall is upholstered in cream; the pillows are in tones of blue, brown, and cream, both plain and striped; the stool is ceramic, glazed cream; and even the cup is dark brown.

that holds—as well as a comfortable living area—a kitchen suspended from the floor and a mezzanine space hung from the ceiling that incorporates both bedroom and office. A deep-blue entrance hall is echoed by the slightly softer blue of the rear wall. Elsewhere, gray, white, cream, and mushroom work in balance and harmony, leading the eye and pointing out the perimeters of each area. Light floods through the two huge windows, and the intelligent architectural solutions to turning a Victorian workplace into a contemporary living and working space are emphasized by the never emphatic, but always appropriate, palette.

Many of the larger spaces that are now subdivided were once nineteenth-century warehouses, industrial buildings, or, as in this case, schools. Because of their size, these are precisely the sort of spaces that

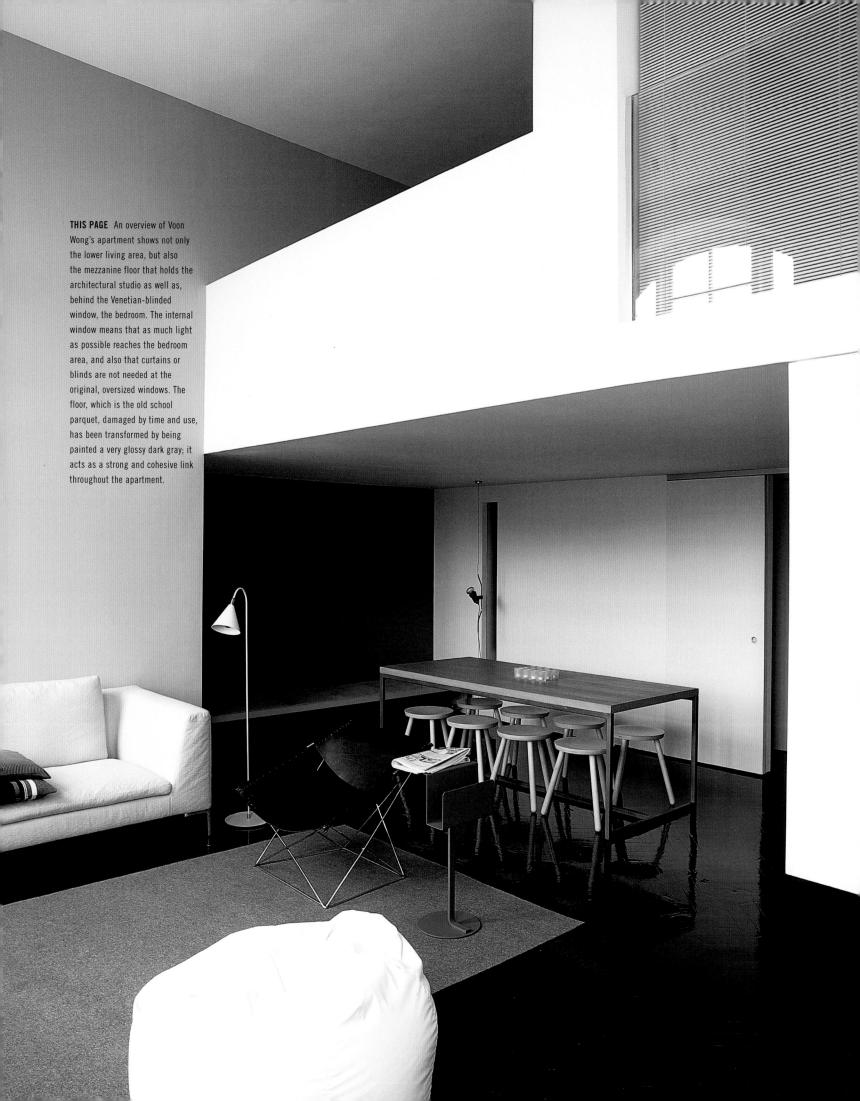

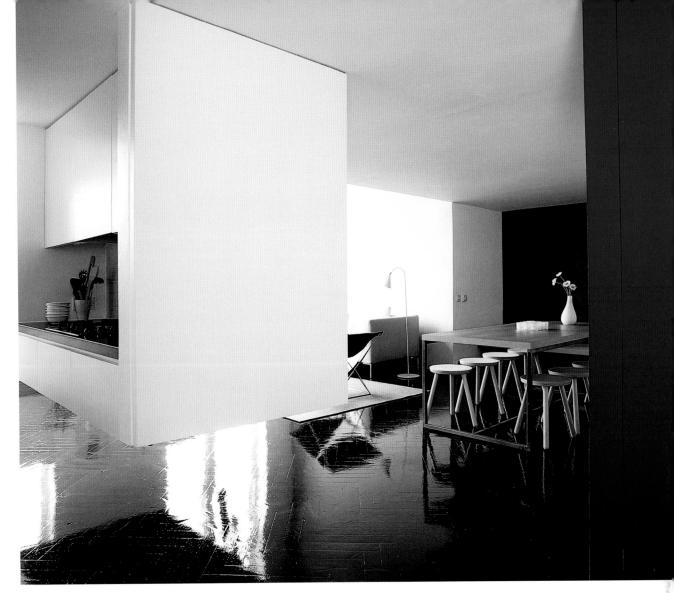

RIGHT One side of the small, cleverly designed open kitchen is built against a conventional wall; the other is suspended from the mezzanine ceiling so that the floor area is not broken up unnecessarily. **BELOW** The small bedroom is simplicity itself, with a low bed dressed in white against white walls and a mouse-gray carpet. Natural light is diffused through the silver-white Venetian blinds. In the wall opposite the bed, a shallow shelf unit has been made with a recessed television slotted into it. The unit is painted in soothing gray-lilac.

benefit best from color used in an architectural manner. When industrial spaces were first converted, they were often painted white, to emphasize the feeling of unaccustomed space. But color works better in an open space, adding personality and presence.

Color used to accentuate or "mark out" can be strong, or it can be subtle and soft—it is the idea of the color making the design points that is important, not the tones themselves. When color is used in this almost mathematical way, the art is to choose tones and shades that work together, that are part of a recognizable palette, yet have enough contrast within that group. The eye must be guided harmoniously and without protest around the space. Nothing must shout, and yet nothing must bore. A counsel of perfection might be to make sure that every other element in the space is also within the same palette, with just a few shots of contrasting color.

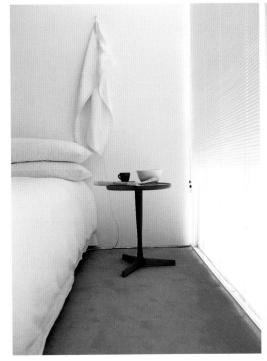

Making shapes

THE POWER OF COLORS TO ADVANCE OR GUIDE, TO RETREAT OR BE NEUTRAL IS BOUNDLESS. IF WE WANT TO EMPHASIZE SPECIAL FEATURES, TO GIVE PROMINENCE TO A PROJECTION, TO DEEPEN A HOLLOW, OR TO CORRECT ARCHITECTURAL FAULTS, THE CLEVER EMPLOYMENT OF THIS POWER CAN BE OF THE GREATEST ASSISTANCE.

With just a little thought, coloring can be used to transform awkward spaces. There are various color constants that can be employed on specific problems. Bright light color, for example, will open up a space and give a new prominence to objects and furniture. Generally speaking, whites, purer yellows, and light pinks have the property of advancing and giving prominence to areas and objects. Greens and blues make objects recede and become less important, while reds—as long as they are judiciously used—are of neutral or intermediate influence.

In a small, low room, a bright light color on the ceiling will extend the room upward, and the same sort of color—best used in a glossy finish—will tend to push the walls outwards.

Whites, creams, yellows, and pale reds all reflect light and would, in most cases, be more effective than duller colors, such as pale grays or browns.

If a room is of irregular shape—perhaps widening at one end, or with walls that slope inward to the ceiling or have other awkward angles—then use only one light color over everything, and avoid eye-distracting contrasts.

Colors that reflect light tend to give a cheerful appearance. Too often an overly dark room is synonymous with gloom—applying a bright light color to the walls will change that. A cold room will benefit not only from a warm color on the walls, but also from warmth in textile color, adding texture to the complete scheme.

Should a room be too large—it can happen—a dark color on the ceiling will pull the ceiling downward. If the ceiling color is painted right down to the picture molding, this feeling will be emphasized. Darker color on the walls will create the illusion of bringing them together; a subtle effect can be achieved by coloring two facing walls

THIS PAGE Artist Andrew Wallace has made a sparkling virtue of his internal, windowless corridor by transforming it into a tale of carefully chosen and combined color that invites close inspection. The walls have been painted an Arts and Crafts "greenery-yallery," which contrasts with yellow-toned dark green glossy woodwork. The ceiling is false—the original ceilings throughout the apartment were a restorer's nightmare, so Wallace took a lateral view and built new hand-cut wooden ones on top of the old; the hall ceiling is painted dark brick red with deep green beams, decorated in almost Gothic style within the panels. The final effect is totally pleasing, and the contrast of the surprising dark ceiling and lighter walls gives the corridor an illusion of width.

168 colors to transform

THIS PAGE In this small studio house, most of the colors are pale and neutral, so the apple green on the staircase comes as a surprise—a welcome one, of course. It is used as a zone maker as well as a decorative contrast, and acts first as a marker—a signpost showing the way as it leads down from the bedroom, which is a symphony in grays and blues, and connects it with the other parts of the house. It also adds a relaxing, soft tone to an otherwise cool environment. Fresh and clean, the green makes the white surroundings sing, and it acts as a strong background color to the pictures and objects that are displayed.

RIGHT In this converted barn, close to the sea and marshland, a small bedroom has been carved out of the eaves; the contrast of such fresh blue and such clear white gives the space a feeling that is far from claustrophobia.

BELOW On the lower level of the barn, the blue walls change in tone and depth as the light hits them; the undulating curve of the surface accentuates these changes, and is itself an echo of the changing sea.

BOTTOM Blue is not the only color used in the barn: another sea color, green—the green of water close to the shore, and water over pebbles—has also been employed. Although they are perhaps not what might be termed sophisticated or "city" shades, together the two watery tones work in harmony, defining and linking the spaces, and altering as they are touched by the ever-changing seaside light.

Colors can have an important architectural role in changing spaces and they can, at the same time, make a room feel instantly cheerful or gloomy.

with one shade, and a slightly deeper variation of the same color on the opposing walls. Dark reds, browns, greens, and blues absorb light, so they will darken a room, and if the texture of the color is flat, light will be further absorbed.

Although, for this reason, dark colors are usually used in lighter spaces, there is an argument for emphasizing the confines of a space with dark strong contrasting color, and conventional narrow entrance halls are good areas for such experimentation. The fact that the area available for using color in the hall and up a staircase is so limited, and the walls and woodwork are in such close proximity to each other, means that you have the opportunity to try out all those unusual combinations that might be too much over a larger area. Think shocking pink with forest green or deep purple; mandarin orange with electric blue; or saffron yellow with terracotta. The one stipulation is that any color chosen—for the wall, at any rate—should be warm in tone—the hall is a place of first impressions, and they should, of course, always be good.

THIS PAGE In the same converted barn, made of brick and flint, color has been used both to open up spaces and to mark out areas. Here, different shades of blue have been used in what might be described as architectural fashion, to work together but also to point out different functions—the stair rail up a wooden staircase; an upper wall leading to bedrooms. Significantly, blue is also used to underline the geographical situation of sea and sky.

BELOW AND LEFT Now that it is no longer considered necessary that every bathroom should look like the inside of a refrigerator—and often feel like one, too—color can be employed in this bastion of gentle hedonism. The smaller the room, the warmer the color. Amaryllis red is the tone used in this bathroom, a velvety soft red which gives an instant air of warmth and comfort. In an interesting contrast, the softness of the color is lifted and sharpened by being paired with a beaten metal basin and a wooden-framed circular mirror. RIGHT AND FAR RIGHT This warm red living room is exotic and—rather surprisingly—calm, as well. The owner-designer achieved the effect by first coloring the walls with a flat rich red pigment, and then glazing the base color with dark red glaze. The finished effect is warm, but saved from all-pervasive richness by the clean and satisfying contrast of the furnishings.

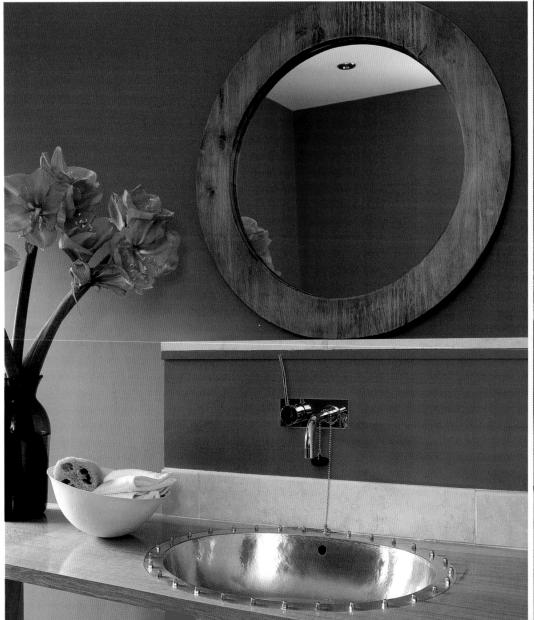

Creating atmosphere

USING COLOR TO TRANSFORM IS NOT ONLY A QUESTION OF WHAT YOU WANT TO CHANGE ABOUT THE SHAPE OR ASPECT OF THE SPACE ITSELF—COLOR CAN TRANSFORM FUNCTION AND MOOD AS WELL AS ARCHITECTURAL FAULTS.

Psychological, as well as optical, illusions can be performed with color. The atmosphere of a room can be enhanced or even transformed by the judicious use of the right tones on the walls and furnishings.

This transformation can be engineered by utilizing people's known reactions to specific colors: we know, for example, that green—soft green, anyway—is a soothing color, so we expect, when we see it on the walls of a room, that everything will quietly blend in and that we will feel soothed. The only problem with this thesis is that many relatively soft greens are not soothing it all—if they have too much yellow in them, they can appear positively bilious; the lesson being that careful choice is essential if you want to use color this way.

One must also consider the uses and purpose of the room under discussion. Different rooms respond to different types of color. Bedrooms should, on the whole, be colored in soft tones; kitchens and dining rooms in cheerful, welcoming colors that are conducive to eating and hospitality; and living rooms—well, they should be whatever suits the function of the room, whether it is a place for entertaining friends,

THIS PAGE Throughout this London apartment, gray tones color the greens and blues, the total effect being a soft impression of everyday London life—but an impression far more pleasant than the chilliness encountered on the average winter's day outside. Inside the apartment, the rooms look as if an opaque film has been lifted from the colors of the everyday world—the greens are crisper, the blues softer, and the grays clearer.

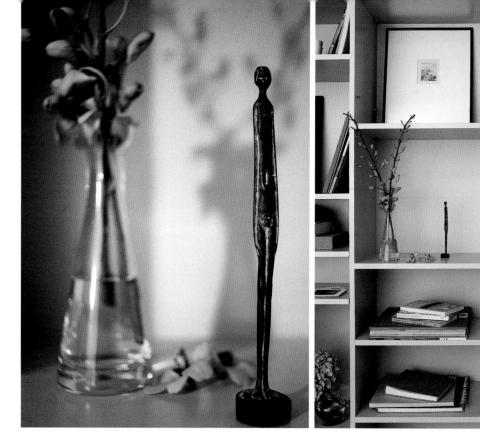

a place for relaxing with the family, or a combination of the two.

A rich red living room can be warm and exotic, but can also feel oppressive and overpowering. Not every room—or every homeowner—is suited to strong color, and many people seek a more subtle and soothing effect when choosing their palette. Nothing could be a greater contrast to the richness of the living room on the previous page than the pale colors of the apartment shown here. Again, natural lighting has played a prominent role in the color selection. The idea behind the decorative scheme of this London apartment was to echo and complement the natural, often gray, tones of the English winter light, so the color scheme is cool, understandably, but also calm and ordered, a combination of color and texture.

The aspect of the room is always an important consideration when choosing colors, but is especially so when the creation of a mood is the purpose. In

Color should always be used in conjunction with lighting, for color can not give light, only reflect it.

a dark room, or where the desired effect is to be dark and rich, color should always be used in conjunction with lighting. Well-placed lamps and background lighting can completely alter a room. Light is reflected differently off different-colored surfaces, so tones and shades of color should be chosen taking into account not only the size and shape of the room and its aspect, but also other less obvious, external factors, such as the proximity of buildings and trees reflecting light through the windows.

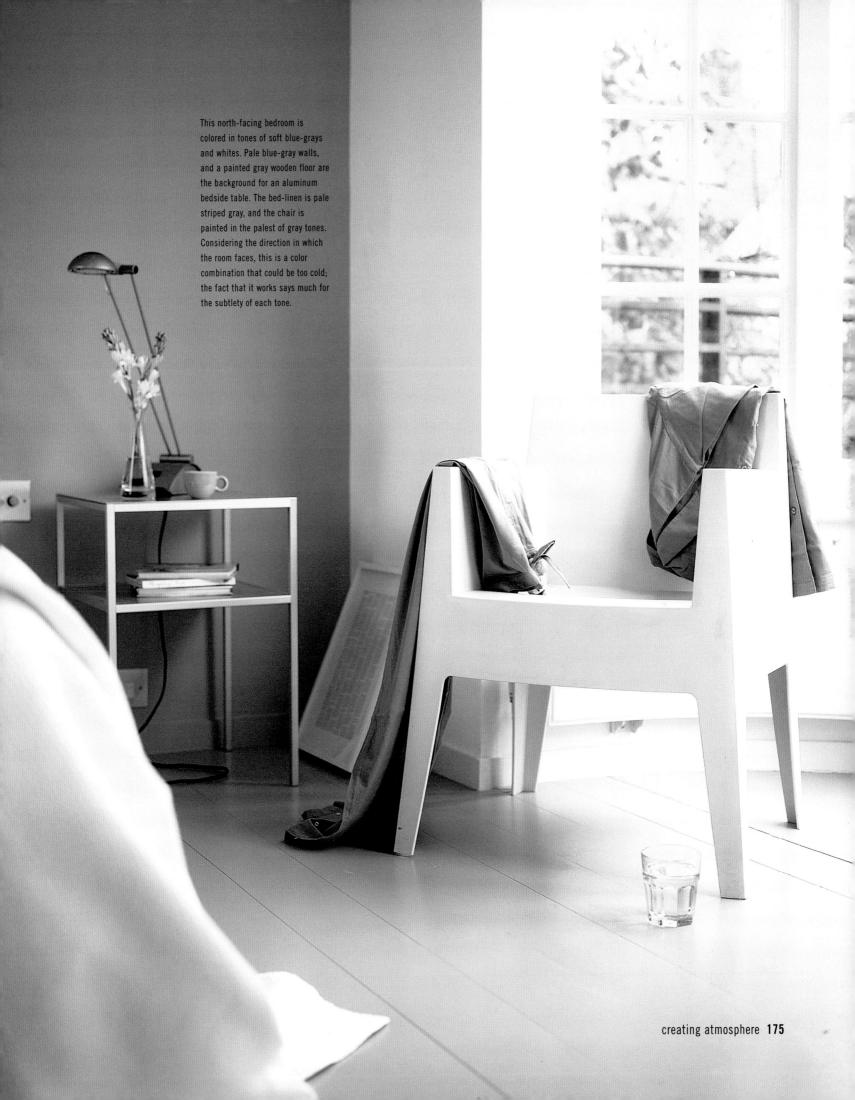

THIS PAGE Many specialized paints made commercially can be used in a domestic context; blackboard paint is an obvious example. Instead of using it on a portable blackboard, why not use it, as here, to cover a whole wall—or walls. Pictured is a small, already dark hallway, where the bonus of a wraparound blackboard so near the front door can be easily appreciated.

OPPOSITE This striking, dramatic effect proves that "keep it simple" applies in more areas than cooking. But, although this is a simple idea, there is a sophistication in the choice of textures, where flat and gloss finishes and metallic paint—another specialized product—have been included.

Color techniques

Color techniques—by which one means the craft of applying color to surfaces in a way that enhances both the former and the latter—are the oldest tricks in the painting book. Ever since man first discovered color, we have been experimenting with different ways of decorating with it. Applying it in multicolored layers, combing, ragging, sponging, dragging it—the inventiveness knew no bounds. And today we are once again fascinated with this decorative art, fascinated with creating texture and pattern, with bestowing instant age and patination on a surface, with covering it in designs that are regular in content, or loose and free-flowing.

The methods at their most basic are just that, and can easily be learned. There are, of course, some techniques that require the skilled hand of an artist, but then there is, after all, an artist in everybody. It is a question of practice and confidence. And, even if you need the help of a professional in translating your ideas into reality, the pleasure that comes from discussing the colors and the design, watching it take shape and admiring the finished result, can be huge indeed. The joy of using any of these finishes on what would otherwise be a plain wall or object is that the end result will be something completely individual and unique.

Unusual finishes

BECAUSE SUCH A WIDE CHOICE OF COMMERCIAL PAINT IS EASILY AVAILABLE TODAY, YOU MIGHT THINK THAT THE BEST WAY TO GET THE SUBTLE, INTERESTING COLOR YOU ARE LOOKING FOR WOULD BE SIMPLY TO BUY THE RIGHT CAN OF PAINT AND SLAP IT ON THE WALL. HOWEVER, A DECORATOR OR INTERIOR DESIGNER WOULD BEG TO DIFFER.

What some would call a "mechanical" finish has always been an anathema to decorators and taste makers. They would, in most cases, consider modern paints to be a trifle too plastic, lacking depth and subtlety. And, useful as commercial paints are in many areas, there are some situations or decorative schemes where a slightly more individual treatment is required.

Such individuality could be achieved perhaps by using one of the many specialized paints now available, which include many once-rare traditional natural paints. Limewashes, distempers, and milk paints—evocative names for those interested in the history of decoration—are paints which, when applied, display soft, almost organic surfaces. Limewashes, for example, are organic and were traditionally used to paint exteriors; they breathe, wear gently over the years, and allow moisture to pass through. And distemper, the traditional interior paint to be used over plaster, has a cloudy, slightly powdery, subtle finish.

Alternatively, individuality could be acquired with one of the new color exotica. Paint that glitters, glow-in-the-dark paint, and fluorescent paint are all now available from large suppliers. Metallic paints, too, which were once only produced by specialized makers, can be easily found in a wide range of finishes: from white-gold and burnished gold to soft verdigris and burnished bronze; from antique copper to frosted silver. Even a touch of one of these could add instant interest to an unprepossessing space.

For many hundreds of years, of course, color was brought into a room and onto the walls by hanging real textiles. Sometimes they were portable, like tapestries, and sometimes they were permanent. Like all the best decorative ideas, wall-hung textiles have never really

ABOVE AND BELOW Gold leaf is one of the most beautiful—and expensive—finishes that there is. Redolent of luxury—Renaissance grandeur and eighteenth-century beauty—few people employ it as a wall finish today. But here, in a

Milanese dining room, it is used to great effect. The entire wall is gold leaf, except for an arched area that has been painted deep turquoise and hung with a collection of plates that follow the golden curve. Below the turquoise section,

paintings are hung almost to floor level. The effect is overwhelmingly rich. The detail shows how small each leaf of gold is and how many are needed to cover even the smallest of areas.

gone away. In France, for example, textiles—often highly patterned like toile de Jouy or bright Provençal naïve patterns—are often hung, particularly in bedrooms. Textiles on walls give a completely different texture from paper or paint, no matter how well printed or applied they are. First, because the walls are usually lined, a material-hung room has a warmth and a softness to it that is inimitable; second, the natural flaws in the weave mean that, even in a plain weave, there is a variety and texture apparent in every yard; and third, light strikes textiles in a different, subtle way, so that each wall looks quite different.

Textiles can be hung in panels, combined with paint or paper or, reverting to the style of the Middle Ages, they can be loosely hung against the wall or even from a rod or pole around the wall to fall to floor level like a curtain. One decorator has attached short lengths of curtain pole on different walls of her living room and routinely hangs an ever-changing library of panels of material to add instant color and design to the room. The secret here is to vary the textiles in an unusual way—perhaps deep-red silk damask might be hung next to a pink and green document chintz and a pale-green and gold sari length.

THIS PAGE Some decoratorsparticularly in Europe-think of textiles as a possible wall covering before they consider paper or paint. The advantages are apparent in the range of texture and tone offered by a fabric-hung wall. The owner of this Paris apartment (right and below) appreciates the variety of textiles and has used them severally. In the bedroom, a matt raspberry-toned textile makes a suitably warm atmosphere; and in the living room the walls are covered in the same green velvet as the adjacent curtains. In contemporary contrast, the walls of this half-bath in Manhattan (below left) are covered with silk in hazel tones with a muted variegated stripe.

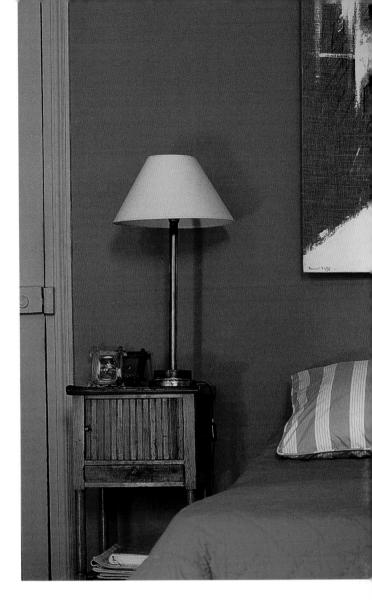

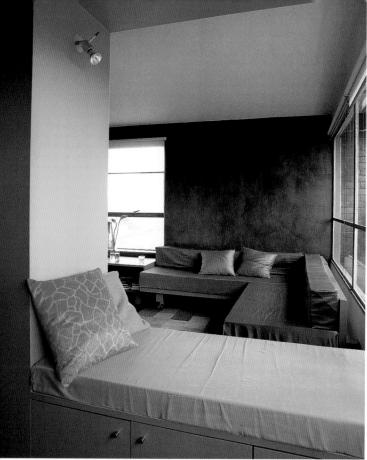

THIS PAGE The joy of using colorwashes and glazes is that you can eventually build up any depth of any color that you want, with as much texture and subtlety as you desire. The best examples no longer look like pigmented color painted in layers onto a surface; instead they resemble almost anything else that is beautiful the celadon glaze on a piece of antique porcelain, the pile of a rich piece of silk velvet, the subtle melange of colors in a panicle of lilac blossom, or the different tones of a ripening apple. Washes and glazes are infinitely forgiving: the buildup of color layers can be worked on ad infinitum, "knocked back" or dirtied until you have exactly the effect that you are looking for.

Washes and glazes

ANOTHER WAY TO ACHIEVE AN INTERESTING FINISH ON THE WALLS IS BY USING ONE OF THE MANY PAINT TECHNIQUES DEVISED OVER THE YEARS. EVER SINCE PIGMENT WAS FIRST USED TO COVER WALL SURFACES (PROBABLY BY THE EARLY EGYPTIANS), PAINTERS HAVE AIMED TO ACHIEVE A SUBTLE EFFECT BY BUILDING UP TRANSPARENT LAYERS OF COLOR, APPLIED ONE ON TOP OF THE OTHER.

This technique can be called colorwashing, although different specialists give it differing names; it is achieved when one or two thinned coats of color are applied over a base color to create a translucent soft effect of color and tone. The layers applied may be shades of the same color or carefully chosen combinations of color, to give subtle effects of tone and shade. The final effect varies considerably according to the materials used and the way the technique is applied, and it can be used on both walls and woodwork to great effect.

There are several methods, depending on whether you are using water- or oil-based paints or tinted

glazes. It is best to consult an expert's book on how best to prepare the surface, and mix the pigments depending on your choice of materials. At its simplest, a basic technique using water-based paints to give a wash of color might consist of a coat of vinyl or acrylic colored latex diluted with water and brushed over a non-porous base coat. The paint should be sufficiently thinned (but not thinned so much that it pours in rivulets onto the ground) to cover the wall quickly, using a wide paint brush. The brush should move in wide strokes in every direction and, as the wash begins to dry, it should be brushed again to partly even out the strokes. It must then be left to dry completely, after which another coat—the same color or perhaps a slightly different tone—can be applied. When applying this second coat, care should be taken to cover any particularly patchy sections of the first coat. The effect will be of soft, shadowy color, and the more coats you apply, the stronger the color will be—it's up to you.

The same technique can be used with oil-based paints—diluted with mineral spirits rather than the water used for latex paint. Oil-based paints remain workable for a longer time, giving you more time to execute the brushwork. The paint should be thinned

enough to allow you flexibility, and the background kept light. At first, until you are confident about combining color, it is probably best to keep the color combinations simple.

A professional decorator would, more than likely, apply a colorwash using a scumble glaze rather than thinned paint. The glaze might be either oil- or acrylic-based, and he or she would tint it with artist's pigments or oil paint for the former, and acrylic or water-based paints for the latter. The glaze is thinned—the more solvent you add, the quicker the glaze will dry—and the color is added. If you are tinting the glaze with artist's pigments, the pigment should be diluted first in mineral spirits and then stirred into the scumble.

A professional might apply as many as five or six layers of tinted glaze; the subtle, translucent finish of the colors achieved this way produces a color of depth and subtlety that might look like lacquer or finely glazed porcelain. These glazes dry quite rapidly, so they are not as easy to apply as thinned paints, and the brush strokes must be evenly applied, but the luminosity and depth of color reward the effort.

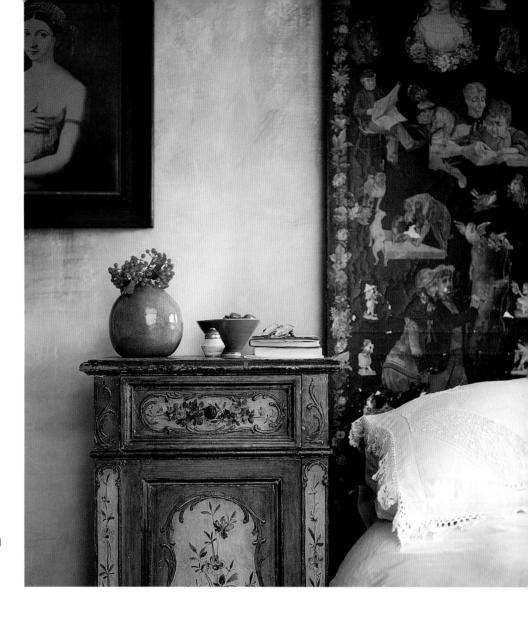

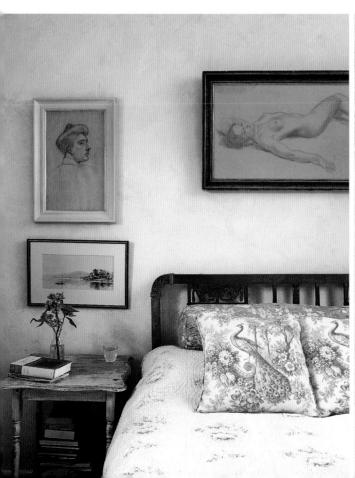

and effective about a wash or glaze that looks almost like polished raw plaster—which can also be achieved, but which is not always practical if the existing walls are already painted. The muted tones of pinks, creams, and browns, worked together and over each other, give a finish that is immensely flattering—as a background for pictures and objects, but also for everyday life.

Decorative paintwork

IF SOMETHING MORE ELABORATE THAN A COLORWASH IS NEEDED, THERE ARE VARIOUS DECORATIVE EFFECTS THAT CAN BE APPLIED, USING TECHNIQUES EITHER TO REMOVE WET PAINT OR TO ADD EXTRA LAYERS FOR TEXTURE AND PATTERN.

Colorwashes can be given a variety of different textures and patterns by distressing the surface—either by brushing on or wiping off additional coats. There are a number of tools and techniques for working with the wet surface of the wall; the most popular finishes are probably sponging, stippling, ragging, and dragging.

Sponging is one of the easiest of finishes. Over a base color, watered-down paint or a glaze is either dabbed on with a sponge (sponging on), or-effected in reverse—a fairly fluid layer of color is painted onto the wall and immediately dabbed off with a sponge and a cloth (sponging off). Using diluted latex paints gives a dry, soft effect; oil-based sponging is sharper, and oil glazes give a translucent finish. Real sponges are best, but cellular sponges will work if you rough them up a bit first so the texture is uneven. Either put the sponge, lightly covered with paint, onto the wall and dab gently, covering the surface, or apply the colored paint or glaze first and then, with the sponge wrung out in solvent, dab to lift some of the glaze from the surface. This can be done over several layers of color.

Stippling is another way to break up the surface in a subtle manner. Usually done using a special brush with a rectangular head, a glaze or wash is applied and then—while still wet—dabbed with the brush so the color is lifted, leaving a texture rather like shagreen.

THIS PAGE One of the pleasures of using paint effects is mixing different styles and techniques together. Here, interior designer Geraldine Prieur has combined tone upon tone of color in different ways: the walls have been washed over a pale pink base and lightly ragged with a darker shade on top; they have then had stripes applied over the wash in a soft, pale melon glaze. The panels of the doors have been painted to resemble watered silk, and the molding is outlined in two different strong pinks-one deeper than the other.

Stippling can be done successfully on water- and oil-based paints as well as over a tinted scumble glaze.

Rag-rolling and ragging do exactly what they say. The first is achieved by folding a piece of cloth into an even sausage shape and then using it almost like a rolling pin over a wet glazed or painted surface. Ragging differs slightly in that the piece of material is crumpled into an uneven ball and then pressed down over the wet glaze or paint. The finished effect is somewhat sharper than the first method. Different textures and effects can be achieved, depending on what type of material is used and how tightly it is rolled or crumpled.

Dragging, one of the subtler finishes, which works very well on woodwork as well as walls, is a technique that has been popular for at least two hundred years. Like an informal wood-graining, a dragging effect is achieved by applying a dry brush, drawn downward through wet paint or glaze to give a subtle, shadowy effect of very fine, irregular lines. Dragging does seem to look better when an oil-based glaze rather than a water-based one is used.

With all these paint techniques, it is sometimes better and more efficient for two people to work together, one brushing on the glaze or paint, the other brushing or dabbing. And, as with everything demanding manual skills, the more practice you have, the better the finished effect will be.

THIS PAGE In this Italian city apartment, paint effects have been used with subtle cleverness and a limited palette. In the kitchen, a warm yellow glaze has been applied over walls and cabinets, with a band of warm terracotta at floor

level. Glazed finishes can actually be very practical since they are usually sealed with clear varnish, which means they can be easily cleaned. In a bedroom, the wall has been divided into panels of color; a broad terracotta frame divides rich saffron-yellow walls, within which are panels lightly washed in a pale yellow-green. There is an interesting balance between the formal and informal here.

The important thing with all these finishes, particularly ragging, is to be subtle in both your choice of color and in the amount of pressure used when wielding the decorative tool of your choice. In the 1980s, when paint effects were first "rediscovered," the most ghastly combinations sprung up, featuring surfaces covered with sharp and unconsidered stabs of contrasting color, the whole looking as it suffered from an outbreak of a particularly infectious, virulent disease.

There are, of course, many other types of time-honored painting techniques that have been perfected over the centuries. It is possible—and generally easier than two hundred years ago—to use color to represent any surface in the natural world. It might be a wood-grained effect—anything from maple to burl walnut—or it might be mottled tortoiseshell, leather, malachite, or lapis lazuli, a million types of marble, or even varying degrees of rust and age. Skill is needed, of course, and, at this level, an artistic bent also—but all is possible.

Equally possible is using color in paint form to add surface decoration and pattern to the walls of a room. Both freehand and guided pattern can be applied to create a design or a trompe l'oeil effect that will enhance or correct the proportions of the room, or merely give pleasure. Freehand painting is difficult—but not quite as difficult as it might seem, particularly if you are relaxed about the direction it will follow.

One of the simplest devices is to add fine colored lines to correct architectural proportions and decorative faults. Where a baseboard is the wrong depth, particularly when it is too shallow, it can be corrected with one or even two bands of color painted above it—either the same color as the board or as a contrast. Similarly, many rooms today are designed without dado rails, or have had them removed. Although many modern rooms do not need them since the ceilings are relatively low, some rooms (particularly Victorian ones) do. The dado rails in these houses balanced the proportions of the room, and if they are removed in the name of modernization, the room can become lopsided and out of proportion. The addition of bands of painted color can give the impression of structure,

THIS PAGE In this golden living room designed by Geraldine Prieur, the walls have been prepared with a base coat of pale yellow, over which a glaze of cool orange has been applied. Around the room, stenciled in airy golden columns, are Prieur's interpretation of classical volutes and acanthus leaves, which, in appearance, are very close to her own favored motif—the arabesque—which she uses on many of the ceramics, glass, and other decorative accessories she designs.

THIS PAGE Color finishes do not have to be complicated. Here, blocks of color are used to achieve the desired effect. The brilliantly simple device of hanging a collection of majolica plates against a colored panel happened after the owner tried them against the yellow wall; unhappy with the combination, she applied, in that place only, a new color, chosen to go with the plates. Her manner of handpainting a zigzag border between the changing paint color is equally simple and equally pleasing.

particularly when the bands of color are shadowed with a deeper tone, in a simple trompe l'oeil effect.

Simple, or even quite complex, paneling also can be painted onto walls to correct the proportions and add an instant sense of period. And, emboldened by the success of these small forays into decorative painting, you might then go on to cover a wall, or indeed an entire hall, in hand-painted stripes. Stripes have been fashionable since the eighteenth century; unsurprisingly, since they immediately add distinction to any room. And anyone who appreciates stripes prefers them hand-painted—the slight unevenness, the variations in tone, the way the color changes with the light, these all add up to an effect that is miles away from the bland uniformity of striped wallpaper.

Alternatively, if you prefer more pattern and color, a stencil can be used to create repeated patterns in several colors over a large area. Stencils are not a new way to create pattern. In fact, they were probably used by the early Egyptians and the Romans. They were certainly used in medieval Britain, and famously, they were employed by early settlers in America on furniture, floors, and walls. Stencils are usually sprayed or stippled onto the surface and can be used to make something as simple as a narrow border or something as complex as making a whole room appear to be lined with antique damask.

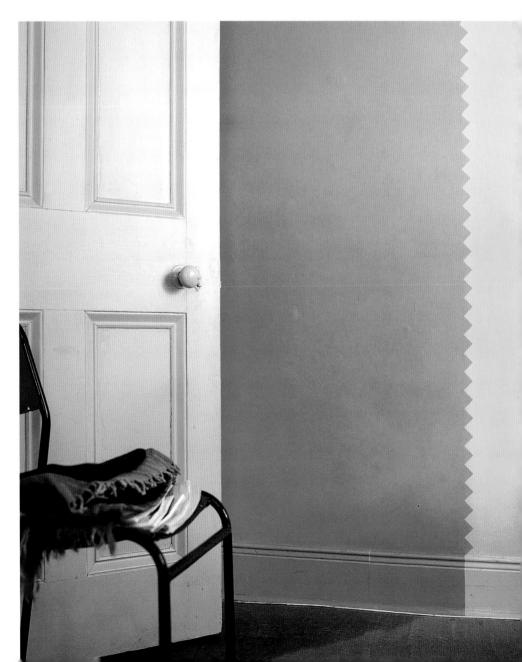

SUPPLIERS

Large paint manufacturers

These manufacturers distribute their products through paint stores and home-building suppliers. In most cases they have dealer locators on their websites and through their toll-free telephone numbers. Useful information is available on all the websites, and you can email the companies with specific queries.

Benjamin Moore & Co.

51 Chestnut Ridge Rd.
Montvale, NJ 07645
(800) 826-2623 for distributors
Interior and exterior paints, plus wood stains.
Many palettes, including a wide selection of whites and over 176 historic paint selections.

Cabot Stain

100 Hale Street Newburyport, MA 01950 (800) 877-8246 for distributors www.cabotstain.com

Transparent and opaque wood stains and finishes in a full spectrum of colors. The website contains an image of a house to try color schemes on.

The Glidden Co.

925 Euclid Ave.
Cleveland, OH 44115
(800) 221-4100 for distributors
Part of ICI Paints. A wide selection of water- and oil-based paints in many palettes.

Martin Senour Paints

(800) MSP-5270 for distributors www.martinsenour.com

A large collection of colors, including Frank Lloyd Wright, Painted Ladies, and the Williamsburg Collection palettes of 69 interior colors and 36 for exteriors. The website features rooms where the visitor can manipulate the color schemes.

PPG Architectural Finishes

One PPG Plaza
37 West
Pittsburgh, PA 15272
(800) 441-9695 for distributors
www.ppgaf.com
www.olympic.com
Architectural finishes, from paints to stains
and coatings. Many specialized color cards.
The ppgaf website has an amazing color display.
Olympic and Lucite are other brands
manufactured by PPG.

Sherwin-Williams Co.

101 Prospect Ave, NW Cleveland, OH 44115-1075 (800) 474-3794 for distributors or your nearest store www.sherwin-williams.com The company also manufactures Dutch

The company also manufactures Dutch Boy paints and many special lines for specific stores, such as K-Mart. The company's main website has useful color wheels and projects.

Designer-licensed collections

Within the lines of mass distributors, more expensive collections may be found, marketed under the names of prestigious designers.

Alexander Julian

LOWE'S COMPANIES INC. P.O. Box 1111 North Wilkesboro, NC 28656 (800) 44-LOWES for your nearest store www.lowes.com

The fashion and furnishings designer has produced paints and other home-improvement products in his characteristic landscape-inspired palettes. These are sold through Lowe's Home Improvement Stores. The website includes store locations and decorating tips.

Rainh Lauren

HOME DEPOT STORES 2455 Paces Ferry Road Atlanta, GA 30339 (800) 430-3376 for your nearest store www.homedepot.com

This designer of everything for the wardrobe and home has devised sophisticated color palettes geared to nature-inspired ideas like the desert or the north woods. They are available from Home Depot stores. There are metallic finishes and several textures, such as suede, that are unavailable in any other mass-market paint.

Martha Stewart

(800) 950-7130 for Martha by Mail catalog

K-MAR

(800) 635-6278 for your nearest store www.kmart.com 256 everyday latex paint colors at moderate prices coordinated with other Martha Stewa

FINE PAINTS OF EUROPE

Martha's estate in Maine)

256 everyday latex paint colors at moderate prices, coordinated with other Martha Stewart home furnishings available at K-Mart.

P.O. Box 419, Rte. 4W
Woodstock, VT 05091-0419
(800) 332-1556 for distributors and mail order
www.fine-paints.com
Three sophisticated collections: Colors of the
Garden, Araucana (inspired by eggs laid by
Martha's hens) and Skylands (inspired by

Paint for historic houses and special effects

For more specialized, still more expensive, paints to be used for particular purposes, paint stores, art suppliers, furniture stores and even some historic sites sell paint of unusual chemical composition and limited palettes.

Bruning

601 S. Haven St.
Baltimore, MD 21224
(888) 666-1935 for distributors
High-quality paints in distinctive colors suitable
for historic interiors. Carriage House, Brutex, and
Wallplate latex and acrylic paints.

California Paints

169 Waverly St. Cambridge, MA 02139-0007

(800) 225-1141 for distributors, mail order, or your nearest store

Manufactures paints, stains, and Historic Colors of America, 149 colors suitable for houses from the 17th to 19th centuries.

Faux Effects

3435 Aviation Blvd., A4 Vero Beach, CA 32960 (800) 270-8871 for distributors, mail order, or your nearest store www.fauxstore.com

Water-based faux-finishing supplies. Products are rated for difficulty of use. Faux Effects produces country-wide workshops at their distributors. They also sell how-to videos, books, stencils, and Venetian plaster.

Fine Paints of Europe

P.O. Box 419, Rte. 4W Woodstock, VT 05091-0419 (800) 332-1556 for distributors and mail order www.fine-paints.com

North American distributors of Schreuder finishes from Holland. Manufacturers of Martha Stewart's Fine Paints. Also painting supplies and books.

Finnaren & Hadley

901 Washington St.
Conshohocken, PA 19428
(610) 825-1900 for distributors or your nearest store
Offers Historic Philadelphia Colors, Victorian Hues, and Shades of '76.

Historic Paints Ltd.

Burr Taven
Route 1, Box 474
East Meredith, NY 13757
(800) 664-6293 for mail order or your nearest store
A limited but highly outboatic polette or

A limited but highly authentic palette reproducing historic colors (which were made from lead and other metal oxides) in non-toxic mixtures.

Janovic/Plaza

30-35 Thomson Ave. Long Island City, NY 11101 (800) 772-4381 for mail order or your nearest store www.janovic.com

Paints (own-brand and other fine lines), brushes, faux-finishing, antiquing, and other decorating products, including stencils, wallpapers, videos, and books. 9 stores in NYC area.

Kremer Pigments Corp.

228 Elizabeth St.
New York, NY 10012
(800) 995-5501 for mail order or store
www.kremerpigmente.de
An alchemist's cave, representing a German
distributor of pure mineral pigments as well as
plant dyes, oils, waxes, resins, etc. Everything
you need to create your own paints and glazes.

MB Historic Decor

P.O. Box 1255 Quechee, VT 05059

(888) 649-1790/ (802) 295-8001 for mail order www.mbhistoricdecor.com

Historic stencils from New Hampshire, Vermont, and other New England locations for walls and floors. All supplies needed for stenciling.
See the website for online catalog.

McCloskey Special Effects Decorative Finish Center

6995 Bird Rd.
Miami, FL 33155
(866) 666-1935 / (305) 666-3300 for
distributors or your nearest store
www.o-geepaint.com/Faux/McFaux
The stores carry a huge range of paints, finishes,
glazes, faux painting supplies, and paint tools
and brushes. McCloskey's also manufactures
finishes and supplies for contractors.

Nawkaw Corp.

8801 Macon Hwy., Suite 1 Athens, GA 30606 (706) 353-2692 for distributors www.nawkaw.com

Manufacturers of a masonry coloring system that can be used on bricks, cement, and other hard surfaces.

Old Fashioned Milk Paint Co.

P.O. Box 222
Groton, MA 01450
(978) 448-6336 for distributors and mail order www.milkpaint.com
Manufacturer of authentic milk-paint powders—add water and mix. They supply instructions, lessons, and photos. They also sell a milk-paint remover.

Old Village Paint

P.O. Box 1030
Ft. Washington, PA 19034
(800) 498-7687 for distributors and catalog
Historic paintmakers. They will analyze colors
and formulate matches; they also have a line
of readymade paint colors.

The Paint Store Online

www.paintstoreonline.com
Online merchant for faux-finishing supplies, casein paints, and paint and paperhanging tools and supplies for do-it-yourselfers and contractors.

Primrose Distributing

54445 Rose Rd.
South Bend, IN 46628
(800) 222-3092 / (219) 234-6728 for distributors and mail order www.oldecenturycolors.com
Manufacturers of colors suitable for 18th- and 19th-century-inspired interiors and exteriors.
Water-based simulated milk paint and wood stains and varnishes.

Real Milk Paint

618 Quakertown Rd.
Quakertown, PA 18951
(800) 339-9748 / (215) 538-3886 for
distributors and mail order
www.realmilkpaint.com
Powdered milk paint, pigments, and milk-paint
base. Instructions are available; the website
has hints and photos of completed projects.
They also sell milk-paint stripper.

Shaker Workshops

P.O. Box 8001
Ashburnham, MA 01430-8001
(800) 840-9121 / (978) 827-9000 for mail-order catalog
www.shakerworkshops.com
Manufacturers of Shaker furniture. They sell
Stulb's Old Village Paints in colors to coordinate

with Shaker tradition. Spectra Paint Center

7615 Balboa Blvd.

Van Nuys, CA 91406
(888) 411-PAINT for mail order or your nearest store
www.spectrapaint.com
Spectra-tone, Pratt & Lambert paints,
Cabot stains, equipment, faux finishes, and
Radiance™ paint, formulated to conserve energy. 3 retail stores in California.

Sydney Harbour Paint Co.

12602 Ventura Blvd.
Studio City, CA 91604
(818) 623-9394 for distributors, mail order, or your nearest store
www.sydneyharbourpaintco.com
Modern versions of old-fashioned eurostyle
paints, such as limewash, distemper, and
glazes, as well as cement finishes, metallic
paints, liquid iron, and instant rust.
Pigments, bases, and supplies.

Waterlox Coating Corp.

9808 Meech Ave.
Cleveland, OH 44105
(216) 641-4877 for distributors and mail order
Specialty finishes like tung oil for interior and
exterior surfaces, coatings for swimming pools,
boat paint, antique finishes, etc.

X-I-M Products

1169 Bassett Rd.
Westlake, OH 44145
(800) 262-8469 for distributors
www.ximbonder.com
Specialty finishes, paints, undercoats, bonders,
and sealers, including TILEDOCTM for painting
bathtubs and tile surfaces.

Metallic finishes

There are many products on the market for the application of metallic finishes to surfaces, from worn metals to walls and woodwork. Real metallic leaf can also be applied for a truly luxurious finish.

A & C Distributors

P.O. Box 70228
San Diego, CA 92167
(800) 995-9946 for distributors and mail order
Ready-made finishes for all types of metal.
Also offers a Liquid Copper Coating that enables
any surface that can be painted with water-base
paint to accept metallic patinas.

Gold Leaf and Metallic Powders

74 Trinity PI., Suite 1200
New York, NY 10006
(800) 322-0323 / (212) 267-4900 for
distributors and mail-order catalog
Genuine and imitation gold and silver leaf, and
all supplies and accessories needed for leafing.

Metallic Coatings and Patina Finishes

3486 Kurtz St., Suite 102 San Diego, CA 92110 (800) 882-7004 for distributors and mail order Copper, brass, bronze, and pewter water-based coatings for all surfaces, plus colored patinas.

Sepp Leaf Products

381 Park Ave. S.

New York, NY 10016
(800) 971-7377 / (212)683-2840 for distributors and mail order

www.seppleaf.com
Gold, silver, and metal leaf, gilding supplies, and tools. Venetian plaster and encaustic,

wood-finishing products. Consultation services.

Ecologically benign products

Many historic products listed in other categories, such as milk paints and limewashes, are formulated with natural ingredients that do not harm the environment. The companies listed here specialize in non-damaging finishes.

Auro-Sinan Co.

P.O. Box 857
Davis, CA 95617-0857
(530) 753-3104 for mail order
www.dcn.davis.ca.us/go/sinan
Ecological building and home-furnishing
products that do not contain plastics, petroleum,
or crude oil. Paints, wood finishes, and glue,
as well as carpets, mattresses, and soaps.
Color charts and books available.

BioShield Paint Co.

1635 Rufina Circle
Santa Fe, NM 87505
(800) 621-2591 / (505) 438-3448 for phone
order or The Natural Choice Catalog
www.bioshieldpaint.com
www.natchoice.com

Washes and finishes packaged in biodegradable or recyclable containers. Collection includes stains, thinners, and waxes, all made in small batches from natural materials.

Fco-House Inc.

P.O. Box 220, Stn. A
Fredericton, New Brunswick
E3B 4Y9, Canada
(506) 366-3529 for distributors
www.eco-house.com
Naturally-based solvents and finishing materials
for ecologically-friendly decorating.

Spectra Paint Center

7615 Balboa Blvd.
Van Nuys, CA 91406
(888) 411-PAINT for mail order or your nearest store
www.spectrapaint.com
Distributors of Radiance™ paint, formulated to
conserve energy. 3 retail stores in California.

Painting instruction

The Decorative Arts Center

Brian Bullard, Director
4915 S. Macklind Ave.
St. Louis, M0 63109
(314) 973-2787
www.dec-arts.com
A constant schedule of classes in all aspects
of decorative painting by a well-qualified
international painter. The website gives a good
overview of Bullard's history and qualifications.

The Finishing School

50 Carnation Ave.
Floral Park, NY 11001
(516) 327-4850 for mail order and retail outlets
www.thefinishingschool.com
Classes in all aspects of decorative finishing
for beginners and advanced students.
Books and videos for home instruction.

The Isabel O'Neil Studio Workshop

177 East 87th Street New York, NY 10128 (212) 348-4464 An established and prestigious school teaching all techniques of the painted finish.

Fabrics, furnishings, and accessories

ABC Carpet & Home

888 Broadway New York, NY 10003 (212) 473-3000 for your nearest store www.abchome.com

Anthropologie

375 West Broadway New York, NY (800) 309-2500 for your nearest store www.anthropologie.com Furniture and home furnishings.

Baranzelli Home

1127 Second Avenue
New York, NY 10022
(212) 753 6511
Local retailer. High-quality fabric and trimmings.

Barneys

660 Madison Avenue
New York, NY
(212) 826-8900
www.barneys.com
Home furnishings and accessories.

Bloomingdales

1000 Third Avenue
New York, NY 10022
(212) 705-2000
www.bloomingdales.com
Department store with 24 locations nationwide.

Brunschwig & Fils

979 Third Avenue
New York, NY 10022
(212) 838-7878
www.brunschwig.com
Fabrics and furniture to the trade.
19 showrooms worldwide.

The Conran Shop

407 East 59th Street New York, NY 10022 (212) 755-9079 www.conran.com Furniture, home furnishings, and accessories.

Crate & Barrel

1860 W. Jefferson Naperville, IL 60540 (800) 967-6696 for your nearest store www.crateandbarrel.com

Donghia Home Furnishings

979 Third Avenue New York, NY 10022 (800) DONGHIA www.donghia.com Fabrics and furniture to the trade. Showrooms nationwide.

Oppenheim's

P.O. Box 29 120 East Main Street North Manchester, IN 46962-0052 (800) 461-6728 Fabric retailer. Country prints, denim, chambray, flannel fabrics, and mill remnants.

Pottery Barn

(800) 838 0944 for catalog or your nearest store www.potterybarn.com
Furniture, bed, bath, and accessories.
Stores nationwide.

Restoration Hardware

15 Koch Road, Suite J Corte Madera, CA 94925 (800) 816-0969 for your nearest store www.restorationhardware.com

VW Home

333 West 39th Street, 10th Floor New York, NY 10036 (212) 224-5008 Retail store of leading interior designer Vincente Wolf. Fabrics and furniture.

CREDITS

Architects and designers whose work is featured in this book:

Key: t = tel; f = fax; e = email; a = above; b = below; l = left; r = right; c = center; ph = photographer

Nicholas Arbuthnott

Arbuthnott Ladenbury Architects
Architects & Urban Designers
15 Gosditch Street
Cirencester GL7 2AG, UK
Pages: 1, 6, 24, 75, 150–151, 152–153, 153

Vanessa Arbuthnott Fabrics

The Tallet, Calmsden Cirencester GL7 5ET, UK www.vanessaarbuthnott.co.uk Pages: 1, 6, 24, 75, 150–151, 152–153, 153

John Barman Inc.

Interior Design 500 Park Avenue New York, NY 10022 t. 212 838 9443 / f. 212 838 4028 e. john@barman.com www.johnbarman.com Pages: 140–143

Roberto Bergero

Interior Designer
4 rue St. Gilles
75003 Paris, France
t. +33 1 42 72 03 51
e. robertobergero@club-internet.fr
Pages: 3 inset cl & inset r, 26 b, 36–37, 37,
55, 117

Bruce Bierman Design, Inc.

Residential Interior Design firm 29 West 15th Street New York, NY 10011 t. 212 243 1935 / f. 212 243 6615 www.Biermandesign.com Pages: 52 c, 56–57

Hugh Broughton Architects

Award-winning architects
4 Addison Bridge Place
London W14 8XP, UK
t. +44 20 7602 8840
f. +44 20 7602 5254
e. hugh@hbarchitects.demon.co.uk
Pages: 62-63

Buildboro

Design & Build
Unit 4, Iliffe Yard
Crampton Street
London, SE17 3QA, UK
t. +44 20 7708 2538 / f. +44 20 7277 2104
e. gordanamandic@buildboro.co.uk
e. petertyler@buildboro.co.uk
www.buildboro.co.uk
Pages: 52 b, 70–71, 154–155, 180 al

Cabot Design Ltd.

Interior Design 1925 Seventh Avenue, Suite 7I New York, NY 10026 t. 212 222 9488 e. eocabot@aol.com Pages: 7 bl, 26 a, 38 b, 39, 58–59, 59, 76, 77 a, 88 a, 94–95, 102 c, 109, 114, 114–115

Piero Castellini Baldissera

Studio Castellini Via Morozzo della Rocco, 5 20123 Milan, Italy Pages: 73

Circus Architects

Unit 1, Summer Street London EC1R 5BD, UK t. +44 20 7833 1999 Pages: 110

Country House Walks Ltd.

Self-catering accommodation/weekend breaks The Tallet, Calmsden Cirencester GL7 5ET, UK www.thetallet.co.uk Pages: 1, 6, 24, 75, 150–151, 152–153, 153

Cowper Griffith Associates Chartered Architects

15 High Street Whittlesford Cambridge CB2 4LT, UK Pages: 170–171

Gloss Ltd.

Designers of home accessories 274 Portobello Road London W10 5TE, UK t. +44 20 8960 4146 / f. +44 20 8960 4842 e. pascale@glossltd.u-net.com Pages: 54, 65, 101 bc, 172—173, 173

James Gorst Architects

35 Lambs Conduit Street London WC1N 3NG, UK t. +44 20 7831 8300 Pages: 47

Yves Halard

Interior Decoration
27 Quai de la Tournelle
75005 Paris, France
t. +33 1 44 07 14 00 / f. +33 1 44 07 10 30
Pages: 3 inset I, 58, 68, 69 ar & b, 88 b, 90–91,
97, 179 a & br

HM2 Architects

Architects & Designers
33–37 Charterhouse Square
London EC1M 6EA, UK
t. +44 20 7600 5151 / f. +44 20 7600 1092
e. andrew.hanson@harper-mackay.co.uk
www.harper-mackay.co.uk
Pages: 160–163

Hut Sachs Studio

Architecture & Interior Design 414 Broadway

New York, NY 10013 t. 212 219 1567 / f. 212 219 1677 e. hutsachs@hutsachs.com www.hutsachs.com Pages: 74 a, 81, 102 b, 119

Janie Jackson

Stylist/Designer Parma Lilac Children's nursery furnishings & accessories t. +44 20 8960 9239 Pages: 39

Jacksons

5 All Saints Road London W11 1HA, UK t. +44 20 7792 8336 Pages: 72 br

Eric Liftin

Mesh Architecture
Architecture & web-site design & development
555 Eighth Avenue, 14th floor
New York, NY 10013
t. 212 965 1974 / f. 212 941 7478
e. info@mesh-arc.com
www.mesh-arc.com
Pages: 100

Moneo Brock Studio

Architecture & Interior Design 371 Broadway, 2nd Floor New York, NY 10013 t. 212 625 0308 / f. 212 625 0309 e. moneof@aol.com Pages: 74 a, 81, 88 c, 101 a, 102 b, 119

Moss Co. Architects

Specialist conservator of early buildings, architectural, constructional, and decorative finishes. Brookgate, Plealey Shrewsbury SY5 OUY, UK Pages: 18 b

Mullman Seidman Architects

Architecture & Interior Design 443 Greenwich Street New York, NY 10013 t. 212 431 0770 / f. 212 431 8428 e. mullseid@monmouth.com Pages: 40 c, 42–43, 169 al

Chris Ohrstrom

Historic Paints Ltd. Burr Tavern Route 1, PO Box 474 East Meredith New York, NY 13757 Pages: 19 c

Jennifer Post Design Inc.

Spatial & Interior Designer 25 East 67th Street, 8D New York, NY 10021 t. 212 734 7994 / f. 212 396 2450 e. jpostdesign@aol.com Pages: 2–3, 26 c, 27, 28–29, 29–30, 32, 34, 49–51, 158, 179 bl

Géraldine Prieur

An interior designer fascinated with color 7 rue Faraday 75017 Paris, France t. +33 1 44 40 29 12 / f. +33 1 44 40 29 17 Pages: 53, 60–61, 103, 134–135, 182 a & br, 184

Lena Proudlock

Denim in Style, Drews House, Leighterton Glos GL8 8UN, UK t./f. +44 1666 890230 Pages: 72 ar, 86–87

Seguana

64 avenue de la Motte Picquet 75015 Paris, France t. +33 1 45 66 58 40 / f. +33 1 45 67 99 81 e. sequana@wanadoo.fr Pages: 128–129

Stickland Coombe Architecture

Chartered architects who have completed over 40 projects for private clients in London 258 Lavender Hill London SW11 1LJ, UK t. +44 20 7924 1699 / f. +44 207652 1788 e. nick@scadesign.freeserve.co.uk Pages: 4 b, 33, 35, 80, 84, 169 ar & b, 174–175

Touch Interior Design

t. 020 7498 6409 Pages: 7 br, 38 al & ar, 40 a, 48, 48–49, 130–133

Urban Research Laboratory

Architects
3 Plantain Place, Crosby Row
London SE1 1YN, UK
t. +44 20 7403 2929
e. jeff@urbanresearchlab.com
Pages: 3 inset cr, 52 a, 64, 74 b, 85, 120–121, 136–139

Hervé Vermesch

Architect 50 rue Bichat 75010 Paris, France t. +33 1 42 01 39 39 Pages: 113

Miv Watts at House Bait

Interior Decoration, limewash-painted furniture, country antiques from around the world Market Place, Burnham Market Norfolk, PE31 8HV, UK t. +44 1328 730557 / f. +44 1485 528970 e. miv.watts@virgin.net Pages: 45, 77 b, 89, 181 a & bl

The Webb-Deane-Stevens Museum

211 Main Street Wethersfield, CT 06109 Pages: 19 a

Voon Wong Architects

Unit 27, 1 Stannary Street London SE11 4AD, UK t. +44 20 7587 0116 / f. +44 20 7840 0178 e. voon@dircon.co.uk Pages: 31 bl & br, 79, 156-157, 164-167

PICTURE CREDITS

1 The Arbuthnott family's house near Cirencester designed by Nicholas Arbuthnott, fabrics designed by Vanessa Arbuthnott; 2-3 Jennifer & Geoffrey Symonds' apartment in New York designed by Jennifer Post Design; 3 inset I Interior Designer and Managing Director of the Société Yves Halard, Michelle Halard's own apartment in Paris; 3 inset cl & r Interior Designer Roberto Bergero's own apartment in Paris; 3 inset c Donata Sartorio's apartment in Milan; 3 inset cr Richard Oyarzarbal's apartment in London designed by Urban Research Laboratory; 4 a Gail & Barry Stephens' house in London; 4 b Alannah Weston's house in London designed by Stickland Coombe Architecture; 5 Lindsay Taylor's apartment in Glasgow; 6 The Arbuthnott family's house near Cirencester designed by Nicholas Arbuthnott, fabrics designed by Vanessa Arbuthnott; 7 bl Warner Johnson's apartment in New York designed by Edward Cabot of Cabot Design Ltd.; 7 br Katie Bassford King's house in London designed by Touch Interior Design; 9 "Color Spheres for Copper, Aquatint and Watercolor" (w/c on paper) by Philipp Otto Runge (1777–1810) Hamburg Kunsthalle, Hamburg, Germany/Bridgeman Art Library; 11 Marilea & Guido Somarè's apartment in Milan; 12 The Art Archive/Musée d'Orsay/Dagli Orti; 13 a Portrait of Cardinal Carlo de Medici by Andrea Mantegna (1431–1506) Galleria degli Uffizi, Florence, Italy/Bridgeman Art Library; 13 b The Art Archive/Musée d'Orsay/Dagli Orti; 14 al, c & b ph. Jerry Harper; 14 ar ph. Pia Tryde; 15 a Edifice, London; 15 b Peter Rayner/Axiom Photographic Agency; 16 a ph. James Merrell; 16 b Ancient Art & Architecture Collection Ltd.; 17 l The Art Archive/Musée Condé, Chantilly/Josse; 17 r Cephas/Hervé Champollion; 18 a Baptism of Christ (& 2 details) 1450s (tempera on panel) by Piero della Francesca (c. 1419/21-92) National Gallery, London, UK/Bridgeman Art Library; 18 b ph. James Merrell/Moss Co. Architects; 19 a ph. James Merrell/The Webb-Deane-Stevens Museum; 19 c ph. James Merrell/Chris Ohrstrom, Historic Paints Ltd.: 19 b The National Trust Photographic Library/Andreas von Einsiedel; 20 I ph. James Merrell/Lillian Williams' chateau in Normandy, France; 20 r Courtesy of the Trustees of the Sir John Soames Museum; 21 a 'Wandle' printed fabric manufactured by Morris and Co. and Aymer Vallance, from The Art of William Morris, pub. 1897 by William Morris (1834-96) Calmann & King, London, UK/Bridgeman Art Library: 21 b David Hockney, Beverly Hills Housewife, 1966, Acrylic on canvas, 72 x 144", (c) David Hockney; 22 Gail & Barry Stephens' house in London; 24 The Arbuthnott family's house near Cirencester designed by Nicholas Arbuthnott, fabrics designed by Vanessa Arbuthnott; 26 a Warner Johnson's apartment in New York designed by Edward Cabot of Cabot Design Ltd.; 26 c Jennifer & Geoffrey Symonds' apartment in New York designed by Jennifer Post Design; 26 b Interior Designer Roberto Bergero's own apartment in Paris; 27 Stanley & Nancy Grossman's apartment in New York designed by Jennifer Post Design; 28-29 & 29-30 Jennifer & Geoffrey Symonds' apartment in New York designed by Jennifer Post Design; 31 bl & br The architect Voon Wong's own apartment in London; 32 Jennifer & Geoffrey Symonds' apartment in New York designed by Jennifer Post Design; 33 Alannah Weston's house in London designed by Stickland Coombe Architecture: 34 Stanley & Nancy Grossman's apartment in New York designed by Jennifer Post Design; 35 Alannah Weston's house in London designed by Stickland Coombe Architecture; **36 a & b** Toia Saibene's apartment in Milan; 36-37 & 37 Interior Designer Roberto Bergero's own apartment in Paris; 38 al & ar Katie Bassford King's house in London designed by Touch Interior Design; 38 b & 39 Warner Johnson's apartment in New York designed by Edward Cabot of Cabot Design Ltd.; 40 a Katie Bassford King's house in London designed by Touch Interior Design; 40 c Margot Feldman's house in New York designed by Patricia Seidman of Mullman Seidman Architects: 40 b Gail & Barry Stephens' house in London: 41 ph. James Merrell/Janie Jackson, stylist/designer; 42-43 Margot Feldman's house in New York designed by Patricia Seidman of Mullman Seidman Architects; 44 Gail & Barry Stephens' house in London; 45 Miv Watts' house in Norfolk; 46 ph. James Merrell/Bill Blass, New York; 47 ph. Andrew Wood/An apartment in London designed by James Gorst; 48 & 48-49 Katie Bassford King's house in London designed by Touch Interior Design; 49-51 Stanley & Nancy Grossman's apartment in New York designed by Jennifer Post Design; **52 a** Richard Oyarzarbal's apartment in London designed by Urban Research Laboratory; 52 c New York apartment designed by Bruce Bierman; 52 b Selworthy apartment in London designed by Gordana Mandic & Peter Tyler at Buildboro (www.buildboro.co.uk); 53 Géraldine Prieur's apartment in Paris, an Interior Designer fascinated with color; 54 Owner of Gloss, Pascale Bredillet's own apartment in London; 55 Interior Designer Roberto Bergero's own apartment in Paris; 56-57 New York apartment designed by Bruce Bierman; 58 Interior Designer and Managing Director of the Société Yves Halard, Michelle Halard's own apartment in Paris; 58-59 & 59 Warner Johnson's apartment in New York designed by Edward Cabot of Cabot Design Ltd.; 60-61 Géraldine Prieur's apartment in Paris, an Interior Designer fascinated with color; 62-63 Private apartment in London designed by Hugh Broughton Architects; 64 Richard Oyarzarbal's apartment in London designed by Urban Research Laboratory; 65 Owner of Gloss, Pascale Bredillet's own apartment in London; 66-67 Lisa Fine's apartment in Paris; 68 & 69 ar & b Interior Designer and Managing Director of the Société Yves Halard, Michelle Halard's own apartment in Paris; 70-71 Selworthy apartment in London designed by Gordana Mandic & Peter Tyler at Buildboro (www.buildboro.co.uk); 72 al ph. Henry Bourne; 72 ar ph. Polly Wreford/Lena Proudlock's house in Gloucestershire; 72 br ph. Polly Wreford/Louise Jackson's house in London; 73 ph. Fritz von der Schulenburg/Piero Castellini Baldissera's house in Montalcino, Siena; 74 a Maria Jesus Polanco's apartment in New York designed by Hut Sachs Studio in collaboration with Moneo Brock Studio; 74 c Toia Saibene's apartment in Milan; 74 b Richard Oyarzarbal's apartment in London designed by Urban Research Laboratory; 75 The Arbuthnott family's house near Cirencester designed by Nicholas Arbuthnott, fabrics designed by Vanessa Arbuthnott; 76 & 77 a Warner Johnson's apartment in

New York designed by Edward Cabot of Cabot Design Ltd.; 77 b Miv Watts' house in Norfolk; 78 Andrew Wallace's house in London: 79 The architect Voon Wong's own apartment in London: 80 Alannah Weston's house in London designed by Stickland Coombe Architecture; 81 Maria Jesus Polanco's apartment in New York designed by Hut Sachs Studio in collaboration with Moneo Brock Studio: 82 a & 83 Marilea & Guido Somarè's apartment in Milan; 82 bl, bc & br Toia Saibene's apartment in Milan; 84 Alannah Weston's house in London designed by Stickland Coombe Architecture; 85 Richard Oyarzarbal's apartment in London designed by Urban Research Laboratory; 86-87 ph. Simon Upton/Lena Proudlock's house in Gloucestershire; 88 a Warner Johnson's apartment in New York designed by Edward Cabot of Cabot Design Ltd.; 88 c Hudson Street Loft in New York designed by Moneo Brock Studio; 88 b Interior Designer and Managing Director of the Société Yves Halard, Michelle Halard's own apartment in Paris; 89 Miv Watts' house in Norfolk; 90-91 Interior Designer and Managing Director of the Société Yves Halard, Michelle Halard's own apartment in Paris; 92-93 ph. James Merrell; 94-95 Warner Johnson's apartment in New York designed by Edward Cabot of Cabot Design Ltd.: 96 a Gail & Barry Stephens' house in London; 96 bl & br ph. Pia Tryde; 97 Interior Designer and Managing Director of the Société Yves Halard, Michelle Halard's own apartment in Paris; 98-99 Donata Sartorio's apartment in Milan; 100 Architect Eric Liftin's own apartment in New York; 101 a Hudson Street Loft in New York designed by Moneo Brock Studio; 101 bc Owner of Gloss, Pascale Bredillet's own apartment in London; 101 br ph. Pia Tryde; 102 a Donata Sartorio's apartment in Milan; 102 c Warner Johnson's apartment in New York designed by Edward Cabot of Cabot Design Ltd.; 102 b Maria Jesus Polanco's apartment in New York designed by Hut Sachs Studio in collaboration with Moneo Brock Studio; 103 An apartment in Paris designed by Géraldine Prieur, an Interior Designer fascinated with color; 104–105 Donata Sartorio's apartment in Milan: 106-107 ph. James Merrell/Sally Butler's house in London: 108 Toja Saibene's apartment in Milan; 109 Warner Johnson's apartment in New York designed by Edward Cabot of Cabot Design Ltd.; 110 ph. Ray Main/John Howell's loft in London designed by Circus Architects: 110-111 ph. Chris Everard/An apartment in London designed by Littman Goddard Hogarth, light courtesy of Skandium; 111 a ph. Andrew Wood/An apartment in London designed by Littman Goddard Hogarth: 111 b ph. Chris Everard/An apartment in London designed by Littman Goddard Hogarth, light courtesy of SCP; 112 ph. James Merrell/Vicky & Simon Young's house in Northumberland; 113 ph. James Merrell/An apartment in Paris designed by Hervé Vermesch; 114 & 114-115 Warner Johnson's apartment in New York designed by Edward Cabot of Cabot Design Ltd.; 115 ph. Andrew Wood/Kurt Bredenbeck's apartment at the Barbican, London; 116 Lisa Fine's apartment in Paris; 117 Interior Designer Roberto Bergero's own apartment in Paris; 118 Lisa Fine's apartment in Paris; 119 Maria Jesus Polanco's apartment in New York designed by Hut Sachs Studio in collaboration with Moneo Brock Studio: 120-121 Richard Oyarzarbal's apartment in London designed by Urban Research Laboratory; 122 Andrew Wallace's house in London; 124-127 Lindsay Taylor's apartment in Glasgow; 128 al & ar & 129 ph. Andrew Wood/Mary Shaw's Sequana apartment in Paris; 128 b The Irish Picture Library: 130-133 Katie Bassford King's house in London designed by Touch Interior Design: 134-135 Géraldine Prieur's apartment in Paris, an Interior Designer fascinated with color; 136-139 Richard Oyarzarbal's apartment in London designed by Urban Research Laboratory; 140-143 Interior Designer John Barman's own apartment in New York; 144–147 Director of design consultants Graven Images, Janice Kirkpatrick's apartment in Glasgow; 148–149 Andrew Wallace's house in London; 150–151 The Arbuthnott family's house near Cirencester designed by Nicholas Arbuthnott, fabrics designed by Vanessa Arbuthnott; 152 ph. James Merrell; 152-153 & 153 The Arbuthnott family's house near Circucester designed by Nicholas Arbuthnott, fabrics designed by Vanessa Arbuthnott, 154-155 Selworthy apartment in London designed by Gordana Mandic & Peter Tyler at Buildboro (www.buildboro.co.uk); 156–157 The architect Voon Wong's own apartment in London; 158 Stanley & Nancy Grossman's apartment in New York designed by Jennifer Post Design; 160-163 ph. Christopher Drake/Juan Corbella'a apartment in London designed by HM2, Richard Webb with Andrew Hanson; 164-167 The architect Voon Wong's own apartment in London; 168 Andrew Wallace's house in London; **169 al** Margot Feldman's house in New York designed by Patricia Seidman of Mullman Seidman Architects; 169 ar & b Alannah Weston's house in London designed by Stickland Coombe Architecture: 170-171 ph. Simon Upton/A house in Norfolk designed by Chris Cowper of Cowper Griffith Associates; 172 b Gail & Barry Stephens' house in London; 172–173 & 173 Owner of Gloss, Pascale Bredillet's own apartment in London; 174–175 Alannah Weston's house in London designed by Stickland Coombe Architecture; 176–177 Director of design consultants Graven Images, Janice Kirkpatrick's apartment in Glasgow; 178 Marilea & Guido Somarè's apartment in Milan; 179 a & br Interior Designer and Managing Director of the Société Yves Halard, Michelle Halard's own apartment in Paris: 179 bl Stanley & Nancy Grossman's apartment in New York designed by Jennifer Post Design; 180 a Selworthy apartment in London designed by Gordana Mandic & Peter Tyler at Buildboro (www.buildboro.co.uk); 181 Miv Watts' house in Norfolk; 182 Géraldine Prieur's apartment in Paris, an Interior Designer fascinated with color; 183 Donata Sartorio's apartment in Milan; 184 An apartment in Paris designed by Géraldine Prieur, an Interior Designer fascinated with color; 185 Lindsay Taylor's apartment in Glasgow; 192 Interior Designer John Barman's own apartment in New York.

All photography by Alan Williams unless otherwise stated. In addition to those mentioned above, the publisher would like to thank: Enrica Stabile in Milan, Jon Geir and Inger Høyersten, and the Heddal-og Nottodden Museum in Norway.

INDEX	Brookgate 18	counter-changing 17	flooring	herbs 14
	brown 40, <i>46</i> , 47 cool 48–51	counters 7, 33, 106, 113, 136, 155,	parquet 36, 47, 51, 90, 97, 132,	Hockney, David: Beverley Hills
Figures in <i>italics</i> indicate captions.	warm 47–8	162 couture houses 12	149, 166	Housewife 21
A	bureaux <i>135</i>	cream 40, 42-5	rubber <i>62</i> , <i>65</i> , 137 tile <i>32</i>	hoods 113
acanthus leaves 184	bulcaux 155	crimson 59	wooden 28, 29, 35, 38, 43, 46, 70,	1
accent colors 71, 111, 162, 162	C	cupboards 149	79, 92, 100, 111, 113, 147, 151,	ice-cream cool 150–53
acrylics 181	cabinets 7, 28, 32, 56, 58, 62, 69, 87,	cups 165	175	Impressionism 12, 13
Adam, Robert 20, 20, 90	100, 106, 136, 155, 155, 162,	curtain poles 65, 179	flowers 10, 12, 14, 14, 30, 52, 60, 67,	India 14, 60, 124
Adam green 90	183	curtains 54, 60, 61, 65, 67, 69, 90,	69, <i>72</i> , 77, 82, 112, <i>152</i> , <i>162</i> ,	indigo 82, 84
alcoves 79, 132	candles <i>85</i> , 115	99, 129, 132, 135, 144, 147,	172	Industrial Revolution 20
aluminum <i>84</i> , <i>175</i>	Cappellini 51	151, 179	Forest Green 93	industrial spaces 165, 167
America	Caribbean 14, 15	shower 85	Fowler, John 28, 126	invisible green 97
colonial period 19, 48, 57	carpets 7, 58, 126, 167	cushions <i>87</i> , <i>92</i> ,	France/French 14–15, 20, 20, 34, 72,	ironwork 96
early settlers in 19, 185 stencils 185	cave paintings 16 ceilings 17, 21, <i>67</i> , <i>70</i> , 78, 90, 126,	D	85, 87, <i>99</i>	Italy 15, 18–19, 20
Angelico, Fra 13	146, <i>147</i> , 165, 168	dado rails 16, 20, 65, <i>69</i> , 93, <i>97</i> , 135,	freehand painting 184 frescos 16, 19	J
apple green 100, 101	false 78, 168	184	friezes 16	jacket <i>76</i>
apricot 64	mezzanine 167	dais <i>35</i>	fruits 10, 12	jade green 95
arabesque motif 184	ceramics 135, 143, 144, 146, 147,	damask 179, 185	fur <i>34</i> , <i>131</i> , 132	jars <i>72</i>
arches 17, 178	184	dark rooms 168	furniture 34, 72, 129, 141	Jones, Owen: Grammar of Ornament
armchairs 95, 108, 131, 132	Cézanne, Paul 13	daybeds 28, 151	bedside 34	21
armoires 65	The Card Players 13	decorative paintwork 182-5	leather 57	jugs <i>113</i>
Art Deco 65	chairs 7, 38, 43, 66, 105, 128, 133,	dining rooms/eating areas 47, 57, 58,	wooden 38, 58, 96, 108, 108, 115,	V
Arts and Craft movement 148, 168	137, 160	<i>60</i> , 63, <i>69</i> , 70, <i>92</i> , 95, <i>97</i> , 113,	151	K
aspect, room 174	antique 36	115, <i>126</i> , <i>137</i> , <i>165</i> , 173, <i>178</i>	C	kitchens <i>7, 32, 33, 42, 62,</i> 63, <i>81, 82, 97, 100, 106, 107,</i> 108, 113,
atmosphere, creating 172–5 autumn light 144–7	bedroom 175	dishtowels 7	G	115, 115, 126, 136, 137, 137,
Aymer Vallance 21	dining <i>32, 33, 47, 69, 130</i> kitchen <i>100, 155</i>	distemper 19, 67, 178 distressing 182	Gainsborough, Thomas 13 games rooms <i>39</i>	148, 154, 155, 162, 165, 167,
Ayliici Valialice 21	leather 28, 29, 47, 51, 54, 56, 57,	door frames <i>77</i> , <i>92</i> , <i>93</i> , 97, <i>105</i>	gardens 152	173, 183
В	143	door panels 135	gilding 10, 17, 18, 19, 20, 64–5, 69,	,
banisters 93	library 59	doors 7, 87, 93, 95, 97, 100, 111	87, 135	L
bark 12, 96	metal 72, 162	sliding 139, <i>139</i>	Giotto 13	lamps 144, 174
barn conversion 170, 171	moulded 139	"drab" <i>58</i> , 95–6	Giverny, France 107	bedside 34
Barragán, Luis 139, 160	plastic <i>62</i>	dragging 176, 182, 183	Glasgow 144	Lancaster, Nancy 36
bars <i>29</i>	straight-backed 101	drawing rooms 55, 61, 66, 95, 179	glass 10, 49, 51, 82, 97, 123, 128,	lapis lazuli 12, <i>81</i> , 184
baseboards 20, 48, 57, 93, 97, 184	tall-backed <i>90, 162</i>	dressers 87	<i>135</i> , 137, <i>137</i> , <i>140</i> , <i>143</i> , <i>160</i> ,	Lascaux, France 16
baskets 149	wooden 150, 151	Dutch painting 148	162, <i>162</i> , <i>184</i>	lattice work 78
bathrooms 25, 42, 48, 48, 49, 63,	chaise longue 61	dyes 12, 14, 19, 21, <i>21</i> , 59, 69, 90	glazes 180-81, 182, <i>182</i> , 183,	lavender 15, 72, <i>72</i> leather <i>28, 29, 34, 47, 51, 57</i> , 95,
84, 85, 108, 137, 139, 172	chandeliers <i>135</i> checks <i>92, 128, 151</i>	E	184	108, 115, 184
bathtubs <i>84</i> , <i>85</i> , <i>139</i>	chests of drawers 45, 82	Eames, Charles 142	gloss finish 100—101, 146, <i>147</i> gold <i>36</i> , 37, <i>54</i> , 64—5, <i>69</i> , 85, 87,	libraries 93
beams 17, <i>153</i> , <i>168</i>	china 42, 87	earth 12, 16, 18, 25, 40, 93	102, 118–19, 118–19, 178	lichen 96
bed-covers 58, 117	Chinese, ancient 78	eau de nil 99–100	gold leaf 10, 87, 87, 178	lighting
bed-linen 38, 65, 72, 82, 175	Chinese lacquer yellow 108	eaves 7, 153, 170	Gothic art 17	background 174
bedrooms 34, 34, 38, 45, 57, 58, 63,	chintz 179	egg (for making tempera) 12	Great Exhibition (1851) 20	natural 13–15, <i>67</i> , 87, <i>132</i> , 134,
65, 70, 72, 76, 78, 84, 98, 105,	chipboard 125	Egyptians, ancient 16, 180, 185	Greece 74	<i>135</i> , 139, 141, 144, 155, 165,
108, 111, 113, 124, 124, 125,	chopping boards 107	embroidery 18, 66	Greeks, ancient 16, 20	<i>166, 167,</i> 174
132, <i>132</i> , <i>153</i> , <i>166</i> , <i>167</i> , <i>170</i> ,	chrome 29, 49, 51, 107, 139, 140, 142	emerald green 95	green 88–101	lights
173, <i>175</i> , <i>183</i> beds <i>34</i> , <i>46</i> , <i>65</i> , <i>76</i> , <i>82</i> , <i>132</i> , <i>153</i> ,	cinnabar 54	Empire style 20	cool 95–7	floor <i>60</i> low-level hanging <i>162</i>
167	closet 70 clothesrod 132	England, Renaissance 19	warm 93, 95 gray 26, 34–7	reading 57
bedspreads 65	cobalt 16, 77	F	with black 34	strip 49
benches 70, 79, 93, 123, 154, 165	coffering 19	Farrow and Ball 151	cool 36–7	lilac 69, 69, 70, 71, 72, 72
billiard rooms 93	cold rooms 168	fashion 12, 18, 21, 72, 136	warm 34, <i>35</i> , 36	lime green 101
black 26, 34, <i>34</i> , 38, <i>38</i> , <i>39</i>	colonial house, New York State 19	faucet 113	grills 113	limewashes 178
blankets 151	color chart 8	feathers 45	grisaille work 34, 36	limestone 84
blinds, Venetian 166, 167	color through history 16–21	fez 76	grotesques 18	Lincoln green 90
blues 74–87, 136–7, 139	colorwashing 180, 182	fireplaces 25, 36, 38, 44, 58, 108,		linen 12, 19, 128
cool 82–7	color wheel 8, 8, 135, 136	113, 124, 127, 133	H	living areas 35, 36, 44, 50, 54, 57,
and orange 111, 123, 136, 136	color zoning 160–67	fires 35	half-bath 49, 179	70, 90, 105, 108, 108, 111, 115, 125, 126, 129, 132, 139, 144,
warm 78–82 bookcases <i>57</i>	columns <i>39</i> combing 176	flat finish 100, 146, <i>147</i>	halls 37, 48, <i>60, 79, 93,</i> 95, <i>100, 147,</i>	123, 126, 129, 132, 139, 144, 144, 152, 154, 166, 172,
bookshelves 144	complementary clash 136–9	floor lights <i>60</i> flooring	<i>150</i> , 165, 171, <i>176</i> , 185 Ham House, Surrey <i>19</i>	173–174, 179, <i>184</i>
bowls 127, 140	complementary colors 8, 8, 12	board <i>125</i>	hangings 18, <i>49</i> , <i>58</i> , <i>65</i> , 178–9,	loft apartments <i>160</i> , 162
brass 65	consoles 69	flagstoned 113	179	Louis XIII, King of France 20
bricks, glass 123, 137, 139	copper 16, 90, 178	marble <i>44</i> , <i>49</i>	harmonious hues 134–5	Louis XIV, King of France 20
brickwork 162	corridors 168	painted 72, 84, 87, 93, 105, 132,	headboards 38, 65	Louis XV, King of France 20
bronze 178	cotton 12, 46	133	hematite 16	Louis XVI, King of France 20

			00 00 00 01 07	
M	paints	red	steel, stainless 33, 62, 80, 81, 97,	verdigris 90, 178
magnolia 28	fluorescent 178	cool 59	101, 113, 113, 142	vermilion 54
majolica plates 185	glitter 178	warm 57	stenciling <i>87</i> , <i>184</i> , 185	Victoria, Queen 96
malachite 12, 16, 184	glow-in-the-dark 178	wine 59	stippling 182–3, 185	Villa Madama 19 Villa of Mysteries, Pompeii <i>16</i>
Mantegna, Andrea 13	metallic 178	Regency style 20, 38	stone 17, 25	violas 14
mantelpieces 36, 108, 124, 133	milk 178	religious paintings 10	stools 39, 108, 133, 165	violet 69
marble 14, 28, 44, 49, 51, 81, 127,	oil-based 180–81, 183	religious symbolism 18	strip lights 49	voiles 128
184	swimming-pool 80	Renaissance 13, 18–19	stripes 37, 61, 67, 92, 125, 127, 131,	volutes 184
Matisse, Henri 13	water-based 180, 183	Renoir, Pierre Auguste 13	<i>135, 144, 147, 165, 179, 182,</i> 185	volutes 104
mats 108	paintwork, decorative 182-5	Chemin montant dans les hautes	stucco patterns 90	W
Maugham, Syrie 32	Palladian decorative schemes 38	herbes 12	studies 48, 93	waistcoats 12
mauve 69, 72	paneling 7, 16, 19–20, 20, 34, 36,	Reynolds, Sir Joshua 13	suede <i>54</i> , <i>65</i> , <i>79</i> , <i>165</i>	waiting rooms 100
Medici, Cardinal Carldo de 13	51, 55, 58, 69, 78, 87, 87, 97,	Romanesque art 17	Suede 34, 03, 73, 103	wallpaper 21, <i>21</i> , 185
Medici, Catherine de 77	105, 124, 124, 128, 131, 135,	Rome/Romans 16, <i>16</i> , 18, 20, 185 roof tiles 78	T	walls
Medici blue 77	179, <i>182</i> , <i>183</i> , 185, <i>185</i>	roots 12	tables 97	bordered 105
medieval decoration 118, 142, 185	pastel colors 151	rosemaling 16	bedside <i>65</i> , <i>175</i>	curved 137, 137
medieval Europe 17–18, 17	patchwork	rubber <i>62</i> , <i>65</i> , 137	circular 143	glass 137, <i>139</i>
medieval paintings 77	quilts 46	rugs 47, 51, 61, 66, 70, 90, 95, 141,	coffee 29, 140, 143	mosaic 85
Mexico 60	rugs <i>70</i> pebbles <i>84</i>	143	dining 32, 33, 47, 69, 130, 137	paneled 16, 60, 97
mezzanine space 165, <i>166</i> , <i>167</i>	pedestals 55	Runge, Philipp Otto: Color Spheres 8	glass 51	partition 137
microwave ovens 33	pictures see paintings/pictures	Kunge, I minpp otto. Ooloi opinoico o	kitchen 100, 113, 162	planked <i>92</i> , <i>93</i>
Middle Ages 38, 90, 179	Piero della Francesca 13	S	marble <i>51</i>	suspended 35
Mies van der Rohe, Ludwig 142, 143	The Baptism of Christ 18	Saarinen, Eero 142, <i>143</i>	pool 39	"Wandle" design 21
milk paints 178	pigments 12	sage green 97	side <i>56, 128</i>	wash basins 25, 49, 172
minerals 12, 16, 25	pilasters 19	Sainte Chapelle, Paris 17, 17	slate-topped 134	washes and glazes 180-81
mirrors 25, 49, 96, 142, 143, 155,	pillar units 155	samples 7	wooden 165	Wedgwood, Josiah 77
172	pillars 44	sari lengths 179	taupe 123	Wedgwood blue 77, 84
Monet, Claude 107	pillows 10, 34, 38, 54, 55, 58, 65, 66,	Sayers, Dorothy 38	television rooms 57	Wethersfield, Connecticut (Joseph
Morocco 15	66, 131, 132, 153, 160, 165	Scandinavian blue 74, 84, 87	tempera 12	Webb house) 19
Morris, William 21, 21	pink 52, 60–67, <i>135</i> , 136–7	scarves 12	tertiary colors 8	white 27–32, 33
Morris & Co. 21	cool 66–7	scrapbook 7	textiles 12, 19, 21, 21, 34, 49, 58, 60,	brilliant 28, 32
mosaics <i>85</i> , <i>136</i> , 137 molding <i>36</i> , <i>55</i> , 87, 135, <i>135</i> , <i>182</i>	warm 63–5	screens 38, 123, 142, 143	69, 90, 128, <i>153</i> , 168, 178–9,	"broken white" 31
	pitchers 107	scumble glaze 181	179	contrasts 28, 29, 32, 33
ceiling 20, 124, 126 picture 124	plaids 128	seating 35, 57, 92, 131	texture 131, 131, 132, 141, 142, 168	cool 31-2
multicolored layers 176	plants 12, 37, 77, 99, <i>159</i>	secondary colors 8, 141, 155	throws 34, 126, 132, 160	pure/off- 28
murals 16, 18	plaster 18, 20, 36, 63, 67, 70, 87,	shades (of color) 8, 25,	ticking <i>36</i> , <i>151</i>	warm 28, 31
Murray, Keith <i>144</i> , 146	101, 130, 154, 155, 178	shades 29	tiles 15, 32, 42, 58, 78, 82, 85, 111,	window frames 43, 46, 95, 97, 124,
Muliay, North 144, 140	plastics 62, 85, 123, 139	Shakers 148, 149	<i>136</i> , 137, <i>139</i>	162
N	plates 36, 69, 178, 185	shapes, making 168–71	tints 8	windows 51, 67, 80, 124, 127, 129,
Nankeen (Nankin) blue 77	plywood 136	sharp contrast 154-5	Titian 13	141, 144, <i>149</i> , 165, <i>166</i>
narcissi 14	Pol de Limbourg: Les Riches Heures	shawls 12	Man with a Blue Sleeve 77	French 152
neutral shades	17	shelves 97, 136, 144, 167	Titian blue 77	wood 17, 36
creams and browns 40–51	Pompeii 16	shower curtains 85	toile de jouy <i>98</i> , <i>99</i> , 179	gilded 18, 87
nearly neutrals 131–2, 133	porcelain 36, 77, 180	shower rooms 80, 101, 111	tones 8, 12, 25, <i>25</i>	painted 18, 19, <i>96</i>
whites, greys, and blacks 26–39	Post-Impressionism 13	shower screens 101	a lesson in tone 124-7	paneled 69
niches 130	pots 61, 113	shutters 46, 95, 124, 135	tortoiseshell 184	wood-grained effects 184
northern Europe 19	pots and pans 149	sienna 18, <i>18</i> , 40, 42	towel rods 49	woodwork 28, 36, 47, 57, 72, 82, 108,
Northumberland House, London 20	primary colors 8, 16, 52, 54, 69, 141	silk <i>49</i> , <i>55</i> , 66, <i>67</i> , <i>179</i>	towels <i>85</i>	149, <i>150</i> , <i>151</i>
Norway 16	prismatic colors 25	silver 178	trompe l'oeil 17, 36, 135, 184, 185	exterior 96
nuances 25, 26	Provençal blue 78–9	sinks <i>87</i> , <i>101</i>	Tudor period 18	painted 19, 58, 67, 95, 124, 126,
	public rooms 100	Sitwell, Osbert: Left Hand, Right Hand	Tuscan red 15, 57	147, 148
0	purple 52, 69–72	72	tweeds 128, 128	uses of colored woodwork 151 wool 12, 19
ochers 18, 40, 42, 54, 58	cool 72	slate 113, 130, 132	twentieth-century tone 140-43	W001 12, 19
offices, home 72, 115	warm 70–71	sliding partitions 111	U	γ
oil 12	0	small rooms 49, 108, 168	ultramarine 77	yacht varnish 70
Omega movement 21	Q	Soane, Sir John 107	umber 18, 40, 42	yarn 12
orange 102, 110-17	quilts <i>46</i> , <i>58</i>	sofas 29, 43, 51, 54, 55, 57, 66, 77,	understanding color 12–15	vellow-green 99
and blue <i>111</i> , <i>123</i> , 136, <i>136</i>	R	90, 95, 125, 126, 143, 147, 165 library 59	unusual finishes 178–9	yellow 102
orpiment 16		soft simplicity 148–9	unusuai iiiisiics 170 5	cool 105, 107
ottomans 51, 57	Racing Green 93	Spanish brown 19	V	warm 107-8, <i>108</i>
over-large rooms 168, 171	radiators 72	spatial harmony 152	Van Gogh, Vincent 13	
D	rag-rolling 183 ragging <i>78</i> , 176, <i>182</i> , 183, 184	spearmint green 96	vases 55, 82	Z
P	ranges 113, 153	spectrum 25	Vatican Loggia 19	zinc <i>97</i>
paintings/pictures 10, 12, 13, 13, 18,	Raphael 18	splashbacks <i>87</i> , <i>100</i> , <i>139</i> , <i>155</i>	vegetables 12, 16	
19, <i>35</i> , <i>56</i> , <i>58</i> , <i>78</i> , <i>82</i> , <i>90</i> , <i>95</i> ,	reading lights 57	spongeware 82	velvet 55, 57, 59, 66, 132, 179, 180	
108, 123, 169, 178	red 52, 54–9, <i>140</i> , 141–2	sponging 176, 182	Venetian blinds <i>166</i> , <i>167</i>	
paints 14 blackboard <i>147, 176</i>	berry 59	stairs 7, 37, 44, 95, 169, 171, 171	veranda 36	
DIACKDUAIU 14/, 1/0	,			

Acknowledgments

Writing this book opened my eyes even further to the possibilities, pleasures, and sheer beauty of color. I realized that one too often takes color for granted, both as it is found in the natural world, and as used in decoration. Making this book look as good as it does was a team effort and I would like, especially, to thank the ever-tranquil Sophie Bevan (at least with me), Gabriella Le Grazie, Catherine Randy, and Sarah Hepworth for producing such a terrific book.